The Fear of Hell

The Fear of Hell

*Images of Damnation and Salvation in
Early Modern Europe*

Piero Camporesi

Translated by Lucinda Byatt

The Pennsylvania State University Press

This English translation © Polity Press 1990
First published 1991 in the United States by the
Pennsylvania State University Press, Suite C,
820 North University Drive, University Park,
PA 16802

Library of Congress Cataloging-in-Publication Data
Camporesi, Piero.
[Casa dell'eternità. English]
The fear of hell/Piero Camporesi: translated by Lucinda Byatt.
p. cm.
Translation of: La casa dell'eternità.
Includes bibliographical references and index.
ISBN 0–271–00734–6
1. Hell—Christianity—History of doctrines. 2. Lord's Supper
—Adoration—History of doctrines. 3. Stomach—Religious aspects
—Christianity—History of doctrines. I. Title.
BT836.2.C3613 1990

261.5'8—dc20 90–44897
CIP

Typeset in 10½ on 12 pt Baskerville by
Acorn Bookwork, Salisbury, Wiltshire
Printed in Great Britain by T. J. Press Ltd, Padstow, Cornwall

Contents

84758

Note to the Reader

The maps of hell have by now become illegible. Not only do we not know how to get there, but it is no longer clear where hell is to be found. Nor do we know whether its gates are still open. Basing his remarks on unidentified sources, a well-known theologian recently affirmed that hell exists but that it is probably empty. Some people suppose that hell must be conceived as a non-place, while others speak of it unwillingly, somewhat embarrassed, as a worn-out metaphor.

Having dominated the Christian outlook, and having been an indispensable point of reference in medieval and modern Europe, the protagonist of innumerable spiritual dramas even before the time of Constantine the Great, and a powerful instrument of conditioning which was continuously perfected and updated over the centuries, this great fund of terrors and agonies, the inexhaustible source of anguish and nightmares, is now quietly dissolving in man's conscious and unconscious mind.

We can now affirm with some justification that hell is finished, that the great theatre of torments is closed for an indeterminate period, and that after almost 2,000 years of horrifying performances the play will not be repeated. The long, triumphal season has come to an end. The devil, master of the material world, seems to have survived. But, he does so as a deposed sovereign, as a king in exile, since the door of his tormented kingdom is closed and he has neither throne, nor court, nor city, nor castles. He barely manages to survive on the paltry income from those evil shares with which his once-flourishing metallurgical industry provided him. A bankrupt with little credit, he can still strike a bargain in a few of the sad cities which flourished in the golden times of heavy industry. But we cannot take seriously the proposition made at the Feast of the Assumption in August 1986 to the faithful of the

Third and Fourth Worlds, that the resurgence of Satan will have a further sequel. We need to realize once and for all that we have entered a post-infernal age, with all the problems that this change will certainly bring. There is no room in the post-modern and post-industrial world for the howling criminal warehouses of hell. They existed for a long time, almost for an eternity, while men worked the earth and wondered with anxious curiosity what lurked in the ground beneath their feet. Today the vortical depths of cosmic space have ousted those of the abyss. In fact, a new scientific fantasy is being formed: the 'overworld'. A millenary fear has been repressed. Space travel (which is, in all truth, not always safe and trouble-free) has rendered any journeys downwards both obsolete and useless.

In parallel to this change of direction, the chthonic myths have also been shaken up. Dreams, nightmares, ravings from agrarian cultures, harmless folklore rubbish, the cumbersome relics of incomprehensible cults of grain and seed, liturgical daydreams of rude worshippers of the bread and the wine (of the kind in which a powerful God makes a hidden offering of himself), hallucinatory and short-lived parousia and traumatic epiphanies, the dreams of the sick and fairy-tale novels all seem to have survived only in the Third World of undernourished visionaries.

'History can be independent of theology,' a full-time demonologist has stated, 'but theology cannot be independent of history.'* Everything that has been constructed by religious meditation is subject to the inevitable wearing-away of the centuries, a tributary to the most tragic human invention: silent and elusive time. The gods grow old, decay and die, broken down by the dust of years. Only time, disguised as a skeleton, has succeeded in penetrating the house of Adam. 'Death climbed in through the window.'

When hell closed its gates, paradise was also liquidated. The bottom only makes sense in relation to the top, as light is only visible in contrast to darkness. This is the inescapable logic of dualist systems such as the Christian–Catholic ethos, built on the balance between opposites. If paradise is light, serenity, knowledge and power, then hell must necessarily be the negative, in the same way as the unconscious is restless and tormented, obscure and impotent in relation to the superconscious. As a 'most unquiet place', the kingdom of evil does not know the harmony of good, nor the ineffable grace of comforting serenity. There is no order down there, only confusion. In

* Jeffrey Burton Russell, *Satan. The Early Christian Tradition*, Ithaca, NY, Cornell University Press, 1981, p. 12.

the reign of chaos the celestial harmonies which delight the blessed are unknown and there is only noise, heart-rending cries, laments and swearing, inexorable dissonances and insupportable music, as in a wild *charivari*.

Even the classic protagonists of hell have almost all disappeared. Instead, we need a flaming prison larger than the earth itself for the new, emerging sinners. Thee is no possible site for the *place locale* of the new Tartary. Unfortunately, the glutton no longer exists (with the exception of a few Levantine nabobs fattened from the proceeds of the profitable arms trade) or is rapidly becoming extinct. And in any case it would perhaps not be appropriate to bury him for eternity in hell. Fast food, which does not induce either dreams or temptations, and is devoid of pleasure (or sin), has, together with health-conscious diets and vegetarian eubotics, made a significant contribution to removing the reprehensible excesses of earlier days. The fear of excess calories is nowadays more potent than the terror of the flaming, vile food of hell. Partridges and woodcook, capons and pies, sturgeon and moray eels, falernian and malmsey wines, infernal instruments of perdition, have fortunately disappeared and it is unreasonable to suppose that onion sandwiches or other 'diabolic dishes' can lead us to damnation. The other world, overturned by eternal punishments, prospered when this world was (for the rich) full of pleasant seductions, sweet to live in and appetizing to the taste: now hell is here, within the reach of all pockets. It is here in the poisoned wines, the tomatoes fertilized with temik, the meat swollen with carcinogenic hormones, the spring vegetable produce covered with pesticides, the beautiful, worm-free apples which have poisonous juices (how powerful tradition is!); it is in fish full of mercury, in water contaminated by atraxine, in the air polluted by tetraethyl of lead. The hell of the stomach is no longer a literary metaphor but a day-to-day, tough, chemical reality. The Augustinian 'gluttonous stomach' and the 'great feasting' of Saint Jerome, which simultaneously corrupted body and soul, become ever more rare and improbable.

If today the soul is comparatively peaceful, the same cannot be said for the misused and threatened body. Saint Jerome (and he was not the only one) thought that 'lust was always connected to satiety'. But today the genital canal is not so intimately connected to the alimentary one and, certainly, it is not so well used. 'The stomach and the genitals are close together', observed the learned Father, 'both in the order of anatomy, and in the order of vices'. Obviously, anatomically speaking, the stomach and the genitals continue to be contiguous, but in spiritual terms they do not have the same relationship as before. They

are like a separated couple still living in the same house. Fortunately, a lack of appetite increases virtue. Saint Ambrose may now with reason be reassured: 'hunger is a friend of virginity'. Hell would frankly be wasted on a population of sandwich-eaters. For this post-erotic society, a post-hell is just what is needed. Sex is nowadays nothing more than a visual vice, especially thanks to AIDS. And 'safe sex' (the sex of the future which glints as colourless as the aubergines packed under plastic in a supermarket) is not the most obvious choice for a sinful walk in the gardens of Venus.

Hell would be equally wasted on prodigals and wastrels. Family savings have replaced the bad habit of prodigality, which was widely practised in Christian Europe, since for some time the old sin–virtue of convivial liberality and seigneurial hospitality has not been in use, and people prefer to invest in government shares, trusts and other financial stocks. As for the hell of smells, we have no further cause for worry. The stench of the underground drains, the stink of damned bodies and the miasmas of flesh corrupted by sin cannot terrify the already condemned noses of people who every day inhale, with obvious satisfaction, lethal doses of carbon monoxide and sulphur dioxide. We have formidable deodorants and we can ignore the dangers both of the invisible and of undetectable contamination. We can therefore live reassured. The hell of the five senses is no longer buried down there in 'the heart of the earth'. And even if it has transferred itself up here, among us, we do not even notice it.

PART I

Hell

1

The House with Three Floors

Half-way between high and low, between the two extremes of good and evil, of happiness and abjection, between the blessed summit and the cursed abyss, the middle world, the terrestrial globe, the temporary resting place for the living and the clearing house for the souls of the dead, suffers from having been placed in this peculiar position by inscrutable Providence.

The influences, temptations and appeal of the two neighbouring Kingdoms, the celestial next world and the infernal underworld, penetrate the middle floor of the great building equipped by God (the triple dwelling). Human society is a mixed realm, a place of conflict, aspirations, tensions, the medium space between the highest and the lowest, between the splendours of light, the consolations of peace, the delights of sweetness, of joy, of melody, of whiteness and sweet-smelling odours, and the iniquities of the lowest stratum, the obscenities of the nether-regions; it participates, in a strange and opposing mixture, in the conditions of its two powerful neighbours, the two superpowers; it oscillates between an ineffable state of total blessedness, which can be neither expressed nor thought of, and an ineffable state of interminable pain, which can be neither described nor imagined. It is an ephemeral kingdom, in which – throughout history – there has been a rapid, tumultuous succession of births and deaths, short-lived triumphs and distressing falls; these events are quickly consumed by the days and hours, eaten by the years which pass as rapidly as seconds, and by the brief seasons which are wiped out by corrosive winds and frozen tempests, and dominated by the sad master of time, sterile but insatiable Saturn.

The stars cast their malicious influences on the sublunary world which is the target of their implacable dust-like power; the moon

3

showers it with cold dews; the sun blasts it with hot blazes. The impalpable angels descend from the sphere of light bringing with them suggestions of ecstasy and inspiring visions; the demons rise up from the night, implanting temptations and contorted, immoderate and impure fantasies. From the two inconsumable houses, from the two floors where time has no power, the secret agents of eternity penetrate the crevices of life (like death which clambers on to the windows of houses), where men in transience live out their laboured existences in the Kingdom of voluble time which aspires to the end, to silence, to immobility. In this middle apartment desire is, on occasions, satisfied, and at other times not: the capriciousness of chance, the volubility of fate, the inconstancy of fortune dispose as they will of their gifts or their misdeeds. The alternation of desire and waiting, of present and future, scans the internal rhythms of the tenant of the middle floor, who sooner or later will inevitably be evicted and moved elsewhere. The rules are different in the other two apartments. On the top floor, nothing is wished for that is not immediately granted; on the bottom floor, nothing that is most longed for can be found. On this scale of desires, the earth lies equidistant between the extremes, between the society of Christ and that of Satan. As the unknown author (perhaps from the seventh century) of *De triplici habitaculo* imagined, the middle floor has many points of contact with the extremes (*'medium autem nonnullam habet similitudinem ad extrema'*). For this reason our world forms part of both one (paradise) and the other (hell) in a continuous see-saw between the extremes:

> It contains light and darkness, cold and heat, sickness and health, joy and grief, hate and love, good and evil, just and unjust, masters and servants, power and subjection, hunger and satiety, death and life, and innumerable other pairs of this type. And in each case, one half contains an image of God, the other, of hell. For the commingling of things good and evil belong to this world.[1]

A border territory, a fragile frontier area between two superpowers, between two immortal giants, between two opposing but specular empires, a place of exchange and contact between the Kingdom of light and that of darkness, a transit camp and passing point for opposite destinations, the departure point for obligatory and unsolicited journeys into eternity and for inconsumable sojourns in immortality, the earth appears as a non-place, a space which is denied permanence and which has no concrete prospect of a third way into the future, either immediate or long-term. The equidistance is, how-

4

ever, purely theoretical, and generously deceptive, since the days on earth seem to be a foretaste of those in the underworld; they are troubled, confused, anxious and painful: a dress rehearsal for the everlasting and severe torments of a temporal hell or, at best, a bitter, full-time purgatory from which there is no hope of voluntary escape. It is not clear whether this world is a successful imitation of hell or whether hell is a model of this world, such is the interexchangeability of their appearances. The tripartition, an ancient legacy (as usual) of the Indo-European culture which divided humanity into three social strata, seems to re-propose an ethical tridivision into (a) the good, the just and the blessed; (b) the perverse and the damned; and (c) the not entirely bad and the not entirely good; the division is reminiscent of the north-western Celtic medieval visions in which the boundaries between the dead were so uncertain and approximate that one only needed to climb over a wall to find oneself in a different zone, in one or other of the next worlds.

Built from anguish and from the tribal fears projected into the dark-rooms of the caves of the soul, over the course of the centuries hell has accurately recorded changes in society by modifying its own scenarios, and adjusting its own statutes. This 'adjustable' space has put on changing performances, raised surprise backdrops and changed scenery; it has disguised its terrors, revarnished its monsters, emptied its warehouses, re-established its fears, re-invented its demons, its fauna and flora; it has re-measured its boundaries, re-studied its hydraulic system, redesigned its urban layout, its ventilation and drainage systems, reconverted its workshops, reformed its hospitals, perfected its torments, sacked useless or superfluous officials, re-thought its structure, demolished all mere semblances and liquidated obsolete allegorical monstrosities; it has both enlarged and restricted its spaces, welcoming all new and well-deserved categories of sin. Even the antique, balanced 'order of punishments' (*ordo poenarum*), the old penal diarchy perfectly divided between the intolerable cold and the unextinguishable heat, has been overwhelmed by the absolute pre-dominance of fire. No trace remains in the modernized hell of the eternal hibernation in ice. The classic range of tortures, which was extraordinarily rich and varied especially during the fourteenth and fifteenth centuries, has become progressively restricted and subject to a severe selective process. None the less, there remained a respectable hard core of punishments and a wide spectrum of torments, but certain options appeared to be inevitable and the process of reconver-sion was accompanied by the need for homogenization and simplifica-

tion, and by the request for specialization and for the thinning out of the archaic superabundance apparent in the ancient litanies of hell:

> Unbearable thirst, the punishment of hunger, of stench, of horror, of fear, of want, of darkness, the cruelty of tortures, the presence of demons, the ferocity of wild beasts, the cruelty of attendants, the rending by undying worms, the worm of conscience, blazing tears, sighs, miseries, pain without alleviation, bonds without release, eternal death, punishment without end, the absence of Christ after beholding him.[2]

Even the seven infernal scourges of the *Vision of Saint Paul*[3] (snow, ice, fire, blood, serpents, lightning and stench) appear under the form of 'smoke, fetor, cold, heat, hunger, burning thirst and worms' in Saint Pier Damiano, who knew the fate which awaits inconstant variables.[4]

In the same way, the 'hard and terrifying region of Gehenna' described by the Cardinal of Ostia, the 'land of torment', the 'wretched land', the 'land of shadows', the 'land of whirlwinds and darkness', the region of chaos 'where there is no order', the city of noise and smell, the great workshop of pain where devils, those indefatigable metal workers (a Christian version of the pagan cyclops, inhabitants of Vulcan's 'pot', as described by Gregory the Great and many other medieval legends) hammer without a moment's respite (*'percutientes mallei resonant incessanter'*) – a picture of a city which is surprisingly modern, unliveable, contaminated, acoustically deadly – all were radically changed by Dante's concept of the city which was rigorously geometric and minutely controlled in every detail. Using an Aristotelian compass and a Thomistic square, the lucid Florentine visionary scrupulously eliminated all the unseemly crowding, every trace of undue confusion, every residue of chaos. He graded the punishments according to the crimes, transferred the damned within hell and placed the others (those guilty of 'incontinence') outside the city of Dis-Lucifer, reserving the lower inferno (VIII, 75) for those supremely guilty of malice and mad bestiality. In the Baroque hell, all the inhabitants, and first and foremost the incontinents, were indiscriminately returned into a single fire (the intelligent and selective instrument, vicar of all other punishments and comprehensive of all other torments). 'Divine revenge' did not distinguish between 'similar vileness' (the evil doers of the '*Malebolge*', the 'circle with evil pockets') and the professional practitioners of excess and intemperance. It was a sign of the times that greed and lust were considered the chief sins during the seventeenth century, and the most valid passports to equalitarian torments in the 'other country' which generously wel-

comed all those who abandoned themselves to sins of the flesh[5] or who were assiduous *habituées* of 'forbidden pleasures' (Gregory the Great). The hell of the five senses was solely for them, for these integral, impenitent hedonists.

The mill of time and the grindstone of the centuries have not only changed the spaces and scenery of the underground world, but, in response to social changes, changing customs, the formation of new classes and social groups and cultural mutations, they have brought about new inventions in the typology of sinners and the damned, and new uses for the punishments.

The spaces occupied by the subterranean penal colony have progressively shrunk; the number of square metres reserved for sinners has become ever smaller; the smell has become increasingly intense and promiscuity ever worse. Transgressions of the work ethic, social crimes and deviations from professional ethics have enlarged the scope of punishable crimes. Not the Dantesque, nor the feudal nor the communal model envisaged punishment for abortion or for the violation of religious vows; nor could they allow for the sins of a torbid imagination or the impurities of mental fornication, as was the case during the period of the Counter-Reformation. These models failed to provide minute and capillary punishments for whole categories of sinners: impolite pettifoggers; lying notaries; pharmacists who counterfeited their medicines; dishonest merchants; surgeons who tormented their patients by using various means to prevent cuts and wounds from healing; butchers who cheated on the weight of their goods; tavern-keepers who adulterated their wine; doctors who killed their patients either from ignorance or malice or who kept their patients alive for personal motives; incontinent monks and nuns; those who offended their superiors and who had scant respect for those of a higher standing; prelates, confessors and preachers unequal to their rank or inept at their office; profaners of the sacraments; instigators of the prostitution of wives and daughters; card and dice players; charlatans, buffoons and frequenters of taverns and baths; the unthinking fatteners of the flesh and the devotees of gastrimargia; provincial Heliogabals; inveterate drunkards; ballerinas; widows who were consumed by desire but who were reluctant to confess or did so only in part; narcissistic females and women who gazed at themselves in the mirror; immodest speakers or those given to speaking in riddles; married women overcome by evil desires and by lascivious imaginings regarding other men; virgins who have remained so only because of a lack of opportunity or for fear of being earmarked by other people, but

7

who 'disregard the fact of being dishonest in the eyes of God and who perform evil acts in secret or amuse themselves with dishonest thoughts and desires'; miserly men-moles who do not eat for fear that the earth might fall from under them; judges, advocates, procurators and notaries who 'armed with a pen caused more damage than lightning, and whose sentences were more terrible than earthquakes and more injurious than thunder, and who, hearing the clink of gold and silver, prolonged their cases to the detriment of their clients, becoming deaf to the supplications of their wards and blind to the widows' tears; those who for incessant gain became harpies of their neighbour's goods and bloodsuckers of the poor';[6] chemists who did not prepare their 'compounds according to the prescription, and sold one medicine for another or used valueless or rancid ingredients'.[7]

Snow and ice disappeared little by little from the infernal scene. By the seventeenth century they could no longer be found and the process of dehydration was almost complete. This was also the case for the serpents, toads, stinking dragons, and slimy monsters from the pestilential swamps. Even the devils tended to become less commonplace, and gradually became negligible presences of mere form or useless pinchbecks of archaic infernal knick-knacks, remnants from Beelzebub's warehouse. In the early modern hell, and above all in that of the seventeenth century in which the acrid sensuality of the period can be seen in the total abandon to the penetrating and perforating flames, fire absorbed all possible graduations and all the innumerable shades and measures of punishment: diabolically (or divinely) intelligent, selective, speculative, and capable of indescribably transforming, the fire succeeded in miraculously imitating its extreme opposite, ice, by engendering the sensation of red-hot ice and burning cold. The black fire, the dirty fire, the colourless sun of dead life, the flame without light, all 'make one feel the fervour of charcoals, the chill of frost'.[8]

The great invention of the Baroque hell lay in the restoration of disorder, in the return to an infernal chaos; it made the damned person into a devil *malgré lui*, and turned his neighbour who had fallen beside him into a torturer. Everyone became the involuntary persecutor of the next man, everyone was an insupportable burden to his co-inhabitant. There was enforced cohabitation, overcrowding and intolerable promiscuity. Although restricted and reduced (and perhaps precisely for this reason), the old 'region of Gehenna' was transformed into a collective nightmare, a fetid container of bruised and faceless humanity, a sea of anonymous, smelly ragamuffins who expired 'putrid breath' from their mouths,[9] an ignominious and classless

lazaretto. The bodies of the damned were covered with 'foul-smelling ulcers'[10] and 'ulcerating pustules' which emanated a 'rank rotten-ness'.[11] At the dawn of a mass-society oozing with syphilis and devastated by other shameful diseases, hell also assumed the gloomy appearance of a complex and overcrowded hospital for venereal diseases, an infamous cavern, a disgusting termites' nest of a brothel where every form of copulation, every friction, all the various positions of an enormous collective congress or a filthy, licentious *kermess* were permitted. The prohibited desire for equality and for sexual trans-gression, in a society which was immobile and rigorously divided into castes, was concentrated in the subterranean ways of the unconscious-hell, in the nocturnal caves of dreams where it celebrated a mortuary and sacrilegious sabbath. The gateway to the Roman hell of Giuseppe Gioachino Belli had been opened.

The bodies were pressed, stuffed into one another, stretched until they interpenetrated and permeated one another in a superfluous, gigantic poultice of mixed, dirty, infected and foul flesh, amalgamated in a sordid mustard of excrement. All the roads of which Dionigi the Carthusian still spoke in the Quattrocento had been closed off; there was now not enough air and the smell provoked fainting-fits, hysteria, contractions and spasms. Promiscuity reached monstrous levels: the sodomite clasped the man of arms, the executioner was stuck into the nun, the virgin with impure thoughts was penetrated by the leper, the nobleman was touched up by the vagabond, the clergyman was violated by the merchant, the reader of prohibited books was seduced by the bestial rapist of animals, the notary was crumpled by the shepherd, the mouth of the intemperate widow was wet by the slobber of a convict rotten with syphilis. The pneumatic hell, the Avernus of shadows ('the empty realms'), breaths, winds and smoke, of which some trace survives in the Celtic underworlds with their large spaces which were blown here and there by the north winds, was pro-gressively transformed into a closed space with well-defined compart-ments on different floors and divisions, encased in circles, subdivided into pits, within a contained, encircled and measured space. The wide and windy plains imagined by the island people were relegated by an urban intellect, such as the Florentine, either to the entrance (the 'grim terrain', III, 130) or to the periphery of the city of Dis (the 'great terrain', IX, 110). The heart of hell, the '*Malebolge*', was not affected. The Celtic inheritance, like the famous storm in Dante's *Canto* V, did not penetrate to the depths, but was relegated to the uncertain morphology of the first inferno.

The 'regions' of Saint Pier Damiano, the 'measureless place' of Ugo

of San Vittore, the valley 'which was very wide and deep, and infinitely long',[12] the space with unmeasurable coordinates described by the Venerable Bede (672–735), the field 'which was so long and so wide that from no part could one see the end'[13] from the Purgatory of Saint Patrizio, all these were redesigned following the models of planned urban spaces. Even the 'throat' of the swallowing organism which evoked the mouth and stomach of a voracious monster ('*rapacissimus et insatiabilis locus*'[14]), an animal contrivance in whose stomach 'whoever was seized, was held firmly',[15] a ferocious abductor who savagely attacked and deposited his prey in the depths of hell ('*infernus, ab inferendo*'), became the 'entrance gate' of a city organism, the well-armed and closely watched entrance into a well-ordered and well-guarded city.

Dante's 'doleful' and painful city, the 'inverted' and 'evil' city described by Giacomino of Verona, which surpassed the suggestions of the writings of John, became the new, emergent hell: the Luciferian city from whose walls the first circles (containing those 'intemperates' who did not possess a sufficient degree of 'malice' and 'mad bestiality' to be admitted to enjoy the delights of total hell which the subterranean statutes reserved for the genuine, first-class citizens of hell) were excluded.

The same occurred in medieval cities within whose walls the inhabitants were accorded full citizenship and rights, while beyond the walls, outside the enclosure, persons of approximative, ill-defined social status bivouacked as best they could in precarious living conditions (like certain shanty-towns in the suburbs of the great modern cities). The latter were rated as second-class persons or worse, fugitives, slaves, disbanded soldiers, vagabonds, beggars, and were pushed to the margins, little recommended, generally suspected, and probably infamous.

It would almost appear that Dante wished to confine these non-citizens within the expanded vestibule, in the peripheral 'dark lands' (Gregory the Great), in the 'evil plain' (which differed from the 'field' of '*Malebolge*' since it still retained something of the misty topography of the visionaries of north-western Europe). He thus reaffirmed that the hard and malignant core of the earth should not be confused with its accessory organs and limbs, and that the periphery was completely different to the centre. In the ancient descriptions of the world, in the imaginary medieval maps, the anomalies, divergences and monstrous races were placed at the margins of the ecumene, on the borders of the earth. One gained access to the Celtic underworld by a frail, oneiric and 'long path' (*The Vision of Tugdal*); in the Italian inferno between

10

the thirteenth and fourteenth centuries the new concept of road network had resulted in guarded entrances, streets and gateways.

In the large vestibule there was also room for a slice of the Elysian Fields, an area with delicate climatization, using air conditioning for the 'great spirits' of antiquity (a larval residue of the pagan pneumatic dimension), for the 'suspended' souls in Limbo and the classical shades whose 'appearance was neither sad nor joyful'.

From the vast 'regions', from these expansive and fluctuating spaces, from the uncertain places with undefined and undelimited borders, as in the Irish visions, in thirteenth-century Italy hell was transferred into underground cities whose high walls were watched by unsleeping sentries, and whose gates were guarded by strict custodians, and above which loomed 'a very high tower' (Giacomino of Verona). In this urbanization of hell the 'throat' was transformed into a door. In Dante this downward process was focused on the vertical axis, on the high/low trajectory. The old horizontal model within a countryside of moors and wide open spaces, or echoing the large oceanic spaces which were familiar to the Gaels from their oceanic travels, shrank in the vision of the urban monks accustomed to life in an Italian city. The infernal region was urbanized according to a development project. The birth of the 'great, tall, long and wide city', the 'inverse earth' of Giacomino of Verona, and of the 'doleful' and painful city reflected the Italian urban landscape of the age of the city-states.

Dante depicted the heart of inferno, the '*Malebolge*', as a 'field of pain and ugly anguish' (XVIII, 4), a damned-growing countryside, an evil farm: the term 'field' represented a delimited space, a unit of agronomic measurement conceived and designed within a project of architectural engineering. The 'device' (XVIII, 5), the mechanism which regulated its structure, was conceived as a measure of urban intervention. Each pit was designed like an enclosed and fortified unit, like a castle whose walls were protected by safety devices, like a fortress surrounded by ditches:

Quale, dove per guardia de le mura
più e più fossi cingon li castelli . . .

that in concentric circles bind their centre
and serve to protect the ramparts of the castle . . .

The geometrification of hell reached an apex in the new Dantesque model. The presence of Euclid in the modernization of the lower regions is probably more than a mere hypothesis since the thirteenth

11

century, an age of organization and system, was moving towards a rediscovery of 'Euclid, the geometrician' (one need only think of Alexander of Hales). On the contrary, the Celtic hells reveal a non-Euclidian geometry and a concept of space which was not organized, in accordance with the rhythms, patterns and calendar of late feudal or proto-communal life.

If in Dante the spaces were still sufficiently wide, and in any case ample enough to accommodate the sinners, and the extensive range of punishments and the plentiful selection of torments were individually chosen and personalized (both the great and the small were known by name, surname and address), in the Baroque hell-tomb the turn of the screw of the Tridentine imagination restructured the post-Dantesque Tartarus according to rigorously prison-like, restrictive, obsessively monotonous and uniform principles. This mephitic tomb was suffocating (the Dantesque perception of hell as a tomb – cf. XIX, 7 'We had already climbed to see this tomb' – led to a partial, sectorial and not universalized morphology); it swarmed with an anonymous crowd and was filled with a massive, cumbersome, excessive and overflowing corporeity. The Counter-Reformation abyss had become distressingly restricted: the 'wide and deep well' (*Inf.* XVIII, 4) had contracted into an oppressive drain, an airless sewer, a narrow and above all unsupportably overcrowded hell. Tomb-like claustrophobia was dominant in this modern hell. The 'dark prison' and the 'gloomy enclosures of hell' of Saint Gregory the Great,[16] the enclosed places without light, were transformed into horrendous excremental drains. This third level of infernality, the Tridentine, lasted until the nineteenth century, until the oafish underworld of Giuseppe Gioachino Belli came into being. Under the Rome of Gregory XVI there was an invisible filthy city in which the dead rolled around in confusion. In this promiscuous, non-selective, cellar-like hell all was coincidental and chaotic. It was a great heap, without place numbers or sectors, without space between the ranks and hierarchies, without respect for the gravity of sin.

> Here, you eat, sleep, shit, pee, cough,
> You shake, stretch yourself and roll over . . .
> But there, brother, you stay as you fall. . . .
> (*Son.* 'Sto monno e quell'antro')

The 'casa-calla' (the 'hot house' of the anonymous Estense author of the fifteenth century where 'dukes, marquises and great barons' were made to overflow with death in the company of 'spluttering

drunkards') became a plebian and rascally place. In the confusion of this brothel-like cellar everyone suffered from the proximity of their neighbour as in an overcrowded one-room flat. Everything was fortuitous, deprived of intimacy and shamefacedly promiscuous. All in a 'heap', the foul, coarse rabble elbowed one another in an enforced and sordid cohabitation, face to face, buttock to buttock, with punches and kicks; in an anonymous, struggling and sordid heap of corpses where intercourse was as fortuitous as the pregnancies, *incerti auctoris*, of uncertain paternity, which resulted from a multitude of promiscuous relations. It was almost a Tartarean version of birth *ex putri*, of irresponsible generation from autofertilizing matter already in tomb-like decomposition.

> In the devil's house you see People
> Everyone all in a heap – faces, arses and bellies,
> And down there no one can sit down
> Taking his just and due distances
>
> Just imagine what happens
> Amongst those people with no manners!
> Kicks, shoves, punches: and, as we're led to believe,
> Every form of scandal and pregnancies.

> (*Son.* 'Li dannati')

This – in malicious Romanesque terms, in a charlatanic sinopite – was an accurate description of post-Tridentine hell, of an underworld which was low in every sense, promiscuous, vulgar and fouly one-track-minded. Even in hell, as on earth, men were 'mixed by the hand of fate'; fate turned them about in confusion in a game of chance, like coffee beans, and so they remained after being swallowed 'by the throat of death' (*Son.* 'Il Caffettiere filosofo').

In this new 'house of troubles', which was not very different from the one in which they were born 'covered in shit and filth', the same 'prick-faced' inhabitants took part in a desperate revelry, a collective orgy, 'heaped together' in a confused and overflowing pile, a livid infernal feast of riff-raff without manners: the dead started to push one another again, to touch and obscenely couple together underground in an enormous collective brothel, a filthy carnage of incorrigible incontinents.

Out of this chaotic mish-mash of bodies entwined round one another, the phantasma of the great collective body of humanity, the archaic belief in a fertile death, a pregnant death, the nursemaid of new life, the sense of continuity in death-life re-emerged. The hidden

13

shadow of the one belonging to the many reappeared, as did the sense of a fatal, cyclical rotation, an uninterrupted pendulum between life and death, between decomposition and rebirth. The dead became pregnant and gave birth, they embraced and copulated with no respect for religious laws, with no regard for ecclesiastical control, Catholic morality, the sanity of marriage or the restraints of their superiors or the hierarchy; they were insensitive to the concept of 'just and due distances'.

> How will the Cardinal Vicar manage
> To make him give up this vice in hell?

The order imposed from above was reversed by disorder and licentiousness, by the equalitarian re-mixing which, in the under-world, in the different country, could at last establish itself in mockery of the ethical control and social distinctions laid down by the Cardinal Vicar, the guarantor of good behaviour and clerical morals. From the depths of this late Baroque hell, which had overtones of earlier pre-Christian images and archetypes taken from agrarian rites and liturgies, resurfaced the 'throat of death', the mouth of the devouring monster, the great serpent or dragon with gaping jaws, the Leviathan-crocodile, the Ogre, the 'insatiable devourer of all things' (from Nicodemus's apocryphal gospel), the tomb which swallows flesh, the peristaltic sarcophagus which, like an ever-hungry stomach, ingests, chylifies, digests and disposes of whatever it swallows.

The Catholic hell marked the definitive disappearance of the remnants of the pneumatic hell, the world of shadows and the theatre of displaced melancholic spirits, smoke-spirits and shadowy larvae which moved in an opaque half-darkness. The last appearance of this Avernus occurred in the 'shaded valley'[18] reconstructed by Boccaccio along the lines of a classical humanist dramatization.

With the exception of those suspended in Limbo, that extraordinary apparition which was exceptional in every way and had no follow-up, like a brilliant *apax* which was immediately buried, the medieval and early modern hells do not possess the melancholy character of the pallid, bloodless and pagan shadows who drifted in cold and lifeless air which only blood could warm, like souls, birds, errant breezes, labile and inconsistent figures, and frozen breaths from damp ravines.

This religion was founded on the rebirth of the flesh, and its ultimate goal was the renaissance of the body and the reintegration of the dead in their complete physical structure; as such, there was no

room for the uncertain, inconsistent and incorporate world of the spirit-shadows. Nothing could be further removed from the larval state in the Christian after-world. There, the flesh was obsessively dominant because 'Christ loved man, coalesced in filth in the womb, brought forth through the private parts, nourished amid endearments' (Tertullian, *De carne Christi*, IV, 2). In Catholicism, a good death meant that one was able to reclaim a glorified, improved and perfect body. The final step, the 'crucial point', was the delicate moment when the man of good faith played the decisive card which would win him a passport to the other world, taking him either to shining sublimation or to the dismal decomposition of the flesh:

> 'remember that on such a step,' warned a preacher in the first half of the eighteenth century, 'depends the very glory of your body or its damnation: if you perform it well, you are blessed; you will find it again agile, and like the wind; thin and more ethereal; beautiful, and more sun-like; impassive and glorious for all eternity. But if you perform it badly, you will be wretched; you will find it again deformed, all dirty and disgusting; immortal and passible; passible and damned; damned and in the flames; in the eternal fire. What a fearful step on which so much depends, and depends for ever.'[19]

Hell was likened to a slaughter-house, a hospital, a torture chamber, and all these variations of Catholic infernality come together in the predominant morphology of the drain through which the flesh, contaminated by the infected spirit, falls. All the sad relics, the world's rubbish, its dirty and lurid refuse flowed into this drain-like hell. In fact, in medieval iconography God is synonymous with perfect cleanliness, with light and dazzling splendour, whereas Lucifer is coupled with darkness, dirt and obscurity. Or, to use another simile, Lucifer was associated with 'stagnant water'[20] (Saint Catherine of Siena), with black and muddy swamp water, while God was associated with the clear, limpid and blessed water of the spring, which is both nourishing and purifying. Hell was likened to the carnage in which the decayed and putrid bodies of sinners, rotten with wickedness, infected the air. In Christian thought, stench and sin coincided. For this reason, the violation of the sense of smell was of exceptional importance. 'Decayed life' continued to corrupt and pollute the air down below and the intolerable 'stink of sinners' infected the abyss. The stagnant air was so 'corrupt' that

> The stench and the foul air filled with burning sulphur,
> And all the smells of this world, which are almost nothing even as
> I speak of them,

15

Would not all together be as strong-smelling
As a mere drop of that burning stench.[21]

The 'horrible stink' was indissolubly coupled with damnation. The wave of stench rose in an impressive crescendo from the pre-Christian underworld, where, according to Heraclitus, 'the souls of Hades only have a sense of smell', to the Catholic Tartarus, where the sense of smell became an instrument of nauseating punishment. This stinking hell, with its 'anguish' and nausea, revealed the putrefaction of the decaying flesh and the decomposition of the bodies of the damned by this outrageous and invisible stench.

This sewer, this 'untiring devourer' was fed on the refuse of life, the scraps of humanity, the impure remains, the rejects from the clean and limpid skies: the throat and stomach of the monster swallowed, masticated and reduced everything to pulp. This 'foul sewer', this 'most rapacious and insatiable place' (Dionigi the Carthusian) was 'dirtier, more intolerable and more stinking than all mud and filth, than any corpse or bilge, than any fish, toad or basilisk'.[22]

This pestilential sewer, the muddy bilge, the 'well' of the abyss was slowly transformed into the cesspit, the great latrine, the suffocating drain in which the putrefaction of bodies polluted the air and took one's breath away. This was Beelzebub's kingdom (whom Dante equated with Lucifer), master of the dung heap and god of filth, at whose feet the stinking remains of the devilish society, the dung of life and the excrement of the earth, were heaped.

It was this 'swamp which breaths with a prodigious stink' (*Inf.* IX, 31), this 'sad hollow' (*Inf.* IX, 16), these 'vile fumes' (*Inf.* XI, 12), this 'horrid hole' (*Inf.* XXXII, 2), the 'deep abyss with vomiting' (*Inf.* XI, 5) which won the underworld the description of sewer. It was a store-room for the ex-votos offered to the devil in his satanic sanctuary and a damned pigsty for the decaying flesh which celebrated its funereal games and saturnalia there. All the damned had corrupted and distemperate humours (melancholy Saturn was also master of the latrines in addition to being the lord of intimate garments) and, on the day of justice, they will be covered with infected flesh, watered with bad humours and malignant juices, and given swollen and slow, sordid and stinking bodies, weighted down by unhealthy fat. On the contrary, the blessed will flit around with beautiful, incorruptible, agile and slim bodies ('The bodies of the elect, after the Day of Righteousness, shall be very lovely, shall not suffer, shall be fine and mobile'[23]).

A hagiographer wrote of the venerable servant of God, Brother

Gerardo Maiella, who lived in the countryside of the Kingdom of Naples in the mid-eighteenth century, 'he had the prerogative to clean lavatories and to muck out stables and carry out the dirt'.[24] Work can certainly not have been lacking for this holy street-cleaner since the primary material for his blessed work was available in unlimited quantities.

The filth and the dung seemed to be providential instruments of mortification and inner purification of his laborious path towards the sweet-smelling and limpid heavens of the blessed, on his long march to reach the uncontaminated spaces reserved for those whom God has appointed to fragrance and candidness. As in the mysteries of Isis where the initiates descend into the latrine in order to re-emerge towards the pure and the sublime, so the neophyte Christian had to pass through the hell of contamination and degradation in order to arrive at the narrow way, the long and vertiginous bridge which would lead him to the Kingdom of the uncontaminated, to the dominion of the shining Omnipotent.

Brother Gerardo (like the angelic street-cleaners in *Invisible Cities** and every blessed person of quality) was by nature a cleanser who fought against the 'most filthy' Satan, and in cleanliness lies salvation. In the gospel of Nicodemus, Christ, the 'saviour of the world', brings life 'out of corruption'.[25]

This inspired, humble and day-dreaming son of the south of Italy, a worker of holy ecology, who, in the name of the Cross, struggled with overwhelming and single-minded passion ('it was his prerogative') in a strenuous battle against the dirty and the unclean, who wallowed with intrepid steadfastness in the torbid manure of the stables, and who emptied the 'filthy vessels' with a serene countenance, made his personal attack on Beelzebub, the god of filth, the prince of flies and master of the dungheap (as the Semitic root of *zvl* from *Ba'al zëvûv* suggests[26]). Gerardo Maiella fought against hell with the strokes of his broom, like a Christian Hercules who emptied the reeking waters and cleaned out the stables. In fact, the 'city of hell' and the 'evil city' were synonymous with the subterranean kingdom of dirty, rotten water, with the *'aque entorbolae'*[27] of Giacomino of Verona, with the city-dustbin, the city-dunghill, the great container of stink and sin, and 'corrupted stench' (Bonvesin da la Riva), which was irrigated by the dark, torbid rivers of 'stagnant water';[28] they were the same as the putrid sewer into which flowed 'all the earth's stench'[29] (*'le puz de tut lo*

* Translator's note: Italo Calvino, *Invisible Cities* – English translation from the Italian by William Weaver, London, Secker and Warburg, 1974.

mondo' was nothing compared to 'that burning stench'[30]), the immeasurable drain into which flowed all mankind's refuse, all the tainted men, the wicked men, the 'obscure' men[31] – as the Sienese saint called them – those who were rotten and swollen with sin and whose flesh showed the stigmata of unclean diseases, the lepers, the scabious and the dropsical whose fermented bodies were pink with malicious humours, like obese dungheaps of vile wickedness. Dante's 'sad hole', which gave off a 'sad breath', the 'corpulent swamp', the 'swamp from which emanated a great stench' became essentially a hell of the sense of smell in Dionigi the Carthusian's (1402–71) explorations of its sewer-like caves. It was a 'stinking sewer' in which 'the dirt of vices, the fetor of the wicked, and the decay of the impious' were amassed.[32] This machine which devoured, this mouth which swallowed and sucked, this horrible, swollen and labyrinthine intestine,[33] this amoebean space, like a gut in perpetual peristaltic motion, 'the most rapacious and insatiable place',[34] absorbed and destroyed this repellent human fauna with its diseased and putrefying adiposity. At the Last Judgement, the bodies of the damned will be fashioned and remodelled using the despicable model of the fat of the poorest quality rejected by the honest tables of the elect: 'The bodies of the unrighteous shall be disgusting, liable to suffering, gross and slow, heavy, foul and smelly.'[35] This was the hell of the fat, the slow, the obese, those with ponderous step, the semi-putrified (*'passibilia'*) and, above all, the fetid. 'Fat and despairing', *masse de péché*, like the hedonists of Emilia who were seen and condemned by the archepiscopal see of Bologna in terms which seem to describe the stereotypes of the joyful fifteenth-century reprobates in a singular iconological analogy: 'the passibility, the weakness and softness of the human flesh'.[36]

This vulgar lazaretto-like hell, from which unhealthy carnality overflowed in every direction, had already been briefly outlined by Saint Anthony of Padua in a sermon describing the degenerative punishments which resulted in 'ugliness, heaviness, ill-health, misery, servitude, weakness'.[37] Contrary to the repugnant obesity of the damned, the blessed, resplendent in the beauty of their healthy and incorruptible bodies, moved gracefully, wonderfully slim and agile, in the heavenly Jerusalem filled with intoxicating perfumes.

Saint Brigit of Sweden (b. 1303) considered the soul of the damned to be corpulent, putrefying, stinking, horribly dilated and deformed: *'terribilis et mirabilis'* to behold, its feet were imprisoned in a furnace-incinerator and it stood upright as if it were nailed; it was incandescent, penetrated through every pore and orifice by a vortex of flames which swelled and melted it to the very core. It was a lurid

wreck from the metal foundry whose human geometry had become monstrously swollen and misshapen.

> The fire of the furnace seemed to rise upwards below the feet of the soul, as when water rises up through a pipe, and through violent compression rose above head-height, to the point where the pore stood, like veins flowing with blazing fire. The ears too seemed like smith's bellows, which stirred all the brain with their continuous blast. The eyes seemed reversed and drowning and appeared fixed on the inside to the back of the head. The mouth too was open, and the tongue, drawn out through the orifices of the nostrils, hung down to the lips. The teeth too were like nails of iron driven through the palate. The arms were so long that they stretched to the feet. Both hands too seemed to hold and squeeze some rotten matter sticky with blazing pitch. The skin over the soul appeared to have the form of a hide over the body and was like a linen garment spattered with semen. This garment was so cold that all who saw it trembled. And from it there came forth, something like the discharge from an ulcer, with the blood corrupted, and a stench so evil that it could not be compared to the worst stench in the world.[38]

It was like a grotesque and obese dummy, slippery with sperm, whose indecent fat gave off an indescribable stench, whose limbs and organs had been disintegrated and deformed: the arms were lengthened out of all proportion; the eyes were moved to other parts of the body, namely to the back of the head; the tongue lolled out of the nostrils; the ears were transformed into outsize bellows. These pre-Boschian fantasies, these sadistic surgical deliria, these deformed monsters were produced by the mind of the suave saint, the noble descendant of the harsh Goths, from the gloomy caverns of a soul which was morbidly fascinated by the incongruous demolition of the human anatomy.

Broken and dismembered, another puppet blinked in a corner of the nordic visionary's workshop of depraved osteology: its cranium was garrotted by a chain and squeezed with such violence that the frontal bones had joined those of the neck.

> There seemed to me to be something like a chain fastened on the head of the spirit of each dead sinner, in the manner of a crown, and it was so tightly drawn that the forehead and the back of the spirit's head were joined together. The eyes too had fallen from their places, hanging by their roots down to the cheeks. The brain was bursting and flowed from nostrils and ears; the tongue, moreover, was stretched, the teeth squashed, the bones in the arms broken and twisted like ropes, the hands, flayed, were tied to the neck, the breast and belly were so

19

strongly linked to the back that the ribs were broken; the heart soon burst out, in company with all the outer parts. The thighs hung by the ribs, the bones, broken, were drawn out in the way that fine thread is rolled into a ball.[39]

Having been plucked out of their orbits the eyeballs hung down the cheeks, grey matter ran out of nostrils and earholes, the bones were crushed, the hands skinned, the abnormally swollen and dilated heart torn out: this bleeding wax dummy had been sculpted by a mad anatomist. Like a common butcher's shop or slaughter-house, slippery with rotting limbs, dripping blood, decaying matter, and visceral and seminal liquid, this gloomy and pestilential hole of hell resembled a devouring mouth, a sucking throat. It was a squirming intestine in whose meanders, in the ravines of whose stomach-drain, the scraps, rejects and rubbish of degenerate humanity, infected by the leprosy of sin, were mixed with its filthy, soiled subproducts; it was a boiler in which the unclean bubbled together in the waste which had ignored cleanliness and luminous whiteness and which preferred the darkness and the dirt to the lightness and health of the pure soul; in it were the greedy and the devotees of 'incontinence' (*Inf*. XI, 83), those who had rejected the healthy diet and had raised sumptuous altars to the spirit of 'filthiness', to 'lurid Satan' in their guts and in the depths of their stomachs.

The cave of hell was an enlarged continuation of the foul-smelling, dark bowels of putrid, contaminated corporality:

> The stench is so great that it comes out of their mouths,
> That he who merely approaches without even touching it
> Will never be free of anguish.
>
> In all time there has never been
> A place or other thing which was so foul-smelling.
> The stench and the fetor which comes from within that well
> Can be smelt one thousand or more miles away.[40]

This ogre's ugly and gaping mouth was like the setting spirit and the nether quadrant of the sun, like a tormented and ravenous vescica, a fermenting and sealed sarcophagus (*id est* devourer of flesh), a device for disposing of the body's residual filth, and since Nicodemus's apocryphal gospel it had been described as an 'insatiable consumer of all things'[41] unsealed and unhinged by Christ, the shining light and vanquisher of foul Satan, victor over darkness, dirtiness, corruption

and death, 'saviour of the world'[42] who brought forth 'life out of corruption'.[43]

In this wretched city, the unhappy land of the black sun, the dirty and stinking fire, the prodigious and inexplicable fire without light, the implacable, speculative and omniscient 'intelligent fire' did not illuminate the still waters where the evil spirit of the miasma lay low and brooded; nor did it reveal the dragon, the water-monster of a thousand legends (known as Rahab, Leviathan and Behemoth in the biblical tradition, and Silla, Cerberus, Medusa or the Nemean Lion in the pagan), the Tarasque (the water-bull) or Mâchecroûte (the monster of Lyons who lay in ambush in the undertow of the Guillotière), or the Coulubre who crouched in the fountain of Vaucluse. It was the swollen, dropsical and gigantic worm (in German *der Wurm* – as Gilbert Durand has observed[44] – is synonymous with *der Drake*), like Dante's Lucifer, whose crest (*Inf.* XXXIV, 42), a detail which often passes unnoticed by the exegetists, represented a garish and inequivocable vestige of its marshy origins was the 'evil worm', and Cerberus, the 'great worm'.

Both gigantic and miniature worms, on a Lilliputian scale, bred in the innumerable verminous colonies and swarmed (like intestinal bacteria) in the ravines of the inferic cavities where they fought over the human refuse, gnawing and consuming it. And in the future will it not be the worms and those elf-like bacteria of the bio-ecosystem, those providential micro-organisms, who will rid us of our insupportable and overflowing refuse?

> As fish feed on water,
> So malignant worms thrive within that fire.
> And they eat the eyes, mouth and thighs
> Of the sinners who are thrown in there.[45]

But in spite of these gigantic or Lilliputian worms, it was always the monstrous mouth of the dragon-monster which swallowed and digested the fly-like souls; it was always the mouth of the monster from the abyss ('Let not the flood sweep over me, or the deep swallow me up, or the pit close its mouth over me' *Ps.* 69: 15) which assimilated everything; it was always the mouth, the worm's mouth (in the *Visio Esdrae*, in the *Visio Tugdali*, in the *Visio Alberici*), which ingested the scales of reprobate flying insects, 'all of which it absorbs at once like flies, so that when it draws breath it swallows them all at once'.

In the verminous intestine of the 'underground world', in the 'stinking sewer' where the 'filth of vices'[46] accumulated, 'monstrous

worms gnawed with poisoned teeth'. 'Most monstrous toads and poisonous serpents' completed the demolition which was started by these 'extremely greedy' worms, suffocating the sinners, piercing them, sucking, corroding, mortifying and, the height of turpitude, kissing them (*'deosculentur'*[47]).

The dominion of dreams and the territory of the unconscious were divided into the nocturnal and subterranean regions which were synonymous with the dirt, the dark, and the funereal, and into the diurnal and superficial regions, which were synonymous with the light, the beautiful, the clean and the healthy. Cleanliness and purity were associated with the image of God which by definition could not be foul, dark or dirty like the ugly image of the emperor of the 'kingdom of pain', Lucifer, who had been transformed from being the most beautiful to the most ugly, and who had moved from the light into the darkness. The infernal abyss was a cesspool which was perforated by a mouth-throat-gate leading into the cavernous labyrinth of the guts, into the lower organs of the earth, into the infected intestinal store-room where the world's refuse (the manure and wealth of the under-world) fermented and decomposed into foul water. The 'other country' was Dante's 'sad hollow' (*Inf.* XXXII, 2), the 'dark well' (*Inf.* XXXII, 16) which in Rabelais's description was condensed into the filthy hole (*'le trou'*), only to expand 'under Proserpine's chair'[48] (the 'queen of eternal suffering', *Inf.* XI, 44), as the 'infernal basin into which she poured the fecal liquid of her clysters'. Under Pope Boniface VIII Rome appeared to Dante to be a foul latrine, a hell on earth prepared for Lucifer's delight, a 'running rhine of filth and blood' (*Par.* XXVII, 25–6). In the upside-down underworld of the Egyptians, the 'inverted earth', the 'dead walk upside down, head down and feet up. "The people walk with their feet on the ceiling. This has the unfortunate result that their digestion works in the opposite direction, and their excrement reaches their mouth." The infernal world is upside down compared to the daylight world and its pattern of behaviour is therefore inverted and perverted. What in the daytime appear to be feces – Freud's diurnal residue – become the food of the soul when everything is turned upside down.'[49]

The underworld of the Osseti (an Indo-European group who have survived on the northern slopes of the Caucasus) is an incongruous place (compared to their daytime world) which is sustained by an inverted system of logic. It spreads over wide areas and vast plains (like the archaic hells of the Celtic West); it has numerous lakes, where 'crowds of men continually dive in and re-emerge among serpents, toads and other repugnant creatures; it also has many mountains and

rivers, and its bridges are as 'narrow as the blade of a dagger'[50] (this is probably an Indo-European legacy which was common in Celtic legends). 'All the oddities in the world'[51] are found in the Country of the Dead: 'the ox ignores the good grass which grows waist-high and chews avidly at an old man's beard',[52] the miserly 'have to satisfy their hunger with frozen horse flesh'.[53] Food is plentiful down there but the dead satiate themselves by gazing at it, and the old Narti 'look at the tables without serving themselves'.[54] The full-blooded hero Soslam exclaims, 'To hell with a country where one is not allowed to eat';[55] he continues on his road and meets a woman 'making cheese from a large bucket full of milk, but the cheese she makes is the size of a grain of millet'. A little further on, 'another woman is making cheese from a spoonful of milk, and the cheese she makes is as large as a mountain'.[56]

2

The Doubtful Eternity

Eternity seems to be a word that has been erased from our modern vocabulary, in which only the future enjoys unconditional favours. It has a strange sound and its meaning is so elusive as to appear incomprehensible. This unused term, which belongs to a language from an inopportunely heroic age, burdened by dismal mythological syndromes, has now been banished to the untouchable margins of the linguistic cemetery. This terrible word may not even have free access to and authorized circulation in diocesan seminaries. The measurement of the years, which was only designed to evaluate a brief period, and the perception that time is nullified in outer space have relieved themselves of the oppressive weight of the endless duration, of the inarrestable passing of days, of the hallucinatory roundabout of the years, of the timelessness of God which dissolves the useless years dated by history into nothingness.

God was named the Ancient of Days (*Antiquus dierum*) 'notwithstanding the fact that He possessed neither antiquity nor days, but only a perpetual present', because 'eternal duration, which is constantly immobile and present unto itself'[1] perfectly coincides with the essence of the divine. Its monstrous, inexplicable quiddity is allowed

> to stretch over centuries without them becoming any longer; to measure their duration without adapting itself to them; and without breaking its indivisible unity, to number time's motion, dividing it into past and future, both of which are tied together by the individual bond of the present.[2]

The theory of hell, which is inseparable from that of eternity ('remove eternity and hell is no longer hell'[3]), rather than having been

24

set aside, seems to have been definitively liquidated. The subterranean bunker has not survived the fission of the atom, and the logic of the new physics has unhinged the door to the cavern of fear. The house of the devil, now closed for an indefinite period, seems to be tenant-less. The past, even the immediate past, has passed away at the speed of light.

Although Christ is still widely spoken of, a heavy theological silence has fallen on the old God of the tribe of Israel: he has been reduced to little more than a literary subject, a romantic fiction, the narrator's voice off-stage which indulges in memories and in the narcissistic pleasure of autobiography.

Having now grown old, he has probably retired to the edge of creation. White-haired Saturn, corroded by melancholy and disgusted by the universal contamination, meditates, engrossed, on the useless-ness of creation, and finds it hard to resist the temptation of the void. Even old Europe, without its choleric and threatening Omnipotent God, without its hell which had made it convulsively aggressive and feared wherever, by military force, it was exported, is becoming a serene geographic expression, a quiet refuge for orphans, a rest home for long, interminable stays. It now offers a cure for a strange malady which once upon a time was called life.

The long drama of eternity, of the 'immeasurable measure of time',[4] is now finished and the obsession about the perpetuity of punishment which had produced such devastating effects, tormented neuroses and painful disturbances has dissolved. 'A life sentence of punishment'[5] for eternity ('this perpetuity is the real essence of the infernal punish-ments'[6]), the shadow of hell with all its terrifying scenography of horrifying tortures and degrading violence, casts acute tensions and desolate fears on to the living. The woodworm of inconsumable eternity and the thorn of perpetual abjection often brought restless souls, who had crossed the threshold of inconsolable depression, to the brink of madness.

> Many people have often said to me: 'Father, thinking about Eternity makes our brains turn upside down. The idea of for ever, and ever and ever: an ever which will never ever finish and which once having been will come back for ever, makes us go mad.'[7]

Melancholic gloominess, dark hypochondria, troubled and heavy dreams, alarming reveries and oppressive thoughts disturbed the nights and vexed the days of many sensitive spirits. Ravings, tortuous and contorted fantasies, extravagant and disorderly illusions, bizarre

dreams, and strange and noxious imaginings installed themselves malignly in the tormented conscience of Christianity. Perturbing visionary pages from 'deluded imaginations'[8] were printed in the 'most wonderful book of the human brain'.[9] The 'wonderful country'[10] of the brain harboured piles of exalted and excessive images.

Breathless anxieties, unrestrainable fears and religious neuroses perturbed the orderly practice of piety and devotion. Sermons, homilies, spiritual exercises, meditations on death, lugubrious penitential rites, collective flagellations, and public and private confessions considerably increased the widespread sense of guilt, spreading desolation and increasing consternation.

The terrifying eloquence of the holy orators, who ranted at simple souls and fearful spirits, provoked profound discomfiture and disturbance, especially among the 'vulgar foolish', the 'womanly people', and 'women with feeble but at the same time vivid imaginations'.[11] A flood of people poured into the churches or into the squares to listen to the voices of the most famous preachers. 'The stupefied and dumbfounded people gathered in crowds' under the pulpits of Bologna to shiver at the words of an apostolic Capuchin friar who – according to the admiring testimony of Claudio Achillini – 'between lightning-like threats' illuminated 'the hope of salvation for those who did not obstinately head towards damnation'.

Small, slight and meagre, his minute physique was totally inconsistent with his larger-than-life personality which was most vitally given form in his implacable voice, the almost invisible, pure, vocal symbol and the transmitter of inaccessible and terrible truths.

> He is so emaciated, immobile and buried in his clothes, that he can barely be seen; in fact, you can see and hear nothing but an agitated woollen garment which shouts, a cloak with a voice, a hood which terrifies, a fire which sends sparks out from the ashes, a grey cloud which thunders terrors, a breathing penitence, and a sackful of accusations which are poured over sinners.[12]

These 'apostolic missionaries' journeyed from village to village, from church to church, through the most inaccessible regions, to the most remote corners, across 'mountainous places, stony paths, in the most disconcerting weather', barefooted, in poor and worn-out clothing, 'humble and unassuming' in their journeying and 'purposefully abject in their external appearance'.[13] Among the many travelling men of God, the Jesuit father Giovanni Pietro Pinamonti (1632–1703), the shadow-companion of Paolo Segneri, for forty years

journeyed barefoot round almost all the dioceses of Italy: he was a preacher and above all an untiring confessor, to the point that 'even after eleven hours of continued confession every day for several months a year, he was unable to stop practising this sacred ministry, as if bidding farewell to a loved one, so that it was always necessary to remove him late at night with violence'.[14] Suffering from a 'perpetual, severe headache', 'for at least eleven hours a day and for the most part of the year, in uncomfortable places, in the open air, in the heat, in the cold, for much of the night and invariably always completely barefoot',[15] he persisted without interruption and untiring at the confessional.

> During the whole of his life, and even in his last illness, he kept a board between the sheets of his bed to make his night's rest uncomfortable . . . In the morning, immediately after having got up, even in the depths of winter, he knelt down in the middle of his room and flagellated himself harshly around his waist for a quarter of an hour; there was no respite from this discipline while travelling, or on days which were more than usually exhausting. He repeated this penance several times during the day and in secret at night, according to what he was doing and on the major feast days . . .
>
> In addition, not only in our colleges but also while on mission or travelling, he used to wear either a hair shirt or chain vest all morning, and it will never be known whether he ever celebrated mass without wearing one of these instruments of penitence.[16]

Writer of holy texts, 'it is known for certain that all that he ever printed was first meditated at the foot of the cross'.[17] And indeed the author of *L'inferno aperto al cristiano perche non v'entri* ('Hell revealed to the Christian so that he does not enter in')* had measured hell in all its horrible width by living it day-by-day on earth. There has not perhaps been another century in the annals of the history of the West which, like the seventeenth century, so despised and violated human nature, pursuing the demolition of its own hateful self and its own 'natural' qualities with stupefying tenacity, and altering, repressing and subverting inclinations, desires, characters and tendencies. It was a century of artefice, of the invention of automata and mechanical devices, of the audacious experimentation of new ways, new forms and new temptations, such as the violation of the vegetable world with surprising and unnatural grafts, and the creation of aberrant unions

* Translator's note: In the Italian title there is a pun on the use of the verb and preposition (*v'entri*) and the word for stomach (*ventre*), a synonym for hell.

by intermingling the essences of different forms; in the same way, the century carried out an unnatural 'programme' on the plant–man in an attempt to modify his biological make-up and humours. Father Pinamonti, a 'fiery, ardent and bilious' character, succeeded in transforming, indeed in overturning, his innate temperament to such an extent that 'he was so pleasant, loving, docile and almost phlegmatic, not to mention composed and quiet in dealing with his neighbours, that to whoever did not know him well he appeared to be a most peaceful character, pacific, dead, and even mortified. The truth was that in the fire of charity he knew how to forge himself a different temperament to that which nature had given him'.[18] The challenge issued to nature in the name of (counter-reformed) culture by many spirits, burning with intense religiosity, was divided into the categories of humility, charity, penitence and mortification. 'Poverty, withdrawal, prayer, penitence and self-examination' were the five preventive medicines which were indispensable for neutralizing the hell of the five senses, that inferno in which the 'punishment of the senses' passed through the five windows of the body: as Saint Anthony of Padua had said, 'The punishment of the senses will affect all five senses.'

The 'fire of charity' was reputed to offer the sovereign antidote, the most efficacious safeguard against the punishing fire of sin. And perhaps no other century fought more desperate battles to suffocate the call of nature, the flattery of the flesh and worldly temptation with the most rigid discipline than the seventeenth century, the century of 'mystical invasion' (H. Bremond). The horror of sin and of offending God were so strongly abhorred that they formed intransigent barriers even against the simple venial sins. 'I would be tempted to say – confided Father Pinamonti's confessor – that I have never met anyone who so hated mortal sin as Father Pinamonti hated venial sin, the sole enemy he still had to overcome'.[19]

Probably no other century regarded this world more disconsolately through the eyes of the other world; over no other age did hell exert such an attraction and repulsion, and in so spasmodic and obsessive a fashion as the seventeenth century. The tortured bodies of the underworld were a sinister invitation to massacre and torment in this world. So that it might be avoided, the painful well was depicted in the cruel flagellations of the diseased flesh of the Christian who squirmed along the earth, weighted down by his guilt and goaded by the exorbitant burden of a doubtful eternity.

Father Paolo Segneri, the inseparable companion of Father Pinamonti, excelled in experimenting with new devices for tormenting

himself: 'His penitence,' wrote his associate, Pinamonti, when recording his virtues by order of Grand Duke Cosimo III, 'was great and he was incredibly ingenious in finding new ways to torment himself, adding them to the old little by little until the end of his life.'[20]

If he was not occupied travelling, he habitually used to discipline himself more than once a day, over and above the penances he performed during his Missions. In the last years he used the scourge three times a day, in the morning, during the day and in the evening ... During these flagellations, he devoutly and repeatedly recited the words of *Dies illa*, starting with *Rex tremendae Majestatis* and finishing with the penultimate triplet *Gere curam mei finis*, continuing for long enough to give himself two thousand scourges, and sometimes he even did many more. At times he drew blood by sticking pins and sharp metal points into the scourge, and he even drew blood sometimes with a normal scourge; but partly so that these instruments of penitence would last longer and partly so that they would not become sodden with blood, he used to immerse them in boiling wax, thus resolving both problems at once.

Furthermore, he was not content with the use of his arm alone, although strong, and whenever he found himself in a lonely place and in the company of trustworthy persons he made them beat him mercilessly, sometimes having been tied to the bedpost in order to imitate Jesus Christ's torments more closely, and at others with his hands tied behind his back like a convict condemned to be whipped. And if he came across someone who was rather indiscrete or who wanted to please him, he reached the point of being so weakened by the blows as to be unable to stand any more ... Since by lacerating himself on his shoulders he would have become incapable of performing the ordinary penances which he did with the others during the Missions by beating himself with iron bars, over the course of time he found a way of sticking many nails into a cork or other object and, selecting the part of his body which he wished to soften [the 'hardest revenge'], he unbuttoned his shirt and baring his chest, started to hit and wound himself ... More than one example of this instrument has survived ...[21] And since the ordinary inventions failed to satisfy in full his desire to maltreat himself, and having read in some Life that this Saint had hung himself with a rope round his arms, from about the year 75 of the present century he started to perform this torture, tying himself by the arms with a rope and hanging with the full weight of his body for as long as he could withstand the pain. Some of these ropes were found after his death hidden in a secret place in his room. Likewise, and in a similar spirit of penitence, he used to collect the remnants of candles and bind them together, lighting them and letting the boiling wax drip on to his flesh in different parts for long periods of time, thus burning himself with great pain.[22]

Father Segneri's room cannot have been very welcoming: there were no superfluous objects, few books, very few pictures and 'similar things'; it was overshadowed by the enormous word, *Prope*, written in his own hand in full view on the wall, which 'without being understood by others acted as a stimulus to him. It stood for "Poverty, Retiral, Oration, Penitence and self-Examination"'.[23] Only when ordered to do so did he use a mattress, and then unwillingly: he regretted not having straw or bare boards, or the 'hair cloth stretched like a towel over a sheet'.[24] For thirteen years he had not worn a shirt, but 'wrapped himself in a piece of rough cloth of the same type as the carters used for their asses'.[25] He 'suffered from the cold', but used to 'roll at night in the snow . . . Or, likewise, he used to shut himself into his room in midwinter, usually after Holy Mass, and he stayed there completely nude and trembling, asking for God's pardon'.[26]

This desolate room, within whose walls he suffered the torments of heat and cold, lashings by occasional persecutors, implacable and punctual autoflagellations and the tortures of the rope, was more like a torture chamber than the study of a learned author of holy texts. When he retired into it, he spent long days 'without leaving the house unless it was absolutely necessary': having interrupted the tiring missions, he then thought up 'some new disciplinary invention' to add to the old ones. And then

> apart from a wooden cross armed with six nails which he wore for a long time with the nails against his chest right from the start, and apart from the hairshirts made from skins and metal points, which he wore in later years, eleven pieces of the same material were joined around his sides, his arms and in several places around his thighs; those that were found in his room measured thirty-three and a half palms in length and were of different sizes so that the metal points were some 3,600 in number.[27]

This inventorial description of the instruments of punishment and martyrdom coincides precisely with the mathematical tastes of the time and with the need to give exact accounts, to quantify, to visualize and to measure the form and width of things and objects (even women were categorized among the 'dangerous objects', as Giovan Pietro Pinamonti was fond of recalling).

The length and breadth of hell, the most dangerous object of all, was measured by a team of learned Jesuits (Cornelio a Lapide, Ribera, Drexel, Lessio and Mattioli) who entered into subtle arguments concerning the surface, radius, circumference and cubic area of *torcular vini irae Dei Omnipotentis*, the cellar where God's press squeezed out the wine of his anger. This peculiar desire to quantify the transient, to

conjecture on the invisible, to number the impossible, to calculate the unverifiable, reached its highest point in the discussion of two solemn and classical themes: the Passion and Hell.

Ribera's estimate of 1,600 *stadia*, the equivalent to 200 Italian miles (not much less than the surface area of the entire Italian peninsula), seemed excessive to Leonardo Lessio, even if one accepted the most reliable estimate which numbered the multitude of the damned who had fallen into the great lake of the Lord's anger at twenty or thirty thousand million (allowing 6,000 years since the beginning of the world).

> Wherefore it seems excessive since a twentieth of this space would have been sufficient to contain all the damned even if they were double the number mentioned above. However, it is very probable that in that place of punishment there is not room for them to stand upright, but rather they are piled on top of one another and heaped together in the same way as wood in a pile, since the narrowness of the prison and the fact of being crammed together considerably increases the bitterness of the torment. It should be added that if we attribute such dimensions to hell, the greater part of it will not be in the middle and heart of the earth, as written in the Scriptures, but quite far from it; and it does not seem probable that God caused such a great cavity to be hollowed out in the earth which, by its nature, should be placed in the lowest place and in the centre of the earth. For these reasons, Lessio estimates that a space of four miles in diameter, that is to say two miles from the centre of hell in whatever direction, would be sufficient to contain the number of damned mentioned above.
>
> In fact, by allotting six square feet to each body of the damned, four miles (namely twenty thousand feet) can contain more than eighty million bodies, and it seems unlikely that the number of the unhappy damned would ever reach such a total.
>
> Father Cornelio a Lapide supports Ribera's opinion and denies Lessio's calculations. Firstly, since it is possible to sustain that the number of the damned is greater than Lessio admits. Secondly, since it does not seem probable that the bodies will be so tightly packed in hell, but rather they will have more space so that the violence of the flames can carry them up high and then plunge them back into the fire, turning them and captivating them in different ways. Thirdly, since it is probable that after the Day of Judgement the demons themselves will be enclosed in bodies in order to be tormented and to suffer the sight of the damned, but since there are so many of these spirits the space calculated by Lessio would be too small.[28]

The statistical estimates of the number of the damned and of the space which was necessary to contain them, a space which varied

according to the position which they adopted (piled on top of one another or otherwise), coincided with the Jesuits' passion for mathematics. However, interest in the mathematical analysis of the holy scriptures and theology was also widespread in other sectors of Catholic culture: the Augustinian, Carlo Rabbi, from Bologna, dedicated his long dissertation *De mathematicarum disciplinarum ad theologiam utilitatem ipsarumque in ea usu* (Faenza, Archi, 1729) to the Camaldolensian Guido Grandi, Doctor of Theology and Professor of Mathematics at the University of Pisa.

But popular piety (not only theology) was also fascinated by figures and seduced by the demon of numbers. The cruel cycle of the story of the Passion, with its 'tormented' stations, was enriched by a stupefying inventory giving the measurements of the times, the steps and the insults suffered by Christ: with minute details of horrific particulars worthy of the most blood-curdling horror film; the sadistic accumulation of so much iniquity reached the vertex of the grotesque and the absurd. The body of Christ, the protagonist of this cruel event, was 'the most beautiful of all the sons of men, with the most delicate constitution and most well-bred in all its parts'.[29]

> There was no part of him which was not in pain: neither his body with all its sentiments, nor his soul in all its power, not a single part of Christ which did not suffer from his torments. These torments were of the most cruel and bitter sort, both because of the very delicate nature of his most holy body and also because of the deprivation of any imaginable relief or comfort.[30]

Antonio Masini (1599–1691), from Bologna, who had long practised as a silk merchant before dedicating himself to the study of the past, recorded the times and distances of Christ's last journey in the *Ristretto della Passione di N. S. Giesù Cristo. Divisa ne' sette viaggi e stationi tormentose che fece prima di morire. Col giorno, hora, misure e distanze di luoghi ove patì', e altre divotioni** with the punctilious precision of a merchant's travel diary: 'Having been forced to make a painful journey of 5,900 feet, he reached Anna's house after six o'clock at night and remained there about half an hour, which was then little more than six and a half hours'.[31]

* 'A summary of the Passion of Our Lord Jesus Christ. Divided into the seven journeys and tormentuous stations he performed before dying. With the day, time, measures and distances of the places where he suffered, and other devotions.'

At the first station (in the garden) 'they gave him a hundred blows on the cheek and one hundred and twenty punches in the face, which were so strong that they shook all his teeth and enflamed his gums, and they insulted him in many other shameful ways'.[32] During the second stage of the journey, 'according to the revelations of Saint Brigida, Saint Elizabeth the Widow and the Blessed Matilda, they pushed him one hundred and forty times, gave him seventy-two kicks, thirty-two blows on his arms and as many on his legs and eighty on his shoulders; they pulled his hair and beard seventy times, gave him one hundred and twenty-two blows on the cheek, thirty punches in the chest and mouth, and they pulled his nose twenty times and his ears thirty times; Christ endured all these misfortunes and tortures with matchless patience, without ever complaining'.[33] The crown of thorns, which were 'long, hard and sharp enough to pierce and penetrate his skull, touching nerves, arteries and membrane and reaching his brain which flowed out mixed with blood', 'made a thousand holes and punctures on his head, amongst which there were seventy-two large wounds'.[34]

Christ's journey, the interminable, slow path towards his final sacrifice, was like a long descent into hell where the 'Jewish mastiffs', the infuriated rogues, the 'rabid dogs', took on the sinister appearance of the devils in the ancient visionary repertory.

The 'devilish ministers' seemed to descend from the horrors of the Vision of Tugdal (the 'enraged dogs'), in particular those demons who 'threw souls to one another, as if they were balls':[35] they 'pushed Jesus back and forwards, as if he were a ball, and such was their cruelty and their desire to give vent to their anger, that they violently pulled out his hair from its roots and tore out his beard in such a way as to tear the skin in some places'.[36]

As in the ignoble, deformed descriptions from Saint Brigida's vision, anatomical deliriums, crushed and clinging limbs and organs, contorted by instruments of torture, reappeared here and there: 'an iron collar was placed round his neck and attached to the column so that he was forced to stand still and could not avoid the lashes of the whip; they now lashed his chest, his thighs and his more tender parts so violently that, as a result of all the blows on his stomach, his intestines intermingled with his kidneys and his stomach was joined to his spine'.[37]

Sadism and piety were mixed in this copious minutiae of horrifying particulars: the last act of the crucifixion on Calvary was filled with details of flaying, dislocations, fainting, hammering and nailing in a setting of bloody butchery:

33

and since the left [hand] would not stretch to the hole made in the cross in which it had to be nailed, in order to make it reach they stretched his arm with a rope, to such an extent that his veins broke, his nerves were stretched and his chest was ripped open exposing the ribs; the same happened when the feet were nailed since the nerves had shortened and would not reach the hole made in the cross . . .[38] When they nailed his hands, wrote Paleotti, the points of the nails were bent so that they passed through the joint of the hand where there are the greatest number of muscles, nerves and small bones, so as to cause more pain; the same was done to the feet using a further two nails. There were four executioners . . . and they hammered a nail without a point through one foot, and then nailed both together . . . they used thirty-six hammer blows on his feet and twenty-eight to nail his hands.[39]

There were 6,666 whiplashes in total.

Hell, which was 'measured' with maniacal and controversial punctiliousness, coincided with Christ's 'imagined' Passion: in Guido Casoni's '*calligrammi*' the verses bend, flow, are modelled and arranged in forms which give shape and body to the instruments of martyrdom (the column, the cross, the whips, the hammer, the spearpoints, the nails and the ladder) made in the 'infernal forge'[40] to inflict cruelties on the Redeemer who mounted the cross in order to close the mouth of the insatiable devourer of the dead, the foul, evil creature which demolished the flesh: 'Hell closed and Heaven opened its doors'.[41]

These measurements and descriptions originated from the same feverish need for realistic contemplation, the need to use a mathematical scale and geometric values to verify both the surface maps and the capacity of the 'terrible, dark house' of the 'region of the dead',[42] and the profile and outline of the nefarious objects made by the blacksmiths of the abyss, the torturers of the damned. The 'proud dwelling-place' of Satan, the 'Judge of torments and king of crying',[43] was furnished like a torture chamber with all the necessary instruments, the same that were commonly used in inquisitorial underground rooms by the rigorous enforcers of religious orthodoxy:

> Revolting instruments hang on the walls
> Which at times are used to punish mortals.
> And, instead of wall-hangings,
> The bloody decorations of this proud mansion are
> Wheels, fetters, chains, spears and mill stones,
> Nails, daggers, axes and other tools,
> All horribly steeped in the blood of
> Bleeding brothers and murdered fathers.[44]

The work *Christo flagellato* (*The Scourged Christ*) (Venice, 1607), by Angelo Grillo, in which the abbot who comforted Torquato Tasso's fears was transformed into a 'crying siren in a sea of blood'[45] in order to 'explain the atrocious scourges on Christ's body',[46] also originated in the context of the illustration of martyrdom, the prospect of giving space and colour to the sacrilegious torture of God in a hair-raising picture.

Ecstatic contemplation, theological reflection, penitential discipline, the hard regime of the flesh which relived and reproduced the Passion of Christ being scourged and martyrized, the continuous transition from a visionary underworld of agony and torment to a life of tribulation and suffering, the secularization of hell and the lasting verification of the Passion, indeed a life programmed like an unending temporal Passion in order to avoid eternal damnation; all these were echoed in what has been defined as *'le poème déchiqueté'*,[47] dismembered and lacerated poetry, with that sacred lyricism of the German Baroque which imitated the chaos of hell, the disorder, the cries, the agonies, the horrors, whose verses overflowed and whose structures were swollen to bursting point under the impact of the verbal explosion. The mystical exaltation of the Counter-Reformation dwelled in this gloomy atmosphere of the denigration of the flesh and hell made its way back on to the earth, insinuating itself into houses, colleges, oratories, hermitages and monasteries. The very structures of common everyday life were based on the bloody foundations of torture and on the cruel mortification of the body. On the other hand, the scourges which devastated society, like the bloody and destructive Thirty Years' War which many thought was the dress rehearsal of the Apocalypse, seemed to confirm that death, riding everywhere, would unexpectedly appear before everyone, since life was nothing more than a horrible deathmask into whose mouth, as into the throat of hell, fell men, pomp, wealth, power and beauty in an ineluctable and continuous pattern. Man was a mere bubble (*homo bulla*), and was likened to smoke and wind. Fantasy brimmed over with people who were tortured in life and tormented in death. In Andreas Gryphius's *Inferno*, written 'while our whole fatherland is being buried under its own ashes and is being transformed into a living example of Earthly vanity', the Tartarus and Germany, devastated, burnt, famished and raped, tended to swap roles and symbols:

Oh! Alas!
Murder! Shouting! Weeping! Terror! Cross! Torture! Verses!
 Wounds!

Pitch! Red! Executioner! Flames! Stink! Shades! Cold! Fear!
Oh! what happens
on High and low![48]

Hell concealed itself everywhere, in every crevice of life, in every ravine of existence. The human body itself seemed to be a miniature hell, a mobile tomb, a living sepulchre, an organic drain. Jeremiah Drexel, who had succeeded in escaping from the horrors and massacres of the flaming German Gehenna, had no doubts in backing the hypothesis which compared the human body to a pestilential micro Avernus.

That the body of man was a tomb, the men of old affirmed ... To be sure the body is very like a tomb and gives off noxious vapours in all directions. Hem! How vain is our toil! A tavern for worms, an inn for serpents, an hostelry for toads, a bilge full of dirt – thus is it to gleam, to be cosseted, to be proud? Is this wretched clod of earth, so dirty, so crumbly, thus to be clothed? Is such service to be paid to the flesh, a mere servant, largely leaving aside the soul, bare and unclothed. Coelius Rhodiginus said, 'Men wrote that the body was like hell, in which tides run riot, and gales rage, and there the burning hot spells of summer, and it becomes the birthplace of the dead, or more truly their place of burial.'[49]

The terror of an 'eternity of agony', the thought of spending eternity in a 'perpetual massacre' was fused into two horrifying and abhorrent adverbs: Never and Always.

The door of that fatal resting place of all evil will be locked by two great iron keys: by *Never* and by *Always* ... And who can tell me how much suffering two so short syllables, *Never* and *Always*, which form horrible eternity, can bring?[50]

To the Christian, the journey to the 'house of eternity'[51] represented the 'anxiety of all anxieties';[52] he journeyed along the most tortuous and obscure path, in the uncertainty whether, after death, he would become 'a blessed citizen of the Heavens or black charcoal in Hell'.[53]

I always feel this palpitation in my heart (said Saint Bernardo), my pulse is in perpetual agitation: 'There is no middle road. Either always to be tortured with the impious, or always to rejoice with the saints.' I look at these two *always* like this: an *always* up there with God, another *always* down there with Lucifer. An *always* in glory, and an *always* in torment.[54]

Horrible eternity, immutable eternity. 'The eternal question' (Saint Bernardo) was awesome in its uncertainty, suspended between the sucking abyss and the sublime heavens. Divine justice did not recognize amnesties, nor did it condone. This vexed, angered and 'unmerciful' God (Lubrano) blew flames of fire on those who had died outside his grace. This 'most rigorous fiscalist' (Muratori), the implacable criminal judge, the 'gaoler' of the great rabble of the damned, who was terrible in his perfect and immoderate justice, amused himself by putting on the mask of Nero when he was in ecstasy before the flames of his burning city.

The master of the punishing fire, the exemplary stoker and the remorseless incendiary, the God who laughed (*Deus ridens*) and grimaced (*subsannans*), enraptured by his pleasure in the cruel spectacle, like Scylla who delighted in the sight of his slaughtered victims. There was no rest for the guilty, and no final liberation.

> Origen believed, and it was perhaps the greatest of his crazy errors, that the act of condemning the souls of the damned for all of interminable eternity was not compatible with God's goodness. He thought that since they had offended God by their temporary capriciousness, it was too harsh to then banish them from pardon for ever and ever. He therefore restricted eternity to a given number of centuries, and in this foolish and excessively platonic invention, he forgot that he was a Christian.[55]

In the rigorous and gloomy Augustinian theology, which was far removed from the 'fatherlike mercy' of the evangelical message, there was only room for the figure of a merciless God, who 'invented' new quintessences of punishment in his dark laboratory suited to the master of torments, the all-seeing bloody idol, the 'hunter'[56] with lynx-like eyes and a heart of stone, and the implacable 'tracker' of abominable wild game.

> God, he said [Saint Augustine], is merciful but still saintly; and since he is equally just and saintly his deeds must still match this attribute of saintliness which is in God, and is God. Now, since his saintliness is eternal, it follows that for eternity it will be the enemy of sin; by virtue of this eternal enmity, eternal justice must eternally punish the guilty.[57]

The enormity of the punishment and the eternity of its duration, which slid towards the definitive catastrophe of the Last Judgement, were materialized into an immobile system of obsessive, oppressive and paralyzing descriptions. The passing and unfolding of Christian eschatological time, the irreversible time with no return, were incor-

porated in the devastating image of the endlessly flowing waters, in the terror of this relentless liquidity which was senseless and inexplicable in its evasive repetition. This hydraulic nightmare was projected by the ineluctable presence of the identical, by the flight from dissolved time, by the repetitive wave which, in an inarrestable multiplication of this constant and perennial movement, led to the paralysis of the mechanisms of numerical quantification.

> Imagine seeing a wretched peasant who, having been condemned to stay on the banks of a river until it stops flowing, waits for his wretchedness to end. What a sorry figure! He waits days, months and years, watching a wave passing, and after that another, and then yet another; after the one that follows it, another overtakes it; after the one which overtakes it, another pushes it; after the one which pushes it, another hits it; after the one which hits it, another pursues it. He looks ahead and cannot see the end; he looks behind him and cannot see the beginning; he gazes at the river which flows on; he asks the wave, how long will you last? Always. When will you finish? Never. How long will I be here? Always. When will I go away? Never.[58]

Always bordering with the kingdom of the dead, this liquid infinity overflowed into the shoreless eternity of time, like water which finds no clay into which it can be absorbed. The fragile mental apparatus of many anxious men was overcome by this water-machine of swampy time, and liquidated in an unstoppable tide of endless waves. But even the past, the memories of sweet, sinful times of past eras, could re-emerge to disturb the present and make the prospect of this eternity both painful and problematical. The 'aridity of the heart', which, at particular moments of life, tormented and overcame the saints, was matched by a particular 'sterility of mind' which, by re-evoking the taste of past voluptuousness, drowned devotion and faith in a wave of insidious memories. The awareness of this indifference in all matters pertaining to religion gave rise to gloomy fears.

> 'Your Lordship says,' wrote Lorenzo Magalotti in 1676 to Grand Duke Cosimo III of Tuscany, 'that he hopes that by this time I will have begun to experience that calm which is caused by a clear conscience, and I must confess that some days, like these last three, I feel that I must be in paradise. But there are also terrible days which I spend in great distress on account of the vividness with which I imagine certain tastes from the past; and above all I am heartbroken not only at the thought of not being able to experience them again, but not even having to think about them again, which is the thing which my soul has always

taken the greatest pleasure in doing, to the extent that if I were allowed to think about them, I would not care at all about all the rest. Added to this, there is a deplorable sterility of the mind, so that not even when I read a devout book and not even (which is worse) when I have the host in my mouth can I keep my thoughts in order, without letting them remember past sins or at best imagining indifferent things: from which I realize that my faith is dead and survives only by willpower, since it has no roots left in my mind.'[59]

In order to ensure himself a bearable eternity, and having performed all the necessary spiritual exercises under the direction of Father Pinamonti, in the spring of 1691 Count Magalotti entered the Congregation of San Filippo Neri at the Chiesa Nuova. But 'extremely perturbed'[60] (as Father Segneri found him a few weeks later), gnawed by 'instability'[61] ('*vent volage*', the spirit of the century was dominated by the '*vagabonde inconstance . . . de ce monde une seconde essence*'[62]), and by such strong agitations and 'infinite troubles'[63] so as to fall prey to 'contorted imaginations',[64] the 'wretched Knight'[65] was overpowered by 'a tremendous diabolical temptation',[66] and having ceased to demand 'particular dishes'[67] and having stopped sweeping the altars with a fox-tail as a sign of humility, he threw the glorious habit of Saint Filippo Neri into the nettles and, like an 'unwelcomed guest',[68] fled in haste from the House where he had cultivated the 'spirit of perfection';[69] he ran to take refuge in one of his isolated, perfumed villas, among hyacinths, jasmine and tulips, and started to eat sorbets of violets and vanilla custard again. His holy, initial resolution, which had stemmed from 'supernatural fear',[70] the fear of hell which was 'based on the maxims of faith',[71] ended by making him act like a 'clown',[72] the victim of those 'two disillusionments'[73] which take possession of whoever 'abandoned himself in prey to the pure sentiments of nature, and did not make room for the loving operations of Mercy'.[74]

According to the accurate diagnosis which Father Segneri outlined for the Most Serene Grand Duke Cosimo III, the agitated Count's ill-doings derived from the fact that, having entered the Order of San Filippo, the great distiller, namely 'Father' Magalotti, had not thought 'of anything except himself, or rather of the salvation of his own soul', nor 'had he ever thought of sacrificing himself to God: and thus God's love had been unable to make anything of him'.[75]

I have great pity on this miserable knight, since on the one hand I realize that he has retained a considerable fear of God, on the other he does not recognize the diabolic temptation, worse than pride, which

dominates him; and not recognizing it he is unable to resist it at all, and instead complies with it as if it were entirely the work of nature.[76]

A mystical specialist in odours, the most refined Count was certainly sensitive to pain, and an enraptured distiller of the perfume of his own soul; without knowing it, he was subject to temptations all the time and he also belonged to that tormented group of the 'gloomy millers of scruple'. Fear of self and 'divine fear' were born from the same dried-up spring of 'sterility of mind' and aridity of heart, from the same substantial lack of love and charity.

3

Scruples and 'Counterfeit Chimeras'

The melancholic syndrome grew during that period, spreading like a black ink stain which infiltrated indelibly out of the nocturnal gloom into the crevices of the soul. Having emerged from the house of anguish, a host of grievous dreams, repellent images, 'strange thoughts', 'strange visions' and 'extravagant and horrible reveries' fermented in the agitated caverns of the subconscious, in the echo of the memory disturbed by the disquieting voices of the preachers, in minds altered by memories, happenings and terrifying images, and oppressed by morbid readings, from both devout and profane works. The 'infernal Proteus', like the flaming 'Tartarean Proteus'[1] who in hell alternated between 'terrible forms and monstrous appearances', ravaged the nights of these melancholic individuals with a roundabout of disguises and devilish transformations. In the novel about the wanderings of the reincarnated soul conjured up by the 'oil lamp' of the Veronese physician, Francesco Pona (1594–1652), it was written that

> night never unfolded her dark coverings over the earth without an infernal Proteus appearing before my eyes, who alternated thousands of monstrous appearances. I imagined that at times, disguised as a rich Ethiopian, he urged me to murder my parents, offering me in reward not only a portion of this vile inheritance but also a golden chest which he kept open at his feet. At times, disguised as a nude and bold female, he urged me to rape my sisters, promising me such pleasure in their complexes as I would have sought in vain in any other gathering.[2]

In the house of horror these torbid dreams marked the moment of nocturnal initiation into the paradise of sin: it was hell which, as in this case (the 'formation' of a hero of evil, the monstrous growth of the parricide-regicide, the 'melancholy' Ravaillac), insinuated itself, abetted by the night, into the 'humours of the body', using malicious 'visions' to work on the 'innate cruelty' of the man predestined to assassination whose eyes since infancy had taken pleasure in 'atrocious spectacles' and 'cruel exercises', and had been ectasized by the 'colour of another man's blood'. The 'night hours' formed the borderline beyond which lay unknown territory, the mysterious land penetrated by the 'animal-like and savage' soul, 'unleashed and let free',[3] yet 'riddled with fear'.[4]

> As the sun sets in the West and heralds the arrival of night, all those involved in tumultuous and uproarious matters, which represent a large part of human affairs, being unable to see where to place their feet on the path or their hands at work, retire in terror from their labours; likewise, they are also frightened by a certain horror which is unleashed by darkness and which colours everything black . . . making it look like the face of hell.[5]

If the darkness of night evoked the darkness of hell, the last stroke of the bell, with its funereal associations, made one reflect on the death and burial of the day. An age-old shiver was felt by innumerable generations before the invention of artificial light broke the sorcery of sunset. 'The day dies and becomes night and everything is buried in darkness. The glory of this world is dishonoured, all substance is blackened. Everything is foul, silent, dumbfounded. Everywhere, there is silence and stillness.'[6]

'Like the most sacred things, sleep requires Darkness and Silence.'[7] And while from the kingdom of sleep dreams slipped out on to the earth, the night distributed starts and frights.

> At times a strange dream is sufficient, or the fear of witchcraft or of evil that may overcome them or the apprehension that these things have already occurred; or at other times the thought that phantoms, spirits of the dead and devils are around at night, patrolling the countryside and wandering around houses, or that the elves are playing at being master in some place . . . Above all, the night has the power of causing terrible frights, for the slightest reason; it has happened that some people have become ill and died merely because of a joke played on them with a magic lantern.[8]

The dreams varied according to the 'whim of the humours'. In fact our humours were 'so occultly linked to these phantoms that when our humours were disturbed in sleep, the phantoms assumed forms and represented things wholly in line with the nature of the humours'.[9] The oppressive, torpid, and interminable dreams without fantasy which were dreamt by the phlegmatic were, however, preferable to the terrors to which dreaming gave rise in the hypochondriacal. The latter were apt to fall into 'melancholic delirium', into black indolence, and 'always saw corpses or other horrific things' in their brief, disturbed dreams:[10]

> No one can ever, if not through experience, say how much breathlessness and fright the sight of these extravagant and horrible dreams can cause, when, overcome by anguish, sometimes in dreams they hear themselves screaming from fright and crying from pain. Finding oneself among the dead in their tombs and amidst the limbs of quartered men and not being able to get out; seeing oneself condemned to the final torture at the hands of the ministers of justice; watching Heaven come down and rain fire and lightning with the most terrifying forms and strange figures; being at the foot of a very high and dark tower without being able to find the way out, and being constricted between two walls and hardly being able to breathe; gazing deep into a mountain of mud and other dirt and filth, and finding oneself on the brink of a horrible precipice and faced with the inevitable danger of falling; being surrounded by a multitude of snakes, all ready to eat one, or imagining oneself chased by the most ferocious and angry dogs or other wild animals, and expecting at any moment to be torn to pieces or devoured by them; finding oneself in front of one's loved ones who are either dead or dying in agony, or having lost them without being able to find them again; these and thousands of other dreams of the most frightening things that one can imagine, are the cause of so much suffering and so much horror that a man would rather choose to die or at least never to close his eyes to sleep.[11]

These 'infernal' dreams, travesties of the abyss, were for the most part apocalyptical and about the Last Day of Judgement. They were anguished fantasies which rose to the surface from the slaughter-house of hell in the emptiness of the night, in the time of hiding, in the time of death's incubation, when the light of the intellect was extinguished. There were dreams of tortures, corpses, fire, lightning, tombs, narrow towers and walls, claustrophobic nightmares, images and the stench cesspits ('mud', 'dirt', 'filth'), difficult balancing points and near falls (the act of tottering on the brink of a precipice represented a variation of the slippery and unpassable bridges which appeared in the ancient

visions), devouring serpents, cruel wild beasts and merciless hunts. This was the classic regurgitation of the well-cum-cesspit, the well-known scenario of horrors, terrors and atrocities which filled the tomb-prison to the brim. The fear of damnation and its punishments penetrated the meanders of the subconscious and with unsupportable fear plumbed the depths of those minds polluted with the certainty of their foul destiny. This religious melancholy appeared in the guise of a spreading epidemic of 'madness and strange ideas':[12] a large number of these hypochondriacs swore that they had already entered the kingdom of the dead and that 'they had already been condemned to hell'.[13]

Silent and creeping, the nocturnal breath of such devout melancholy also penetrated the cloistered shades and pensive hermitages. Even the solitary saint had difficulty in distracting himself from Saturn's malign influences. The monk's solitude degenerated into a stagnant pool of abandonment and isolation and he oscillated between dejection and idiocy, between hallucinatory meditation and mystical excess. 'It is a commonplace of the iconography of the humours', André Chastel observed, 'to illustrate the melancholy man as a monk'.[14] The solitary saturnine person alternated between 'serene contemplation' and 'a state of crisis characterized by temptations'.[15] As in *Tentations* by Gustave Flaubert, the hermit imagined all the voluptuousness of the senses and all the pleasures of the spirit as thousands of different illusions (*libido sentiendi, libido sciendi, libido dominandi*); he was devastated by fantasies of liquidation, lying on the edges of that wretched and cursed country which Blaise Pascal imagined as becoming red hot, rather than wet, from the three rivers of Babylon (*'malheureuse la terre de malédiction que ces trois fleuves de feu embrasent, plutôt qu'ils n'arrosent'*).

The 'melancholic's dream', most poignantly represented by Saint Antonio the Abbot, was transferred to and revived in the disturbed and tempted consciences of many other hermits living in the numerous hermitages of Western Europe. The melancholic person's night-time fear of 'finding himself in front of one's loved ones who are either dead or dying in agony, or of having lost them without being able to find them again'[16] alternated with the anguish, instilled by the inhuman cruelty of ecclesiastical pastoral care, of falling into an inferno in which the damned were reunited with their family whom they found screaming in agony: 'there father and son, brother and sister, friend and relative are crowded together and rain down blows on top of one another.'[17]

The fear of losing members of the family and of the silence of loved

voices was divided between the fear of being reunited amidst the excruciating cries of the damned, and the fear of being obliged 'to listen to the well-known voices of wives, husbands, children and parents, who with inconsolable laments beseech their most loved ones not to comfort them but to kill them'.[18] Having been reunited forever in an evil eternity, the family group begged for the comfort of murderous violence to put an end to the insupportable, unending punishment at the hands of their own relatives, and in vain besought the final, unattainable torture of death. These laments and supplications were useless since 'death is immortal; it has the evil effect of removing all good without having the good effect of ending all evil'.[19] To this hell which 'surrounded the damned' was added 'a still more pitiless hell within themselves'.[20] None the less, according to Paolo Segneri, the 'essence of all punishments', 'the hell within hell', will not be the life sentence of all the family members and relations, but the 'the soul's violent separation from the Supreme Good and from the centre of all hearts, which is God'.[21]

It is understandable that this endless round of tragedies might cause one to doubt not only divine goodness and mercy, but might also create a continual cycle, an obsessive chain of 'scruples' which would induce the believer, 'each time he repented of his faults and mended his ways',[22] to doubt 'God's love towards him, and instead he suspected and imagined that God scorned him'; it might convince him that his confessions were incomplete, fragmentary, inadequate and perhaps even useless, and that pardon was doubtful even after the confession of his sins.

The soul fell into a deep quagmire, 'into the blackest and most remote caverns',[23] where diabolical breezes ('*spiritus procellarum*') blew up into terrible winds which shook the soul tempestuously, rocking it with violent waves to the point that it believed ruin to be imminent and shipwreck certain. These tormented spirits fell headlong into that livid, muddy shaft which the Jesuit mystic, Jean-Joseph Surin (1600–65), called the 'hell of the soul':

> the widespread gloom and darkness of blindness was caused by the devil who formed a cloud in front of his eyes, thus creating an intolerable night which darkened not only the light of his faith and piety, but also that of common sense; this caused tremendous suffering and it seemed that his soul had fallen into the darkness of hell and into the shadows of death.[24]

This fall precipitated the soul into a well which was so deep and so far from God that the terrible miry lake, disturbed by livid, evil waves

('the spite, anguish, fury and despair'[25]) could only be called 'the lowest hell'.[26]

> In this place, the soul only seems to hear flashes and condemnations of God . . . or to comprehend that God himself ensures that his providence disposes of all manner of things and events to torment the soul and to convince it that it is pursued by all things. If the soul opens a book, it will find its condemnation written there. If it enters a church, it will hear some word from the Psalms or from the New Testament which will arouse its fear . . .[27]

In this state of 'extreme affliction',[28] 'mistrust in divine goodness'[29] led to the fatal generation of 'bad and melancholy humours and scrupulous anxieties' in the labyrinths of the conscience;[30] and aroused the fears of the 'timid and scrupulous, who are subject to so many worries not only about the sins they have committed, but about those which they worry all day that they might commit', to abnormal levels.[31]

Saint Filippo Neri said that there may be a truce, but no peace for those who suffer from the 'illness of scruples'. The illness was so tormenting and difficult to cure that the 'overwhelming conviction of his damnation'[32] constituted a real ordeal for those who confessed these individuals. 'It is still uncertain whether this evil causes more trouble to those who suffer from it or to those who attempt to treat it. I am convinced,' a confessor complained, 'that these scrupulous souls often try the patience of the confessors more than their own.'[33] This syndrome of fear, this devotional virus had infiltrated Christianity since the time of Saint Augustine who, often finding himself faced with difficult cases, tried to alleviate this problematic state of anguish, which he had greatly contributed to creating. This was the state of anxiety of the soul, according to the diagnosis of the great father of the church. But the ancient 'illness' was virtually transformed into an epidemic during the centuries of the Counter-Reformation, and became one of the most lethal variations of the Black Death.

> Scruples are born as a result of the innate temperament, or in other words when some melancholic humour is predominant. You should observe whether they increase and become more troublesome as the humour becomes gloomier, in accordance with the phases of the moon and the circulation of the blood, and, if this is the case, those things which you call by the honourable name of scruples, are in fact deliriums, fatuities and madness . . . Such persons should place themselves in the hands of a physician rather than a spiritual adviser.

46

Nevertheless, what you can do is encourage them to perform holy penance, and resign themselves to the divine will which has made them carry this cross.[34]

Contrary to L. A. Muratori's conviction (he had rightly conjectured the importance of the fear of hell in the origin of the syndrome of scruples), many ecclesiastics in the eighteenth century continued to identify the devil as the distiller of this poison.

For the most part these scruples are the work of the devil and they should be called diabolical temptations rather than scruples. It is easy to know how to distinguish between them. When they leave the soul disturbed, worried, languid and slothful in all that concerns the service of God, and when they exhort evil deeds with a certain degree of desperation, do not hesitate to think what other origin they might have, as these are the work of the Angel of darkness.[35]

Instead, it was the slow transformation of the image of the Omnipotent during the course of the eighteenth century, the super-imposition on the ancient, majestic figure of God the Judge of the image of a less tremendous and more comforting God of mercy, which attenuated, together with the fear of hell, the morbid melancholy of these scrupulous souls.

And we must regard it to be an article of Faith that God's Mercy will eternally be incomparably greater than all man's iniquities.[36]

These reassuring words opened the way to the decline and demise of the classic image of hell, even if pastoral practice continued for a long time to pave the road of terror with threatening reminders of the 'immeasurable size of those fires'.[37]

The 'tormenting phantoms',[38] the 'fixed meditation of the soul',[39] the 'most vexatious ideas',[40] the horrific fantasies, the 'deceived imaginations',[41] the 'extravagant peripetetics of the human brain',[42] 'vehicle of madness',[43] were all gradually attenuated, and little by little the constant thought of damnation flowed away, ebbing out of the circle of anxiety. The image of the relentless persecutor of the seven-teenth-century 'unmerciful' God (Lubrano) who rejoiced in the martyrdom of sinners gradually became fainter. Little by little the 'clamour of the holy orators'[44] and 'zealous holy preachers'[45] – as they were described with imperceptible irony and muted sarcasm by L. A. Muratori (despite the fact that he was a friend and admirer of Paolo Segneri) – and their 'declamations',[46] complemented by the dis-

heartening reading of 'certain spiritual works',[47] lessened their grip on those terrified consciences. The dismal and threatening colours with which this 'incautious melancholy'[48] had covered the portrait of the clement, 'good heavenly Father',[49] the 'most lovable Creator',[50] thus changing him into the 'most rigorous Fiscalist'[51] and 'Tyrant',[52] were dissolved by the restoration of 'regulated devotions' and the true colours shone again on the relaxed and charitable face of the 'Father of Mercy'.[53] The 'gloomy images'[54] of the 'dismal millers of scruples and fears'[55] began to disappear from the tormented scene:

> 'I have met women,' wrote L. A. Muratori, 'who became insane on the occasion of a wonderful sacred Mission and it took a great effort to restore them to their senses. Oh, unhappy ones, who do not realize the great wrong that they do to our sublime Lord God, who is the most loving, most merciful Lord who one can imagine, and who, knowing man's present state, namely as a sinning and fallible creature, has pity on us and anxiously waits for us to repent of our guilt and beseech his pardon before restoring us to his grace and embracing us as his beloved children.'[56]

The theme of divine mercy, uncommon in the sermons of previous centuries, became more frequent in those of the eighteenth century. Even the sacred pulpits sensed the signs of change and started to adapt themselves to the new movement of reformed piety. But not all. Many not only ignored it, but, tenaciously hostile to the changed image of the Only Begotten, started a new campaign against the 'abuse of God's mercy'. Others more subtly insisted on the necessity of reconciling fear with hope: 'God commands that we should both fear and hope. And since whoever fears without hope is far from the road to salvation, the same is true of whoever hopes without fear'.[57] None the less, even those who put forward this mixed and hazy interpretation of divine will did not hesitate to condemn the 'most insidious spirit of presumption' and the 'abuse of God's patience'.

> After having sinned they hope to have time and grace to repent; they hope to be granted pardon every time they request it; above all, they hope that divine mercy will save them from God's anger, which they seek to provoke, and entrusting themselves to this vain hope they head towards eternal damnation in a state of sin.[58]

This abuse of mercy was the 'most manifest illusion'[59] and trick of the Devil, since the 'Tempter used his habitual artifice to speak to us of divine mercy so that we might overcome our fear of sin'.

But, despite the efforts of the zealous preachers, and irrespective of whether or not this was one of the usual tricks of the Evil One, another deception, perhaps the most malicious of all, namely the spread of a new relationship with the Omnipotent which was founded not on terror but on a reasonable and orderly faith in his just mercy, opened the door on to a different climate which was less dramatically excited, less convulsed and less overheated. As a title of a devotional book, *L'homme criminel* (1644) became totally improbable a century later. In the same way, the image of God as an implacable bloodhound and a merciless hunter of sinners, and the God with the cruel and chilling laugh who, together with his court, delighted in the torments of the damned, could no longer be circulated without provoking doubts and causing profound dissent. It was precisely this God who in Italy would later be regarded as being a 'fiscalist' and a 'gaoler'.

Even the old-fashioned, terrifying terminology for the punishments of hell, the harrowing, tormenting, flaying, cutting, roasting, crucifying, martyrizing, lacerating – the entire stimulating and perverse dictionary of hell – had to be revised and attenuated, and, where necessary, some of its violent extremes and verbal unrestraint had to be abolished. Certainly, not all the horrific infernal rhetoric was laid aside, but it became somewhat uncommon in the eighteenth century to hear a description of

> a slaughter-house in which the sheep chosen by the evangelical shepherd, having been separated from the reprobate goats, taken from the sheep-folds of the world and massacred by death, were cruelly cut to pieces by the barbaric butchers of hell, on the chopping block of the crimes which they had committed, by axes, flames, and with piercingly painful blows.[60]

And, above all, this description of Purgatory by Romolo Marchelli was so like hell as to be mistaken for a passage from the *Centro squallido in cui la morte vive** (F. F. Frugoni).

In many instances, even 'holy madness' became a problem associated with diet, and correct eating habits became a precept of evangelical medicine and served to make the corrupt humours, which through the blood polluted the brain and fermented disorderly fantasies and immoderate visionary excesses, less impure and dissolute. 'It is possible that only the art of medicine,' Muratori advised, 'can relieve such fantasies, by exorcizing the evil animal spirits by means of a strict

* 'The squalid centre in which death lives.'

diet.'[61] Some of the extraordinary *exploits* of the Baroque saints were also regarded, if not with open incredulity, at least with suspicion. The librarian to the Most Serene Duke of Modena confessed that, 'what I read in the life of the Venerable Padre Giuseppe da Copertino made me raise my eyebrows. I will not mention his raptures but rather his flights of imagination'.[62] The perplexities and strong reservations concerning these seventeenth-century 'fantasies' little by little dismantled the stronghold of terror, the fortress of fire which the disturbed imaginations of the Baroque period had created, re-inventing them with copious ostentation and chilling scenarios. The return to order imposed a careful control on the phantoms let loose by the previous century, and established a quarantine for 'overheated imaginations', 'devout phantoms', 'supernatural visions of celestial things', and 'revelations'.[63] Fantasy was regarded as a 'mad thing' to be placed in chains and under medical treatment. It was like a beguiling siren who had to undergo severe therapeutic treatment, subject to the cautious control of 'good taste', and, above all, subject to the 'good taste of the senses' which was tempered by a prudent natural equilibrium, since 'the perfection of the organs, the temperament of the humours and the disposition of the juices are all things which keep the senses uncontaminated and ardent'.[64]

This filter had to purify the 'astonishing oddities'[65] which had emerged from the 'mad and unreal fantasy'[66] of the Baroque dreamlike forays; it had to purge all the monsters, the 'dirty thoughts',[67] the 'whims of fantasy'[68] and the 'counterfeit chimeras',[69] continually changing 'like Proteus and Vertumnus',[70] which surfaced in dreams during the buried ego's nocturnal spectacle when the 'soul retired behind a screen like a thin veil so that it could see but not be seen';[71] when

> the playful phantoms appear on the stage and enact a comedy but they enact it the way a company of actors would perform it if all of them were drunk or mad: so made-up are their faces, so strange their clothes, so unseemly their behaviour, so unexpected and out of place the changes of scenery, so mad their actions and unruly their speech . . .[72]

Phantasmatum deliramenta which, when melancholic eyes were closed, popped out like night birds, 'funereal and lugubrious, like noctules, owls and the like . . . and fluttered around their heads',[73]

> infame turba de nocturnas aves
> gimiendo tristes y volando graves.
> <div align="right">(Gongora, Fabula de Polifemo y Galatea)</div>

Or, in the depth of the night, 'fantastic oddities'[74] appeared and made up an incongruous 'mosaic of errors',[75] interwoven with 'foolish forms',[76] like the 'grotesque style'[77] in art:

> from the stalk of a flower sprouts the neck of a crane at the top of which is a monkey's head with four snail's horns spouting fire; a peacock's tail flowers on an old man's chin like a beard and a thick pigtail of coral; another person's arms are screws, his legs twisted ivy, his eyes two small lights shining within a shell, his nose a flute, his ears a pair of bat's wings, and when he looks in the mirror he sees the reflection of a Mammon.[78]

It was the new-found good taste which, by introducing a 'reasonable custom', removed the 'errors of fortuitous apprehension': in the same way as the 'sickly sweetness' preferred by children is substituted in adults by 'fragrant' and 'spicy' tastes.[79] The 'good taste of the senses' and 'mental good taste' went forward in convoy. Like a mad and irresponsible exhibitionist, fantasy was a beast which had to be kept chained up: the incubator of unseemly dreams, altered images, visionary scenes, and spoilt and overturned forms,

> how many times does fantasy not deceive in showing us the appearance of things . . . ? How many times does it not lie by representing chimeras which have never existed, by proposing falsities which will never exist? It is not only the heads of those who sleep which are subject to an eruption of that disorderly phalanx of larvae which fantasy always keeps enlisted. It makes even the most vigilant persons dream . . . And it mixes, confuses, disperses and transforms everything in such a way that nothing represents what it was before, or else appears different. Fantasy gives peculiar appearances to transcendent and abstract things. It attributes natural and finite proportions to things that go beyond nature and extend through infinity. It grafts divine things on to humans. It gives body to the incorporate, measure to the immeasurable and number to the infinite. But with what consequences? Ambiguities, fallacies, errors, and monstrous, illusory and false opinions.[80]

The innumerable fantasies concerning hell, its decorations and Tartarean interiors, its spaces and boundaries, the minute and punctilious measurement of its area and volume, and the precise number of its guests, the most exact calculation of its future inhabitants, the statistical survey, the detailed birth records, the accurate accounts of its business, and the prevision of the number of square metres necessary for the foreseeable number of tenants, which had taxed the minds of many learned, religious men (Drexel had calculated the area

51

and had estimated it to be not more than a square German mile, large enough to house a hundred thousand million souls), also came within the syncopes of reason and the paralyses of the mind provoked by these immoderate fantasies. The mathematical hallucinations of these surveyors of the invisible, the wild dreams of these architects of infinity, and of the land surveyors of the unknown, coincided perfectly with the claims of the imaginative who were illuded into attributing 'peculiar appearances to transcendant and abstract things',[81] and giving 'body to the incorporate, measure to the immeasurable, and number to the infinite'. 'This power of ours is like a madwoman', wrote Muratori, who deceives and raves, an incubator of 'fanatics, who, allowing themselves to be ruled by fantasy and, shall we say, imagination, are derided by fantasy herself who makes ridiculous, false and contorted fancies appear to them as being noble, true and orderly'.[82]

There were also the fantastic creators of ambiguous monsters and corrupt idols, of torbid deliriums and bizarre dreams, of extravagant and disorderly opinions, and of grotesque mental edifices. The victims of the 'strange power' of an unhealthy, 'rotten and distraught'[83] imagination, many erudite fanatics also raved 'about matters of importance, and, above all, religion'.[84] Even more insidious than the swooning visions of silly women and of the 'vulgar and the foolish' were the 'subverted fantasies', the 'devout deliriums' and the 'over-heated imaginations' of the 'Catholic *letterati*', who were devoid of 'good taste' and enslaved by 'devout and spiritual fanaticisms'.[85]

Among these 'delirious' spirits and alongside the 'misery of many women' (among whom were the prophetesses Priscilla and Massimilla), the most orderly priest from Modena, the solitary inventor of the Middle Ages, clamorously includes one of the founding fathers of hell, the passionate and terrible African, Quinto Settimio Tertullian, who was the cruellest exegetist of the punitive fire and of the vindicative justice of God, and perhaps the founder of western Christian theology. In other words, he included the 'wretched Tertullian, who was one of those men who possessed great genius coupled not with eminent wisdom but with an overwrought imagination'.[86]

The 'overwrought imagination' of this fanatic Christian-Montanist had delighted in producing the great spectacle of the wholesale roasting of the pagans, 'who groaned, liquified, turned red and quivered'[87] in the flames ('leaping flames'), and were shot with tongues of fire ('tossed in the fire') on the Day of Judgement, in the midst of the angels' exultant cries and the laughter, joy and jubilation of the saints and the righteous. 'How great a spectacle!',[88] he had shouted, foreseeing the great slaughter in the abyss which ('in the deepest dark-

ness'[89]) would consume governors, persecutors, philosophers, tragic and comic actors, athletes, charioteers, and the whole perverse world of 'ethnics' amidst the delighted cries of the celestial court.

And yet this 'abominable fancy' (as Dean Farrar later called it in a sermon given in Westminster Abbey in 1877), this hateful vision which was conceived in the early decades of the third century, during the years of bitter suffering for Christianity tormented by persecution, and during a dramatic period for the new faith, was corroborated by the authority of the most famous doctor and father of the Church, Saint Augustine, and later by the prestigious figures of Saint Thomas and Pietro Lombardo, the calm 'master of thought'. This dark and vile 'theatre of Providence', set up by the severe African whom the Anglican theologian Thomas Burnett (1635–1715) defined as an 'unmerciful doctor' in his work *De statu mortuorum et resurgentium tractatus*, continued to put on the play which had been dear to Tertullian during the entire span of the Christian centuries, and preachers insisted on staging its flashing reverberations up until the eighteenth and early nineteenth centuries.

The time of justice did not coincide with that of mercy. 'It is a fearful thing to fall into the hands of the living God. For then,' Saint Bernardo of Chiaravalle warned, 'there will be no time for pity, no time for judgement. Nor should we believe that there will be any mercy towards the impious, in a place where there is no hope even of correction.'[90]

Among the many reasons for such blessed joyfulness, the saint from Chiaravalle gave, above all, the understandable satisfaction of the elect of having escaped from such destruction:

> So you will consider with your eyes and you will see the punishment of sins. First, since you have escaped, secondly on account of the complete freedom from danger, thirdly, by way of comparison, and fourthly, because of the perfect imitation of justice itself.[91]

The old tribal God of Israel, the Lord of death and blood, cast such a thick veil over the charitable and merciful face of the Christian God that one might suppose that those who saw the New Testament as a subtle parody of the Old were not far from the truth, so clamorous was the desecratory contrast. The humanization of Jehovah or, on the contrary, his apotheosis as a bloody idol, coexisted in medieval Christendom in a difficult and opposing equilibrium, not only among the top ranks of the hierarchy but also among the aesthetes and contemplative scholars, like Bernardo of Chiaravalle, who was a devout follower of the cult of the Virgin Mary, a papal councillor and a promoter of the Second Crusade.

4

The 'Unhappy Country'

In the seventeenth century the warehouse of the damned 'containing millions and millions of rotten bodies',[1] the 'unhappy and stinking Arabia',[2] the 'land of misery'[3] whose air was 'heavy, rotten and putrid',[4] definitively became a separate place, a sealed ghetto, as far removed as possible from the other house, the eternal house, and as remote as possible from the country of the righteous. The separation was total and irremediable. The thought of people walking calmly in hell, like the priest who, in the *Vision of Tugdal*, was seen 'joyfully crossing the bridge with a palm branch in his hand',[5] became absolutely inconceivable. It was also impossible to imagine the spectacle of the blessed being led to visit the 'dregs of the abyss', or to imagine the damned being brought for a reciprocal exchange visit, to walk in the land of the blessed.

> Lord, if it pleases you, tell me: if it is true that the righteous were not worthy enough to enter the doors of death, why are they led into hell? The angel replied: if you wish to know why the righteous, who must not suffer punishment, are taken to visit hell, this is the reason. They are taken so that having seen the torments from which they have been spared by divine grace, they will be more ardently fervent in their love and praise of the Creator. On the contrary, the souls of the sinners, who have been rightly condemned to eternal punishment, are first taken into the glory of the saints so that, having seen their merits, the pain of punishment is even greater, and while their pains increase they are tortured by the memory of that glory which they could have acquired earlier.[6]

The damned had no need to pass through paradise to be tortured by remorse for this lost goodness: the worm of the conscience did not

cease to gnaw at them for a moment. On the other hand, the blessed, observing the punishment of the damned, were both pleased and infinitely satisfied, and felt no pity for the slaughter. Like 'catacombs of torture' and 'drains of corruption',[7] these places of punishment had to be placed as far as possible from the elect, in the centre of the earth:

> You must imagine a vast concave space down in the most intimate centre of the earth, in the heart of the earth (so that the damned are removed as far as possible from the blessed), which, shaped like a completely enclosed tomb, lets in no glimmer of light since there is so much earth covering it, both above and below and on every side.[8]

This damned cavern resembled a desolate slaughter-house filled with plague victims, like those overcrowded common graves into which infected bodies were thrown haphazardly in times of epidemic. It was a nauseating dump which gave off the fetid smell of a mortuary, of eternal corruption.

> And all will be in this tomb after the Day of Judgement in the same way that corpses are thrown into their tombs in times of plague; the tomb is filled to the brim and the bodies are heaped on top of one another, crowded together in such a way that they can never lie down, stretch, open their mouths to give vent to their grievances, or utter a distinct syllable or a sound . . . likewise, they can never open their eyelids in an attempt to see anything.[9]

The 'sepulchre of hell', 'with its fetid corpses which were indissolubly linked to hundreds of others',[10] this 'rubbish heap of rotting matter which devours the dead without disintegrating them, disintegrates them without incinerating them, and incinerates them in everlasting death',[11] worked like a peculiar self-feeding incinerator which simultaneously disintegrated and regenerated the rubbish which flowed from the rotten world, and paradoxically transformed the ephemeral into immortal, elevating the rejects and garbage into eternal, glorious trophies of divine justice. It was like 'a rubbish heap filled with little worms'[12] whose contents are continually regenerated and reintegrated in an incomprehensible cycle of sublimated destruction.

Crammed into the ditch-like sewer where 'all the dregs of Tartar' accumulate, and amassed in 'Lucifer's stable',[13] the bodies of the damned, whose limbs were all perfectly reformed after the Last Judgement, following the 'most monstrous', the 'most concrete and the most miraculous miracle of miracles',[14] would furiously explode with

delirious requests for recompensation and sensual consolidation. All their senses, having been humiliated and tortured for so long ('the punishment of the senses will affect all five senses', as Saint Antonio of Padua had foreseen), would shout like mad. The windows of the body would be flung open to invoke the reasons for which they were created.

> The eyes will shout out their demand for light and yet they will be always constrained to gaze on terrors, shadows and smoke . . . The ears will shout out their demand for the pleasure of harmony and yet they will hear nothing but groans, shrieks, uproar, oaths, and curses for all centuries . . . The sense of taste will long to assuage its burning thirst and hunger and yet there is no way of satisfying it, not even with the refuse of the sewers . . . The sense of smell will demand perfumes and yet it will not be able to smell anything except such putrid air, such a stinking fetor that a single whiff would infect the entire earth. *Et erit pro suave odore foetor*. The whole body, accustomed to satisfying its hunger for forbidden pleasures, will ask the soul for pastimes, delights, amusements and will obtain nothing except a horrible fire which will penetrate all its muscles, veins, bowels, joints, bones and everything as far as the marrow.[15]

In this total privation of 'good', the absolute negative will become the perennial norm: the senses, having been outraged for eternity, will become the persecutors and torturers of the body for whose service they were created. In a clamorous revolt against the carnal machine of which they were the prime participants, aerials and outposts, 'the senses will change themselves into the magistrates of Divine Justice and will be completely oblivious of mercy: the eye will continually be terrified by horrible visions, the ear will be deafened by blasphemous cries, the nose will be infected by disgusting things with an abominable stench, the sense of touch will be pierced by scorching wounds'.[16]

In comparison to the tortures of hell, even the most intolerable worldly affliction is a relief to the senses and a balm to the soul.

> Love your darkness, oh blind persons; lepers, cherish your sores; epileptics, love your falls; paralytics, your tremors; sufferers from gout, your stabbing pains; feverish persons, your worries; oh, prisoners, love the fetters which immobilize you; galley-slaves, love the chains which enslave you; condemned prisoners love the ropes which strangle you, the wheels which break you to pieces and the pincers which tear you.[17]

This Ignatian exercise of hell (predated by a few years by the thoughtful admonition of Cornelio Musso, 'Descend, descend into hell a short way, men and women, in your minds . . . Descend, descend

into hell, men and women, in your thoughts . . .'[18]), with its striking appeal to 'see' with the eyes of an 'imagination pushed to the limits of contortion',[19] with its 'continuous . . . reminder of materiality: visual, but also olfactory, auditory, tactile and gustatory',[20] with its personal simulation of hell, which was sensually explored by the novice (according to the methodic instructions of the instructor), caused the five senses to be active witnesses of the imaginary visit to the 'kingdom of agonies',[21] but above all to be hallucinated protagonists entranced by the exhausting outrages which were inflicted on the tormented flesh.

The dogma of the resurrection of the body, 'the most stupefying form of dogma' (Chesterton), excited the material feelings of pain and terror to a point of unbearable tension and gave a free rein to the most indisciplined fantasies concerning the rebirth and reconstruction of the body, which had decomposed and turned to dust, thereby encouraging singular hypotheses and extravagant thoughts regarding the new and definitive remoulding of the flesh:

> In the blinking of an eye, all the souls descend from Heaven and come out of Hell; and each one finds set out before him by the Angels the flour of his ashes and the water of his own decay, and he watches while the form of his body is recomposed. And without the yeast of seminal virtue, without the oven of the maternal womb, and without natural warmth, the crumb in the flesh and marrow, the crust in the skin and membrane, and the biscuit in the cartilage and bone are remade in every way according to their correct organization and cooking times.[22]

Under the direction of the baker-angels, and from the floury ashes of bones mixed to a dough with the rotten water of putrefaction, the bread-like man was born again 'without the oven of the maternal womb', but complete with both crust and crumb. It would be a day of 'strange metamorphoses',[23] the moment when new forms and new human mannequins, created with extraordinary artificial limbs or sinister malformations, appeared on the scene.

> If that woman, who lived in a retiring and modest fashion, in this life had a small defect, like a crooked mouth or a squinting eye, then on the day of the resurrection in glory she will rise again with a mouth like coral and sugar, with a brilliant and shining eye, all beauty and lovableness and wonder; but the woman who in a daring and vain fashion dabbled in luxury and intrigues, and in this life covered the ugliness of her face and hair with perfumes and other ornaments and false hair, then she will rise again in hell and have a coarse skin, a bald

head, a discoloured face, like an extraordinarily dried, stinking, de-
formed and abominable mummy.

If that youth who lived honestly and soberly in this life had dull hair
or was hunchback or clubföoted, then resurrecting in paradise he would
rise again with a well-groomed and attractive head of hair, he would
stand firmly on both feet, have square shoulders, and be well-disposed
and wonderfully kind.[24]

In the eyes of some Baroque preachers even the 'tragedy of the Last
Judgement' changed context and was transformed into a 'rabid
parody'.[25] The last act of the great spectacle of the world, having been
renewed and fixed for ever in eternity, changed scene and became a
paroxysmic and grotesque dance, a surprising and disconcerting
parody. It would be the last production of the 'revolving theatre'
before the old world 'with scattered fragments could be seen falling in
ashes and sparks'.[26]

But even after the destruction of the 'temple of ignorance', in the
second half of the enlightened and reformed eighteenth century, a
placid and lovable Jesuit, Giovan Battista Roberti, continued to
sustain that 'the doleful souls will return to their renewed bodies in the
universal resurrection, but that their bodies will not be reformed but
instead will have all their old imperfections; they will be ugly, inert,
ponderous, pallid and afflicted ... they will not possess that bright
beauty, but instead will be shamefully deformed'. Only the righteous
'will rise again with bodies which have been patched-up and re-
touched where necessary. If a righteous soul had a defect of stature,
then his body will have grown to a suitable size If a reprobate had
been of a petty and miserable stature, he will remain so'.[27]

It may seem even more disconcerting that this acute, sensitive and
charitable Jesuit, a lover of strawberries and chocolate and the most
learned author of the *Annotazioni sopra la umanità del secolo decimottavo**,
could seriously wonder whether, 'according to the doctrine of Saint
Augustine, the entire population of Pigmies which are mentioned in
history will resurrect as Pigmies'.[28]

But the count—abbot, doubtful of the existence of 'a similar little
race', dismissed the obscure and controversial dilemma with the
peremptory reply that 'Pigmies would not return to life since they had
never lived'.[29]

In the seventeenth-century hell the spectrum of punishments passed
through the filter of the five senses, which in turn became the desper-
ate protagonists of the 'torture of the senses', the persecutors of the

* 'Annotations on humanity in the eighteenth century.'

body which, on earth, they had served, smoothed and caressed. Baroque sensuality revealed its sensitive soul in what – for once with complete coherence – we might call an inferno of the senses. It was the senses which became the vibrating filter of the 'everlasting horror': ears martyred by the excruciating, dissonant and wild music of groans and imprecations; eyes shocked by horrible visions and cruel spectacles; skin and flesh subjected to slimy and ignoble contacts; the throat punished by hunger, when it was not irremediably insulted by foul drinks and excremental meals; the nose devastated by unbearable smells. Having fallen into hell, the noble gentleman awoke in this house of troubles (the theme of the 'awakening' was recurrent in seventeenth- and eighteenth-century descriptions of hell), and glanced

rapidly at his palace and his earlier banquets. He glimpsed the long succession of decorated rooms in a flash, since they disappeared in a moment; he then reflected on his present state where, in a narrow tomb six palms wide, for interminable years he would not even be able to roll over ... He saw those tables laden with game and fish which was still steaming ... He saw the grooms and other servants avidly drinking from large beakers taken from the cellars which he had lain down for his own use ... He saw the sumptuous litter curtained with silver where he used to recover from his hangover until midday, and he screamed with pain finding himself nude above feather-like flames of burning charcoal ... Oh, what wretched extremes, oh what a bitter change from enjoying the perfect air of the regal villas to breathing this stifling air and waves of fire! From the belvederes of the richest hunting lodges to seeing horrendous spectres and terrifying visions. From blessing the ear with the music of terrestial angels to being horrified by the shrieks of demons and blasphemies against God without getting a minute of sleep. From smelling amber in gloves, liquid amber from Messico in food, the essence of roses in baths and balsams in oil lamps, to suffering the infected stench of decaying bilges in that enormous sewer.[30]

This was a hell which was specially designed, carefully built to measure, destined to depress the rich and privileged, to perturb ladies, gentlemen and high-ranking ecclesiastics who spent their splendid days in pursuit of the pleasures of the ear, the stomach, the nose, the eye and the skin. The precious musical scrolls and the flattering words of 'wanton songs'[31] would be extinguished by the 'perpetual dissonances of hell';[32] the voluptuousness of the 'animated lyre',[33] the mouth, the 'seat of Taste and supreme judge of food and drink',[34] would be overcome by Satan's 'detestable and funereal table',[35] by the ignominious and nauseous, sewer-like mush; the 'splendour of the

dining tables',[36] the 'decoration of side-boards',[37] the 'artful and hand-made furnishings',[38] the 'magnificence of gold, purple-dyed materials, and gems', the 'halls filled with portraits of the great, the porticos with emblems and painted coats of arms, the inscription of mottoes, the pride of palaces, the delights of the villas, the furnishings of houses, the pomp of trophies, the crests on weapons, the festoons and shields on gateways'[39] would all be dissolved by the darkness of the 'gloomy caverns',[40] by the emptiness of 'stinking cess-pits'.[41]

In the secret rooms of palaces lascivious pictures tempted the eyes; illusionistic perspectives, fantastic gardens, complex labyrinths of plants and musical waters which flowed from hydraulic machines, mythological figures, sonorous devices, exotic fruits, and monstrous grafts accompanied the aristocratic walks amidst the delights of the villas and hunting lodges, along the 'parterres' and belvederes. Exotic scents filled the greenhouses and the fragrant 'promenades', the interiors were inundated by scents from the 'perfumers' and by sprayed essences; aromas and spices were smelt, spread, eaten and drunk in foods which were scented with amber and musk, spiced, iced and coated with sugar in the form of monumental pies and made into ingenious 'sculptures' of sugar etched with heraldic and blazoned reliefs; scented water, snow-cooled wines, aspics, preserves, sorbets, citron syrup, lime juice, syrups, ratafia biscuits, honeyed drinks, bitter vinegars, spirits and volatile oils, granitas, acquavits, frozen sweets from the sideboard, the marvellous 'flambé' dishes from the kitchen, the voluptuous ecstasies of the alcoves 'curtained with silver', and the velvet breath of the wardrobes softened the hours of the day and the night.

To the inhabitants of this wonderful world of odours, who were always searching for new and 'enticing scents',[42] the 'torment of the sense of smell, the stench of sulphur, the stink of gangrene, the breath of so many foul-smelling bodies in a completely enclosed sewer, more than three thousand miles away from the air and without any openings, without air',[43] and the fact of 'being immersed for ever in the scum of that drain, all crowded together like sheep in a slaughter-house',[44] the eternal 'agony' of 'those putrid bodies, who had no respite by day or night from the most deadly stench, packed one on top of the other, and mutually polluting each other with a reciprocal fetor',[45] must have seemed absolutely intolerable tortures.

This foul and sewer-like hell, vile and full of scum, was designed – so one might think – more for those corrupted by the senses than for the virile sinners; this hell was the avenger of soft pleasures, of amber-scented voluptuousness, of lascivious orgies, of hedonistic and environ-

mental delights, of rural amenities and auricular refinements. The magic of music was so insidious that even the most religious spirits, like Father Atanasius Kircher in his *Musurgia universalis*, 'claimed to be able to make simulacrums who spoke with human voices by using pneumatic thaumaturgy, moving wheels, drums and internal bellows'.[46] Rather than the age-old 'evil', it was the opulent way of life which was punished, the fasts and the splendours of noble Baroque society, its pomp, its voluptuous excesses, its carnal sensuality, its intellectual curiosity, and its morbid attraction for the extraordinary and the rare. According to ecclesiastical policy, this 'most scented century' was forced to live under the threat of a most foul-smelling hell. The century of perfumed noblemen lived in perpetual terror of falling into a polluted drain, or into a stinking sewer.

> Not only were perfumes used in an abundance which for us is barely conceivable, to scent clothes, gloves, rooms, and food and drink, but it was fashionable to produce them and to make new combinations oneself. Including the princesses and sovereigns, who continually distilled essences in golden containers in their palaces, there was no elegant person who did not have his own distillery at home.[47]

The hell which was created by the Jesuits – the dominant model which would later influence the hells of other rival 'religions' – had been primarily conceived as a deterrent for the noble and high-class world, and designed to make the loathsome and disgusting smells of the tomb waft up those large, refined noses. It was not only the sordid and ignoble images, but also the outraged sense of smell (a Tartarus filtered with alembic) which instinctively transmitted a sense of repugnance.

> 'Imagine, gentlemen, a wide and terrifying concave space or vortex in the darkest centre of the earth,' preached Jean Louis de Fromentières (1632–84), Ordinary Preacher to his Most Christian King Louis XIV, '... then imagine that in this deep vortex or sewer, into which are dumped all the filth and the most insupportable fetor of all the rubbish that has existed since the beginning of the world and that will be until the end of all centuries; as I was saying, all the damned sinners will be submerged into this sewer without mercy and, like bricks piled up in a furnace, they will stay there for all eternity.'[48]

To the Sun King's delicate, perfumed and well-fed soul, the prospective of being extinguished and blackened in such a foul abyss, in the turbid swill of his sinful subjects, cannot have been particularly

attractive. Nor could the Most Serene Duke of Baviera, Maximilian, Elector and Great Seneschal of the Sacred Roman Empire, or his wife, the Most Serene Elisabeth, have felt very comforted after having heard the voice of the court preacher, the Jesuit Jeremiah Drexel (Dresselius), as he revealed the foulness of the subterranean abode. Nor could the voracity of the corpulent lords of Baviera have been cheered by hearing that 'sin, or rather the cause of the sin of Sodoma, was nothing other than overeating and being fat',[49] or that the sinners would be rolled into the tightest of prisons, into the 'narrowest of graves' and 'bound tightly with ropes that cannot be untied'.

> If 30 or 100,000 million persons were condemned to hell, and if this prison was one German mile in each direction, that is to say high, wide and long, it would be amply sufficient to house such a large number. A prison should above all be narrow, since spacious living is a part of freedom. Then the whole herd of the damned, those riff-raff will live in the narrowest space; they will be like grapes in the press, or like sardines in a barrel, or like bricks in a furnace, or logs in a wood-pile, or charcoal in a brazier, or like so many sheep slaughtered in the slaughter-house . . . The narrowness of the prison and the fact of being so tightly packed on top of each other make the torment even greater. God will collect the refuse and dregs of the whole world in this small and narrow circle.
>
> In this world the ugliness and dirtiness of the place is enough to cut short any desire to be joyful. Who is it who can stay for long in a workshop where tallow is melted, or in a tannery? . . . What pleasures could possibly be found in the wretched workshop of divine anger?[50]

The image of the tannery, or the infernal laboratory where the nauseous tallow was produced, where, as Jeremiah Drexel described, the air was 'polluted by the horrible stench of semi-putrified skins',[51] was particularly repugnant. The cities of the past had been well acquainted with the foul smell which emerged from the cellars and hovels where, in the midst of horrible fumes, the tanners and dressers, the dryers and manufacturers of candles, oils and the strings of musical instruments (which were made from animal guts) were obliged to work in a 'hot atmosphere and often half naked',[52] with the 'disgusting smell of putrefied urine and oil',[53] up to their knees in a watered down mixture of urine while they trod the cloths. These workshops were usually sited near the walls of the city, in the peripheral areas which were often the worst polluted, 'since all the refuse of the city was carried there'.[54] Even animals fled in terror from these hovels: 'no goad, no amount of insistence,' observed Bernardino Ramazzini, 'would persuade the horses to pass in front of those

workshops since, once they smelt the stench they bolted for the stable like mad things, paying no heed to the reins.'[55] 'Pale, cachetic, plagued by coughs and nausea',[56] those condemned to this most iniquitous of trades moved about half naked in damp and slippery places, in their oozing, hellish workplaces. These slimy 'stoves', these semi-voluntary prison baths, these torture chambers were dominated by the totem of their trade, the jar into which the workers, according to the terms of their contract, had to urinate in order to have a ready supply of one of the prime materials of tanning: vesical liquid, which acted as both a deobstruent and a detergent.

The prospect of finishing imprisoned and enclosed in these infernal tanneries, in these nauseous holes with no breath of air, of rotting, entrapped, in encrusted underground workshops (with no openings or fireplaces, unlike the medieval hells) which were even more pestilential than those in which tallow was produced and whose stench was so tremendous that it made the living faint or become hysterical, must have been particularly unpleasant to those who, amidst the comforts and golden pleasures of noble life and 'gentle living', spent their days in well-aired and pleasantly scented places.

It is not possible to know with any precision how those employed in these menial and vile trades, or those who were constrained by dire necessity to work in the 'dishonourable' professions, reacted to the probability of passing from a life on earth spent smelling rotting flesh, refuse and disgusting pulp, to an equally smelly eternity, full of swill and excrement. To tortures of this kind they had become, if not inured, certainly accustomed. In his own fashion, even Drexel took account of this: 'the filthiest and smelliest of trades,' the wise Jesuit observed, 'become easier with habit. But the torments of hell can never be mitigated even by eternal tolerance.'[57] And, truthfully, what hold could this vile future have on those who spent their days as involuntary reprobates, 'amidst faeces and urine'; on those whose damned professions led them day after day to empty drains, cesspits and infected houses, whether they were 'latrine cleaners, the 'ugly' professions, or those 'courageous' workers who 'expurgated houses and goods which were infected and suspected of contagion', those constrained to 'handle goods which breathed death from all sides',[58] and those who disinfected the insides of houses visited by the plague by washing the furnishings and laundry of the dead; what hold could it have on those who breathed in the vile smells of the rags and swallowed the dust of the mattresses dirtied with faeces and the dried bodily remains of those who had first lain there in agony and had then died there; or on the gravediggers who lived all day with the

cemetery's stench and decay; or on the saltworkers, 'who were almost all cachetic and dropsical', with 'ugly sores on their legs'[59] and who, 'perpetually thirsty and ragingly hungry, worked in the sun-blistered salt-deserts with a straw hat on their heads and rags to cover their genitals'?[60] What effect can the 'sulphurous lake' of the subterranean Gehenna have had on the miners, or on those who melted, fused and smelted disgusting substances day and night? What did the grooms, mulateers, pig-keepers, butchers or the muddy peasants (whom an infamous heraldry had attributed with a bestial birth and a genesis from dung) think of this filthy and faecal hell?

And what did the multitude of poor starving devils, of shabby beggars, of human odds and ends, reduced by hardship and discomfort to 'pure waste' (Baldessarre Bonifacio, *Il Paltoniere*),* to walking skeletons, to ashen, leaf-like, shrivelled mummies, think of the eternal hunger, the unquenchable thirst and the ineffaceable stench? Did they take it seriously, or did they joke about it like the buffoons at Zuan Polo who pretended to have been informed by the soul of a fellow jester, Domenego Taiacalze, that the otherworld was not totally without comforts, and that its solaces were not truly punitive. Down there, from the buffoons' point of view at least, one could end up in a 'room deprived of passionate feelings',[61] and without the punishments and torments which the house of troubles generously reserved for its other guests. In this underground inn, where 'plenty of wines and sweetmeats could be found',[62] one of the good companions stood up from the table, holding a 'capon without a crest in his hand', to welcome the soul of the newcomer.

> Here, take this, brother, because you're tired;
> You can confort your melancholy soul.[63]

And the melancholy but above all starving soul, by then on the verge of fainting from weakness, did not wait to be asked twice:

> Since I felt myself fainting
> I began to eat without fear
> because my spine was touching the side of my body.[64]

Punitive theology was mocked at even in the linguistic heart of its system of horrors, through the impertinent use of a term, the purgatorial and Augustinian *'refrigerium'* (a sacred word which also appears in the *Canon Missae*, *'locum refrigerii, lucis et pacis'*), which in this context

* *The rogue.*

was degraded to a hedonistic and wholesome orgy of food, to a refrigeration-cum-refreshment-cum-restoration of the body, rather than the 'spirit'. An enormous 'kitchen' was enthroned in the centre of the 'place of torture'. There was no trace of ropes, cells, or suffocating prisons. The appetizing smell of meat on the spit completely removed all fear. The 'strongly smelling hell' had disappeared and there was no trace of the miseries proposed by Saint Girolamo: 'amidst the flames, roasting human lust bubbles in its own fat'.

> It was a very wide space,
> Of which my eyes would not allow me to see the end,
> And I never thought to see anything as wide.
> Against this background I spied
> An infinite number of bronze cauldrons
> And people roasting meat on hand-held spits.[65]

The fire, the instrument of divine anger and the terrible fire which was used by the merciless executioner, which, guided by his infallible hand, penetrated the marrow and the most intimate tissues of the heart; the inexplicable 'rational fire' of the holy fathers, the spirit of fire and the quintessence of the fire of the holy scriptures, the 'judicious fire' (*ignis sapiens*) of Saint Gregory, with knowledge of the criminal motives of torture, the 'Creator's instrument', as described by Tertullian, the flame which burns but does not consume; all these now fell from their apocalyptic heights to the level of the mere kitchen fire, the humble and domestic auxiliary instrument of sinful man and of his impenitent, carniverous appetite.

Human lusts do not melt down when grilled in their own fat, or was overheated by burning flames: only capons, pheasants and kids sizzled on the spit, and boiled meats broiled in an enormous number of pans (the '*caldiere bronzine*'). The fire used for baking bread, as in the Psalms, (*clibamus ignis*) and the same domestic fire described by Saint Cyprian, the red-hot oven and the 'mill house' of the Irish visionaries disintegrated into nothingness. The hell-cum-saucepan described by Gregory the Great, Vulcan's 'pot' and the great cauldron from the island of metalworkers were transformed into an infinite number of pans which bubbled gently, filled with food for the stomachs of the dead who were always ravenous and had good appetites. If anything was cooked in them it was certainly not the bodies of the damned which were 'soaked in fire; the fire penetrated their heads and made their brains boil; it entered their bones and cooked the marrow; it entered their chests and guts and filled them with flames'.[66]

This fire was at the service of the damned who were peacefully seated at table: the sole 'grinding of teeth' which could be heard was the noise of their jaws intent on consuming an impressive number of courses, and there were no screams from souls tortured by the fire which, as the preachers threatened,

> would course swiftly through their veins, would bubble through their arteries, and would boil like liquid lead or extremely hot molten metal in all the interior cavities and channels, and, oh God, would torment everything with supernatural power; yet by the very virtue of this power it would not consume anything.[67]

This inferno, this blast furnace and foundry, this house of death without death, whose mouth-like door was thrown wide open to swallow sinners and make them slide down into eternity, this 'house which is round like the shape of an oven',[68] (the house of terror in which in primitive cultures the initiates were segregated, was placed in this infernal setting as an initiation rite to eternal pain), this oppressive house without windows and without chimneys was transformed in the jesters' anti-hell into a 'reasonably wide space' whose limits could not be defined: 'My eyes would not allow me to see the end and I never thought to see anything as wide.'

For them the 'good Minos',[69] guide and superintendant of justice, had reserved a 'sweet place' which was untouched by crying, pain, sadness or the gnashing of teeth, a 'reasonably spacious place' free from punishment. Lucifer, who lacerated and tortured souls, adored music and beautiful voices and was very indulgent towards anyone who could entertain him with 'Greek, Bergamesque or Albanian'[70] songs. The table was particularly well provided. It was governed over by a famous chef, a historic cook with an illustrious name, Margutte.

> We greatly enjoyed ourselves amidst the savoury dishes and
> sweetmeats
> Drinking wine and eating sugared almonds,
> Without feeling the least passion.
>
> There were whole loins and kids,
> Pheasants, roast partridges and
> Steaming quails, and the choicest thrushes.
>
> Green gingers, with every sort of compôtes
> And as many types of fruit
> As would never be found in the world.

But to give you an inkling of the whole occasion,
And just imagine that we could relish it in complete peace,
Our cook was called Margutte.[71]

The parody of classic hell, the anti-model suggested by popular-carnevalesque culture, was an instrument of apotropous exorcism, a formula for exorcizing which drove away fear with laughter and jests. It may be placed within the broad spectrum of sacred parody, the use of scornful registers, inverted liturgies and other comic practices which the pre-Tridentine Church not only tolerated but even suggested and prepared. This fat and greasy hell, this underworld for gluttonous jesters, was exactly parallel to the prayers and confessions from the carnevalesque prayer book. The following 'devout prayer' was recited every morning during Carneval:

Most holy, crowned hen,
Whose son was a young capon,
Thou shalt be married to the lasagna
Together with the sweet liver;
And the sausage was martyred
And well crushed and placed in a gut,
And so that it suffered great pain and sorrow,
It was hung and placed over the smoke-stack.[72]

The following extract is taken from the '*Confessio Carnisprivii*', which is in the Marciano codex (*It.* XI, 66, c. 153v):

Let us pray
And make our fat confession
And say together: I confess to Our Master Saint Capon
That the fatter he is, the tastier he becomes.
And I confess to Our Lady
Saint Hen who makes
Our dishes so fat
If I have more now
I will not have any tomorrow . . .

This was the mundane hell into which Aucassin wished to descend, where knights, ladies and buffoons lived together in pleasant joyfulness, while paradise seemed to him to be a gloomy and boring place inhabited by priests, one-armed men, deformed persons and hermits who had died of hunger, cold and poverty.

What would I do in paradise? I will not try to enter paradise . . . It is to hell instead that I wish to go, since it is to hell that the good-looking

clerks, the handsome knights who die at tournaments or in dashing wars, the brave men-at-arms and nobles go: it is with them that I wish to go. There also go the beautiful women who are courteous enough to have two or three friends in addition to their husbands; there go the gold and the silver, the vair and the squirrel fur; there go the harpists, the jugglers, and the kings of this world: it is with them that I wish to go . . .[73]

Aucassin's hell coincided with the paradise which was imagined by the jester, the 'king of this world'. But, all things considered, jesters were privileged and their witticisms, although apparently irreverent, served to lessen the anguish of those who were terribly afraid of death and damnation. It is difficult to quantify the extent of popular scepticism, of religious indifference and incredulity with regard to these dogmas. Certainly, even in Italy there were those who affirmed that 'whilst we live in the fear of hell, we have it',[74] and there were also those who mocked reincarnation, the virgin birth, the Trinity and many other things. Whereas libertinism, atheism and anti-Christian disbelief, which were widespread in intellectual circles, have been well studied, the other world, that of popular religiosity, continues to remain obscure. Too often we are led to confuse the rejection of ecclesiastical hierarchy with a rejection of faith. While it is true that 'the hold of organized religion upon the people was never so complete as to leave no room for rival systems of belief',[75] there is little value in reconstructing the universe of religious dissidence using the testimonies of *litterati*, or in any case literate persons, since they only knew the world of popular piety by hearsay. It may also be dangerous to give too much importance to certain jokes, such as that made by the Reverend Richard Baxter in 1691 (in a social and cultural context which was very different from ours) which stated that:

> if anyone would raise an army to extirpate knowledge and religion, the tinkers and sow-gelders, and crate-carriers and beggars and bargemen and all the rabble that cannot read . . . will be the forwardest to come into such a militia.[76]

It might be worthwhile to reflect from time to time on the little known case of Giovanni Boccaccio, the scornful critic of the superstitious cult of relics, who in private was a devout collector of these thaumaturgical fragments.

5

The 'Foul-Smelling Drains'

When the final act ends and the elements separate, the 'ultimate purification of the world' will take place; everything that is pure and noble will be left to glorify the blessed, while the remaining impurities, everything that was 'slimy, ignoble and disgusting' on earth, will be poured into the 'well of the abyss' (*puteus Abyssi*), into the vortex of death. This nauseous stream was thought to flow into and contaminate a place of limited dimensions, which was narrow and small. During the Baroque age (and to some extent in the eighteenth century) the 'prison of hell'[1] tended to contract, becoming more restricted and transforming itself into a suffocating sewer. The perimeter of the 'pit of destruction' (*puteus interitus*) was progressively shortened, its area was reabsorbed and concentrated within a limited space, and its volume was redetermined. Even though it was reduced in size to little more than a geometric point, the Baroque hell carefully avoided becoming a purely imaginary place, or a symbolic abstract image. It retained its solid spatial dimensions, even though these became increasingly circumscribed, and its punishments, although these were reduced both in number and variety, lost none of their intensity. Perhaps it slowly became apparent that the perception of the form of punishment had changed: it was not different but more intense, a form of torture which was moral and psychological rather than physical in form, and which concentrated more on the inner being. The destruction of the wide spaces of the medieval hell (the 'wide and deep valleys which were also infinitely long'[2]), the loss of the vast plains and of the extremely high cliffs where fire and ice alternately dealt out punishment, led to the consolidation and limitation (and to the simplification) of the tortures; the accent was placed on the 'punishment of the senses', inner punishment, 'damaging punishment', the 'infinite depri-

vation', and the total and irreversible loss of God. This was the 'hell of hells', as Paolo Segneri wrote soon afterwards.

The spatial restriction was a prerequisite of the intensity and above all of the quality of the punishments. Nor was it by chance that it was primarily the Jesuits who circulated this suffocating and repulsive description of a confined hell among the leading groups and the superior classes, a hell in which there were no reserved or separated places, and where the latrines were shared by everyone, nobles and plebians alike. The analytical and minute measurement of its size and the mathematical assessment of the numbers it would hold, all formed part of the Jesuits' strategy of computerized terror.

> That prison will be three thousand, five hundred and sixty miles away from us and two hundred and forty million miles away from Paradise; it will not be more than one league wide, measuring four Italian miles, but this will be sufficient to contain eight hundred thousand million bodies, if there should ever be that many; one such league, which measures twenty thousand feet, multiplied by its cube can contain this number of bodies if each were to occupy six square feet. But they would not stand on their own feet but would be pressed together, like coals or stones in a furnace, like grapes in a wine-press or like ears of wheat in sheaves of corn.[3]

A mere six square feet '*pro capite*' is too small a space in which to spend eternity. In spite of having refused the role of 'audacious geographer', since he did not dare trace the 'precise topography' of the 'unknown land' which lay at 'the antipodes of the Empyrean', that 'country which is unknown to any human mind', Padre Ercole Mattioli (1622–1710), a fellow-countryman and a contemporary of the cosmographer Giovan Battista Riccioli, could not, however, resist the mathematical temptation to give lessons on the underworld to his noble pupils at the Jesuit college of Parma. Using the precision of mathematics and the glacial authority of numbers, he could draw the plan of the prison in which, as in the most famous prisons of old whose inmates felt 'their humanity being eroded day by day by their rotting guts', the suffocating stench increased the torture of enforced im-mobility.

> This narrow place, which was not only full of sulphurous fumes but of every form of refuse, every rotting substance, every poison and all the most abominable filth, gave off an intolerable and punitive smell which was worse than that which Emperor Trajan discovered on the other side of the Euphrates, at the entrance to a cave; this pestilential smell was

such that no creature on earth could bear it, nor could the birds of the air even fly over it without fainting . . . ; but in that place there were none the less a few openings through which some of the evil and unpleasant smells were dispelled and dispersed. In hell, the stench remained intact and could not be dissipated since there were no apertures, so that . . . if a mere whiff emerged into the daylight it would cause (said the seraphic Bonaventura) a widespread and universal pestilence.

And none the less, those wretched persons, pressed together, distilled in decaying and contagious humours, and touching mouth to mouth, are obliged to breathe a nauseously death-giving life or a life-giving death.

In addition, the narrowness of the prison will cause another strange torture, amidst so many other torments: namely, the fact of being completely immobile. As an appendix to every massacre and as proof of invincible constancy, in his description of the martyrdom of Arethusa the theologian Nazanzieno underlined that, having been tightly bound and smeared with honey, Arethusa was exposed to the stings of extremely fierce wasps without being able to shield himself.[4]

The idea of such a restricted space and of such an abominable 'habitat' must have produced feelings of intolerable anguish in the 'delicate nobility', those noble scions who were accustomed to living in great ancestral palaces, to moving around in the spacious rooms of their villas, to galloping in the hunt and to enjoying a life without restraints. The oppressive narrowness of this six-foot square stifling hole, the enforced immobility, the unseemly cohabitation with unknown, shady, low-class, lurid and slimy persons, breath meeting breath, touching skin to skin, with 'miserable, infectious humours dripping with putrefaction, and mouth to mouth', appeared to be infinitely greater than these haughty noblemen's possible threshold of suffering, even when dead. This threat to their sense of smell offered the Jesuits a magnificent instrument of wholesome terror which enabled them to control in advance the state of the souls of the dead. The stench of the poor man, the smell of his filth, the inhalation of the odour of his class, the constant trickle of his excremental humours, that crude intimacy forced upon one against one's wishes, that terrible and most audacious 'mouth-to-mouth' contact, that repulsive kiss, all must have caused repugnant gut reactions and intense class disgust, and a violent rejection of this intimate and indecent contact, of this unacceptable and promiscuous *status* in the darkness of the underground, in the fire-spitting and iniquitous 'pit' into which all the world's filth was poured, covering the bodies of the damned with stinking black honey. This intimacy was unacceptable, and the threat

of that atrocious kiss was worse than any infectious contact; it was more horrific than the desperate 'kiss' which the incurables who lived in isolated caves tried to obtain from snakes (as Caesar of Heisterbach described); it was a drastic cure made of 'disgusting and nauseating substances, which horrified human nature'.

> If one is covered with incurable sores, what fear does the act of entering some snake's lair not arouse? Trusting that the creature's poisonous kiss which licks the pus of his sores, will help him more than the surgeon's art, by maiming and poisoning his disease alone.[5]

The '*transplantatio morbi*' could not be performed in hell, in this immortal latrine which the Jesuits unfolded in front of gentlemen's eyes (but above all in front of their noses), knowing the profound trauma which this would cause in the inner regions and more hidden parts of their bodies. The intimate embrace of the man-cum-snail, of the miserable, stinking beggar covered in sores and filth, of the verminous relict of the streets and of the evil outcast of the most corrupt social class, appeared to the aristocrat as the worst of all possible downfalls from his privileged position; likewise, the substitution of aromas, oils and balsamic ointments for the plagues and festering boils of the underground horrified him.

The punishment of the sense of smell, which was a fundamental component of hell, was certainly not unknown in the medieval under-worlds: the '*foetor incomparabilis*'[6] was present throughout the medieval hell, but was less concentrated in the larger regions where the souls were not heaped up and squeezed together like grapes in a press. In the Baroque inferno this pestilential claustrophobia grew into a gigantic, collective oppression. Every spark of retaliation and every trace of a relationship between guilt and punishment disappeared. The foul-smelling fire, which made no distinction, incinerated all that remained of personality. Promiscuous anonymity became common law, the prison rule for all those who served life-sentences in the immense underground penal colonies. A new form of anguish, which was more subtle and impalpable, made the 'narrow gut' (no longer the 'great pit' (*puteus magnus*) as in the good old times of the Venerable Bede) even more disgusting and appalling. There was only immobility and a repellent and contemptible sedimentary intimacy. The wide open spaces disappeared, and the season for wild game and for whirlwinds, for furious races between the spirits '*alla Gianni Schicchi*', for aerial flights and tumultuous clashes between opposing sides, for the diaboli-cal games and strategies of the tortured, and for the malicious tricks of

the devils, the plebian riots and heroic resentments was over; the statuesque magnanimity, the common quarrels and the whiplash word-matches, which were more suited to a gothic tavern, ended; the repertory of blasphemies, outrageous gestures, and arrogant and agonistic poses was exhausted. All movement stopped as bodies, tongues, hands and feet were squeezed and pressed in the confused crowd of the damned, already well on the road to becoming a mass of damned souls, a prelude, one might say, to a damned mass society: the Baroque infernal container was in fact designed to house eight hundred billion bodies in a space not more than four miles wide. The Baroque hell was planned with a rationality which is similar to our own, and was a forerunner of the present megalopoli, those contemporary crowded human containers and warren-like cemeteries of the living. By the end of the seventeenth century a mass hell had virtually arrived, and the Jesuits prepared for it scientifically, measuring it with an arithmetical eye which looked towards the future. The foresightedness of the sons of Saint Ignatius cannot but compel our sympathetic admiration, even though their provisions and calculations seem to anticipate the cities of the living rather than the hospices of the (wretched) dead. Their prophecy was undoubtedly correct, but with the passing of time it was completely reversed: their maps minutely outline the very visible ruins of our modern necropoli rather than the other invisible city.

The inferno–chaos of Saint Pietro Damiani, the 'harsh region', the 'land of affliction . . . of whirlwinds and darkness . . . in which there is no order . . . in which a luxuriant abundance of chains, weeping and groaning, and woes in turn afflict the impious without pity'[7] was now long past. Here, there were neither whirlwinds nor a wide variety of torments ('*alternantia mala*'), but rather a gloomy uniformity of impossible and extremely painful positions. The Venerable Bede's laughing devils had disappeared, as had those of Brother Giacomino of Verona, those ferocious predators who were unleashed to hunt the damned ('*corando como cani k'a la caça è faitai*') and who, having caught them, dragged their bodies into the cursed city with a cord around their necks and 'a string through their noses', according to the old hunting method. The bodies of the damned were then smoked in the fireplace (the mountain dwellers still use this method today for beef and pork). 'The flesh of cows', Saint Anthony of Padua observed in a sermon, 'is hung before the smoke, and is kept there until eaten. So the demons shall hang up the flesh of those who are fed on fine foods in this life before the eternal smoke, until they pass to the greater punishment of the flames'.[8]

These were the favourite dishes of those greedy, impenitent wor-shippers of the belly (*mediatorium latrinarum*) who had waited with avidity to select the best mouthfuls for their obese and dissipated bodies.

In this hyper-realistic folkloric inferno, the 'fury of the peasants' appeared to have been transferred to the gangs of wild predators from the abyss who ran riot in plebian hunts and in savage, anti-noble and anti-feudal routs; as in a tumultuous peasant '*jacquerie*', they fought with improper arms such as the tools used for working the fields, and were led by 'a large peasant from the depths of the abyss, Satan's companion thirty paces high with a club in his hand to belabour the false Christian's shoulders'. These scenarios of carnevalesque games were borrowed, one might think, from the infernal shows of the market-place in which giants wearing colossal masks brandished clubs and cudgels. This agitated, bloody and lively hell was pervaded by the smells of roasting meats or of meat hung up to smoke in the fireplace; it was a hell which had reverted to a rustic setting in which the gigantic devil–peasants seemed to reincarnate the 'hairy' satyrs of the New Testament.

The unseemly gestures of these vulgar demons of the woods, their roguish attitudes taken from the basest butcher's shop and which were aggravated by their 'great fury' and 'anger', the frenetic, convulsive movements of these irascible 'savages' let loose in a bloody hunt, like furious butchers possessed by a mania to massacre and lynch, and who, like merciless bloodhounds, hounded the man–beast, the human boar to slash its veins, to tear it to pieces, to hang it from a cord threaded through its nose, have all dissolved into a funereal im-mobility.

> And here are demons with large clubs
> Who smash his bones, shoulders and flanks . . .
>
> One devil shouts and the other replies,
> Another forges irons and another pours bronze,
> Others stoke the fire and others run around
> Making trouble for sinners night and day.
>
> From there, many large devils run into the square
> Where a crowd of miserable people have assembled,
> Each crying: 'Kill, kill, kill!
> That rascal thief and good-for-nothing cannot escape'.
>
> Others seize shovels, others rakes
> Others flaming brands and others spears and knives.
> They do not take courage from shields and helmets, nor leaders,
> Since they have axes, hoes, hayforks and hammers.[9]

This convulsive and barbaric hunt had no rules; it was both loutish, plebian, and lynch-like, tumultuous and obtusely savage:

> Some hit him on the arms, others on the legs,
> Some break his bones with clubs and bars,
> With hoes and shovels, with axes and spades,
> So that his body is covered with gaping wounds.
>
> Almost dead, the wretch throws himself on the ground
> And is tightly bound.
> They rope his neck and put a string through his nose
> And drag him through the city, beating him.

The scene was now very different. The season of the great hunts was over. The chimneys were closed. In the tomb-like immobility, there were only slimy contacts and repellent, dripping bodies, smeared with rubbish and filth. Situated diametrically opposite the fragrant Eden-like places, at an abyssal distance from balmy paradise, hell lay immersed in the stench of sewage. The 'lay brothers' of these gloomy and foul-smelling cloisters breathed an air which was far removed from those small, delightful earthly paradises, from those hermitages whose aroma of virtue – according to Pietro Damiano – refreshed the silent and contemplative inhabitants who moved between their cells and the fragrant cloisters.

> The desert is a paradise of delights where, as though varieties of fragrant colours or the gleaming flowers of spices, so it gives forth the perfumed odours of the virtues. There, if anywhere, the roses of charity blaze with fiery redness, there the lilies of chastity whiten with snowy propriety, and among them even the violets of humility are content with their lowly place and are tossed by no winds; there the myrrh of perfect mortification drips, and the incense of regular prayer drops forth without interruption.[10]

Both a hospital and a prison, the Baroque hell was completely bereft of those solaces which, however small, brought temporary relief to prisoners and patients. It was a place of insomnia and perpetual remembrance, and it had the 'narrowness', the 'darkness' and the 'stench' of a prison. In the Loyolian 'manual', *Inferno aperto al cristiano perche non v'entri*,* which proposed 'infernal punishments' 'as a subject of meditation in order to avoid them', the old 'region of Gehenna' had contracted into a small, very crowded prison which the 'Lord himself' had built in the 'lowest place in the universe . . . so that it is as far as

* 'Hell revealed to the Christian so that he does not enter in.'

possible from Heaven'. In this prison which, contrary to the calculations of his fellow Jesuit, Ercole Mattioli, the author estimated lay 4,000 rather than 3,560 miles from the earth's surface.

> although the place will be almost too large, none the less the damned will not even have those comforts which a poor prisoner has walking up and down inside his cell, or a wretched sick person has by rolling over in bed Thus, because of the multitude of the condemned this great ditch will seem narrow; and even more on account of the fire itself which will act as shackles and chains Therefore, those wretched people will not only be constricted but also immobile; for example, if a saint (wrote Saint Anselmo in his book of *Similitudini*) is so strong that if necessary he could move the whole earth, in contrast, a reprobate will be so weak that he cannot even remove a worm from his eye while it is gnawing it. Thus, this prison will have walls which are more than four thousand miles thick, namely the same distance as is between us and hell; but even if they were as thin as paper, the prisoners would be so weak that they would be incapable of breaking them down and escaping.[11]

Into this hole flowed 'all the earth's refuse' and the 'sulphur alone makes an insufferable smell by perpetually burning in tremendous quantity. And lastly, the bodies of the damned themselves will give off such a pestilential smell that a single one placed in our world . . . would be enough to infect it.'[12]

> What will that pestilential breath be like which will be given off by the cavern in which all the multitude of tormenting demons and all the bodies of the tormented are gathered, squeezed together, without air? The air itself, having been closed for a long time, and never refreshed, becomes in supportable; can you imagine that there could ever be such a sink of so much and such nauseating refuse, without any ventilation? . . . These are the magnificent Palaces which are being prepared for those who despise the poor and who push them away because of their stench.[13]

The prospect of being forced to live with the filth of the poor man in a suffocating tunnel, in a sewer of misery, was also used by this Tusco-Lombardan Jesuit, Padre Segneri's inseparable companion, to provoke an upsurge of class feeling. During the seventeenth century, when the sea of poverty rose in a suffocating and alarming fashion reaching the threshold of the *'piano nobile'* of the patrician palaces, the reaction provoked by the stench of the beggars caused a physical rather than social reaction, an instinctive rejection provoked by a conditioned reflex.

'Today you cannot stand the stink of a beggar,' warned Paolo Segneri, 'who slightly offends your nostrils when he approaches you. What do you make of this? Could you bear the stinking sewers in which you will have to feel yourself being infected, suffocated, and overcome by perpetual anguish?'[14]

The desolatory idea of spending eternity together with the dregs of the streets, heaped in a pile of foul 'door-beaters', the idea of remaining year in and year out intimately touching the flesh of 'putrid, human worms' and of 'sordid snails', of breathing their breath, of absorbing their polluted excrements through the pores of one's skin, of feeling the slobber and foam of these insect-like men, fed on revolting remains, pour over one, aroused a feeling of infinite repugnance. As in a sad dream caused by the slow distillation of dripping pituitary humours, mucus and catarrh, a loathsome excremental phantom appeared before the eyes of the noblemen. The apparition symbolized the wretched contaminators of the elements and of the social peace, the pollutors of air and water from whom all turned away in disgust, the sordid larvae of the starving who scrounged in the rubbish heaps and the fleas who fed on excrement and were carriers of pestiferous miasma and filth. There were men in the shape of stinking unclean creatures, worms, flies, rats, toads and fleas. These abominable creatures were all the more feared because they were unavoidable down there where the bodies were 'not only restricted in space, but also immobile', where the noble reprobate, overcome by a deep, sluggish cachexy would not have the strength to move a finger and would be incapable of removing 'a worm which was boring into his eye'.[15] The spectre of the city-cum-hospital, of the city which was plagued by 'the crowds, the filth and the stench of innumerable beggars day and night', the city which was overwhelmed by 'the intolerable smell of the poor, the infirm and the paupers',[16] which inhaled 'the breath and other putrid odours'[17] of the 'riff-raff',[18] the 'rotten stink of bodies which were already weakened and deformed by hunger, dirt and discomfort';[19] the nightmare of the unventilated city whose air was as polluted as that in the 'anguish of hospitals'[20] by the 'multitude of evil breaths',[21] by the oppression of the rabble and the crowded and densely packed multitude, by the rise in temperature provoked by 'so many trampled people';[22] the disgusting 'perspiration which passed from one person to another, from bodies which were neither clean nor dressed, except in filthy and foul-smelling rags',[23] reappeared in the overcrowded and overheated city—hell evoked by the preachers of the seventeenth and eighteenth centuries. In hell the 'sumptuously

nourished' rich[24] would have found the same day-to-day reality of the cities in which they had lived, the same livid human panorama, which they had avoided with such care, the same 'mendicants and the same starving persons ... dying from weakness',[25] the same 'stinking breaths of the poor peasants',[26] all of which they had tried to forget by sniffing musk, amber and zibet enclosed within their palaces or set apart in their villas.

This flaunted democratic promiscuity *post mortem* must have been more greatly feared than death itself. Physical horror and a guilty conscience made the thought of such a fate, the threat of such a foul cohabitation throughout eternity, insupportable.

Like a hospital for incurable diseases stretching over an infinite number of centuries, this hell of physical corruption, of corrupted matter and tortures to the sense of smell appeared in this world with the revolting face of a beggar scratching among the rubbish heaps, or of a wan vagrant covered with sores. It made one reflect and think with horror about the unheroic and degrading punishments of the world of the dead which cast the shadow of the overcrowded hospitals for the poor, the hell of the living, into the underworld.

> Whoever wants to understand what is meant by the strength of the rotten breath of sick persons, and in particular the smell of ulcers, sordid wounds, and of dying and cancerous parts of the body, needs only to reflect that a single man suffering from an evil ulcer, which is full of corrupted matter and blood, produces a stinking and nauseous atmosphere around his body which is so strong that it strikes whoever comes near him and breathes it; to such an extent that the persons who are not accustomed to seeing such diseases or who by nature have a weak stomach, faint. This atmosphere corrupts the surrounding air and gradually the rest of the air which fills these small rooms and the whole hospital ward is affected, thus contaminating clothing and, to some extent, the floor and walls themselves.[27]

This description was not written by a preacher involved in medical work or suffering from a 'hospital syndrome', but instead is the realistic report of a Neapolitan doctor who worked in the capital of the Bourbons during the reforming eighteenth century. The Jesuitic hell, the image of a corrupted city, had repainted, in a dramatically red hue, the fresco of the metropolis whose atmosphere was rotten and smelt like a 'skunk' or 'bilge', polluted by the presence of countless 'riff-raff' whose blood was infected and whose flesh was covered with sores.

The bleak reality of the hospital, where sweat and putrefaction,

processes which were accelerated by the atmosphere which was 'heavy and soiled by sordid exhalations',[28] infiltrated the patients' bodies, and where the 'healthy caught similar diseases if by chance they inhaled the inmates' putrid breath',[29] evoked a certain similarity to conditions in the evil house of hell.

In reality, the distance between the healthy and the sick, and between the hell of the living and that of the dead, was limited, and the differences were quantitative more than anything else.

> . . . it is necessary to add that the perspiration of the healthy, although in comparison much less corrupt, is none the less of the same nature, in other words it is apt to decay; so that between the sweat of the healthy and that of the sick there is a difference of degree rather than of kind.[30]

In this degenerate reality, the difference between a state of corruption and one of putrefaction was only a question 'of degree rather than of kind', thought Tomaso Fasano,* since, 'by definition, the nature of animal humours . . . tends to become contaminated' and the very blood 'which circulates in their veins' carries with it the 'seeds of corruption'.[31]

> The matter which we perspire and all the humours which in different forms are expelled from our bodies are putrescent by nature; in the sick, they are merely enhanced and made visible. Thus, the room in which a person sleeps, acquires such a smell during the night that when the person himself, having got out of bed and gone into another room, comes back in he is disgusted; he therefore lets the fresh, clean outside air in in order to expel the air which has been closed and contaminated by sweat. The dirt of linens which are used next to the bare skin is similar to this, and likewise handkerchiefs and table napkins which we use to dry and clean ourselves, not to mention other items. Sweat itself (and I am not speaking of that caused by high and bad fevers, but the sweat of healthy persons) is often very smelly; and yet it is not different from the matter which is imperceptibly transpired; nor can one say that it is a humour which is poured out of bodily channels and is thus already stagnant and corrupt. There are persons whose breath in its natural state has a very strong smell and whose humours are so infected that within a short time they dirty their underclothes and clothes with sweat; therefore, doctors deem that such individuals would be subject to chest pains or consumption if this infected matter were to stop being separated from the blood and expelled by means of the perspiration of the skin.

* An eighteenth-century Neapolitan physician.

Who is it who does not know that the excremental humour expelled from the nose and from the throat of a person suffering from catarrh, when the catarrh is mature, differs very little from real pus?[32]

The nightmares caused by this fetid air, which was perennially tainted and polluted, inhaled in a 'cavern full of fire' in which even the fire is 'restricted and has no outlets',[33] conjured up once again the image of a polluted and diseased city, infected by plague and dysentery, where fires burnt continuously, both in winter and in summer in the streets and in the houses: braziers which gave off bitter and pungent smells, piles of aromatic woods which were burnt with animal dung, making a deadly stench and smoke which was so violently purifying that it chased the volatile spirits and the invisible enemy, which moved malign and untouchable, through the air, away into nothingness. Even during the 'time of quarantine' the city took on an infernal air: the fires, instead of being a cleansing instrument, cloyed the sense of smell, in accordance with the strategy of an enforced and prophylactic fumigation of that ambiguous element, the atmosphere. Like in hell, the fire became gloomy, stinking and impure, and required the demoniacal forces which were innate and latent in its dual, bivalent nature.

Exactly the opposite to what Gaston Bachelard had hypothesized in abstract then occurred: 'one of the most important reasons for the increased value of fire is its power of deodorization. This is, in any case, one of the most immediate proofs of purification. Odour is a primitive, authoritative quality which imposes itself on the most hypocritical or importune presence. It truly violates our intimacy. Fire purifies everything since it suppresses all nauseating odours.'[34] Instead, thanks to the polluting flames, the city became even more nauseous: the skins and hoofs of animals, sulphur, leather, filth and dung were all burnt, together with anything that would give off bitter, sickening fumes which would serve (it was thought) to keep away the secret agents, the volatile spirits which filtered through the pores of the skin, the harmful smells which drifted unseen through the atmosphere.

As a purifier or pollutor, a redeeming power or the minister of divine anger, the fire united the most incompatible extremes in its multiple and discordant qualities. Interpreters of the occult have not failed to attribute dual meanings to this ambiguous and polyvalent element, or to throw light on the dramatic game of contrasts and opposites. Widely divergent symbolic messages were hidden in its flames: 'the holy spirit and revenge, good will and spiritual fervour, the ardour of saintliness and impatience, the light of science and jealousy, the virtue

of charity and lust, concupiscence and good will, eternal punishment, the fire of justice, temporal excellence and the tricks of the Antichrist, miserliness and tribulation'.[35]

The city-furnace represented the moderate and 'civilized' version of the 'eternal furnace' (Bede had already underlined the stench of the 'furnace of the shadows') in which the 'breath of God's anger acts as a pair of bellows which increased the strength of its blast beyond all measure'.[36]

In the 'unfortunate country', the reprobates were

> like fire, although that flame which is so intense and so broad, will not only torment us on the outside, as happens now on earth, but it will penetrate our bones, our marrow and the very inmost parts of our being . . . Every damned person will be like a heated oven, blazing hot on the inside and inside his chest; the filthy blood will boil in his veins, as will the brain in his skull, the heart in his chest, and the guts in his wretched body[37]

The 'judicious fire' (*ignis sapiens*), the industrious and learned rapist of all intimacy, the 'inexplicable fire' (*ignis inesplicabilis*), the magic assistant to its master, it burnt flesh without consuming it. The 'tartarean flames', which were not distributed 'for man's benefit', following Prometheus's example, but fanned by 'the revenge of the wicked' and lighting 'sulphurous and tar-like materials', will demolish but at the same time embalm the flesh of the damned, and, like salt, will prevent its decay. 'It will burn without consuming, and yet Christ compared it to salt, "For everyone will be salted with fire" (Mark 9: 49), since by tormenting with unseen heat, like a flame, it prevents the reprobates from becoming corrupted, like salt.'[38]

In the morphology of the hell–tomb in which fire is the absolute master, the confines of space, although restricted, were always moving, now broadening, now shrinking, like modules.

> Under the lash of the immortal flame, infinity learns to enclose itself within limits and an indivisible centre becomes capable of harbouring the unending circumference of an eternity of torment.[39]

It was a limited infinity, a dilated and fiery point which miniaturized the immensity of the tomb, an enclosed immensity in an 'indivisible centre', a point which was enlarged until it became an 'unending circumference' inside which eternity was imprisoned.

Under the influence of the new sciences, the paradox of the infinity of the finite developed during the seventeenth century. This was a

controlled delirium in which geometry, astronomy and mathematics sparked off the fascinating game of new worlds, new infinities, and of dilated or contracted spaces. These spatial gyrations affected the dark and limited perimeter of the 'kingdom of insomnia'; in fact, the century which gave a feverish movement to form, shattering the Ptolemaic cosmos and nourishing itself with dreams of infinity, nevertheless built a Jesuitic hell of very finite size. But the tantalization of movement resurfaced and as a result the place of punishment was depicted as being flagellated by endless waves of fire, and as a rough sea in continual agitation, shaken by furious tempests like in certain contemporary pictures.

The Genovese Romolo Marchelli (1610–88), General of the Barnabite Order, a master of the sacred Baroque style, painted an infernal scenario which was wild and turbulent, and very different to the immobile country of the Jesuit preachers.

A Sea of fire rises from the depths which has no shore which is not watered by the fabulous Phlegethon or which is not shaken by perpetual tempests; the Furies swim on its waves, which foam in fury, and carry new torments everywhere, and Death freeboots in all weathers to lie in wait for human lives, and keeps all its most painful flags, except for the murderous sickle, unfurled.

The fire lives without food, and although it is voracious for torment it does not feed on the pain of others, but irritated by such a long abstinence its rage increases; and since it cannot satisfy its hunger with a meal, which it could bite with its teeth, it becomes an even more famished torturer of the torments of others, like the most ferociously cruel tiger. Ice and fire are joined in a marriage which death cannot dissolve; and cherishing each other reciprocally with merciless faith, they look forward with capricious lust to the birth of punishments and torments which will inherit the characteristics of both maternal breasts and become ardours which freeze and frosts which burn. This is hell.[40]

Since the time of the founding Fathers, order was unknown in the kingdom of chaos, of contradiction, of reversal. '*Nullus ordo*' governed the abyss according to Gregory the Great – 'not because God does not order the torments according to the deserts of individuals, but because in the matter of torments the correct characteristics of things are not preserved'.[41] In the seventeenth century the kingdom of disorder became the dominion of opposites, of antitheses, of oxymorons: every law of nature was violated, the properties of every object ('*rerum qualitas*') were altered, each geometrical rule was overturned.

This place, which by natural law must be the same as the above narrow prison, keeps innumerable prisoners; this narrow seraglio encloses more wild beasts than all the forests; this small furnace harbours the largest fires; by penetrating the bodies, the part restricts the whole, the circumference is found in the centre, long lines are drawn within a point, any surface area fits onto a line and horribly abyssal depths can be seen inside every surface.[42]

As if drawn by a mad Euclid, this frenzied geometry was in perfect harmony with the experimental acrobatics of the most audacious Baroque architecture.

The medieval morphology of the Country of Fear, of the 'formidable kingdom' of Seneca's descriptions was broken up by the hammering of the new builders whose orderly deliriums threw the topography of the old criminal chambers of horror into disorder. The Dantesque structure was terribly remote, and it was as if it had never been constructed or described in minute detail. Nothing remained of that admirable order. His model became as obsolete and remote as if it had been drawn by a solitary Euclid, or an abstracted Saint Thomas who was so absent-minded as to mislay the plans. There was no trace left of the circles, the cliffs, the plains, the heaths, the swamps, the rivers, the valleys, the glaciers, the towers, the 'houses of prayer', the arches, the castles or the cities. The whole of the 'different country' had dissolved into an indecipherable, primitive space, almost more abstract than geometrical, into a fluid space with neither centre nor periphery, in which the centre could become periphery and where 'central' and 'peripheral' acted as interchangeable variables: 'the part restricts the whole, the circumference is found in the centre, long lines are drawn within a point, any surface area fits on to a line and horribly abyssal depths can be seen inside every surface'. The road leading to the non-place was now open.

In this polymorphous and cross-disciplinary 'school of torment' the fire became the sole polyvalent torturer. In the 'zealous fire', as Tertullian wrote, the flames competed in inventing all forms of torture and in substituting all other punishments by incorporating their elements. The 'inexplicable fire' was transformed into the great rascally expert in all forms of torture and was learned in every discipline of pain. The Tartarean Proteus

alternates terrible forms and monstrous appearances with ugly metamorphoses. So that hearing is not overcome by the torment, he conducts frightening concerts with thousands of shrieks of wild beasts and monstrous discords. So that the sense of smell is not vanquished, he

83

evaporates all the fetors of the smelliest sewers bound together in a single stench. So that the sense of taste is not overcome, he distills the most bitter quintessences of wormwood, gall, myrrh and poisons on their tongues . . .

Thus, not content with having learnt to torture the spirits so ingeniously, and to flame without light, to live without food, to burn without making ash, to occupy a small space and still be great . . . and having made its fellow tormenters into its rivals, the fire competes with them in tormenting.[43]

An alchemist God distilled a 'quintessence of heat' into that fire, and condensed an immense, savage energy into the flames: '*In spiritu ardoris*', as Isaiah had prophesized. Having transformed himself into a cunning magician and a prodigious distiller, God distilled all the most subtle cruelties 'in the stills of divine anger'. The 'distiller of Justice', the fire 'worked beyond the genius, nature and power of fire', '*supra virtutem ignis*'.

In the opinion of the most severe theologians, it is a great wonder that a single fire can eminently contain the cold of ice, the stings of thorns and metal, the gall of vipers, the poison of snakes, the cruelty of all wild beasts, the wickedness of all the elements and stars, thus confirming Saint Girolamo's words, 'in hell the sinner will feel all torments in a single fire'. An even greater wonder however, *et supra virtutem ignis*, is that that fire, despite being composed of a single element, knows how to distinguish between sinners and to torment most the person who sinned most; for this reason Tertullian called it the 'judicious fire', and Eusebio Emisseno 'the arbitrating fire' because since it had to adapt the size and diversity of its tortures to the size and diversity of the guilt ('therefore there are as many diverse tortures as there are diverse sins', as Augustine had observed), the fire almost seemed to be gifted with the power of reasoning and full knowledge so as to differentiate between sinners and make the harshness of its severity more or less felt. But the greatest wonder of that working fire, *supra virtutem ignis*, was the fact that it was not content only to wound the bodies . . . but in all its materiality, it would glorify in penetrating incorruptible spirits . . . and encroach upon the spiritual souls of the damned.[44]

The prodigious fire, which was truly 'inexplicable', had astounded Saint Doroteo and many other saints after him.

Now completely ignored by theologians, moralists and preachers, the Dantesque model increasingly appeared to have been a solitary cathedral in the desert, which had neither past nor future and was far from the patristic tradition and extraneous to theological debate.

While developing the scriptural outline (*'Magnus furor Domini stillavit super eos'*), in an epoch which was characterized by stills and 'founderies', by stills and scented perfumes, the seventeenth century construed a surprising image of God as the distiller of subtle ferocities, inventor of the perfect quintessence of pain extracted from the still of divine anger. The taste of the century revealed its unseen presence in the revision of the library of poisons and pains, the statutes, procedures and recipe books of hell. An alchemical vocabulary and Paracelsian terminology were combined to form a new Tartarean lexicon.

'But among so many pains and torments', the Jesuit Padre Ercole Mattioli wondered, 'was some comfort never introduced or even intermingled with the tortures down there? In what the followers of Paracelsus called the "damned earth", namely the filth which remains as a residue in the still once it had been burnt over the chemical burners, a vein of precious metal is sometimes found which can then be turned into ingots; and in the residue, in which the blackest soot ever was produced, I have seen the most beautiful colours, such as Lapis Lazuli, light blue and other different hues. And might there not be some joyful metal in that country which is truly of the damned with which one could make gold ingots to lead those wretched condemned persons to the Elysian Fields of some pleasure? And why do those miserable souls not know how to extract the colours of some gratifying object with the mastery of their thoughts and loves, while their bodily senses, rather than the residue, undergo a universal martyrdom? In discussing this question theologians concord in the opinion that the condemned are denied any form of joy . . .[45]

The art of druggists and apothecaries contributed its distillations and quintessences to the mental crucible of the men of God in order to perfect the new map of the alchemist's hell using a 'distiller's cunning'.

In order to torment the damned even more, God has become a distiller and has encapsulated the most ravenous pains of hunger, the most scorching thirst, the most freezing colds and the most burning ardours inside those distillations of hell; he has also encapsulated the torments of those who were slaughtered with knives, strangled by a noose, incinerated by flames and torn to pieces by wild animals; he has included the pains of those whose flesh was eaten alive by worms, devoured by serpents, slashed by razors and lacerated by combs; the arrows of Sebastian, the grid of Lorenzo, the towers of Eustachio, the lions of Ignazio; the sliced breasts and shattered bones, disjointed joints and dismembered limbs; all the most acute pains, all the most violent

anguishes, all the strongest pangs, all the longest agonies and all the slowest, the most laboured, and the most atrocious deaths.

And distilling all these ingredients together, down there he produces a distillate of this nature; and every drop of this quintessence contains all the pains in a refined and distilled form, so that every flame, coal, and even every spark of that fire encapsulates within it all the torments distilled into a single torment. As Saint Girolamo said, '*In uno igne omnia supplicia sentiunt in Inferno peccatores*'.[46]

In this damned 'workshop', in this underground laboratory, where – as in a depraved pharmacy – revolting liquids are distilled, the wretched inmates torture and slash one another in crowded confusion. The 'presence of the damned', as the Jesuit Father Giovan Pietro Pinamonti said, will be an additional torture since 'whereas in Heaven the blessed are filled with charity and love their neighbours like themselves, in hell all are filled with hatred and with an enmity which all eternity cannot reconcile, they will wish their neighbour dead. Every law will be overturned, all reason disbanded, and no blood or family relationships, no love for one's country, or other clause or motive can mitigate such desperate anger.'[47] As in a cursed ship, the hateful 'enemy crew' will attack each other 'not merely for a few hours each night, but during a never-ending night'.[48] Thus, in a very modern way, hell was embodied in the other person.

This active participation of the damned, who themselves became the protagonists of punishment, led inevitably to the progressive eviction of the devils, the outside tormentors, the contracted torturers. Their presence became increasingly rare and of secondary importance as the evolution of hell moved towards the use of inner punishment, towards the 'mental prison of the spirit'.[49] This was yet another step towards the modernization of the abyss. Even the infernal backdrops, the sumptuous scenarios taken from the dramatic melodramas which the Dantesque tradition had erected in the subterranean theatre of horror, tended to fade away, as in modern drama, leaving a flat, bare and empty scene, a non-descript space which was polyvalent and could be enlarged or diminished at will, as if it were made of plasticine or some other inert, synthetic, polymorphous material.

The absolute primacy of fire, which embodied all the world's torments and evil, swept away all those backcloths which the Dantesque production had majestically erected and placed everywhere. This crowded hell was nude, uniform in its deformity, and desolate; built in a vacuum, its doors and openings were hermetically sealed and it provoked a sepulchral sense of suffocation. The social

claustrophobia of the seventeenth century was reflected in this tomb-like space in whose larval and unformed morphology the damned themselves played the role of the devils. They became the new torturing devils, the brutal executioners of their neighbours and 'dear ones'. As in a vicious circle, in this collective subterranean slaughter-house, which was in continuous evolution, the most savage persecutors of the new martyrs were the damned themselves, devoured by an insatiably evil fever of cruelty.

In that multitude of wretched persons the miseries of one become the torments of the others; as the wood increases with the size of the fire, so the ardour increases; and as a weight is weighted down by other weights, so they all groan under burdens which are not their own; pains come from every direction, and everyone suffers from the pains of others and reciprocally communicate their distress, and all hearts suffer terrible agonies from the torments of all. In that slaughter, '*Unus clamabit ad alium*', Saint Bernardo said, '*percute, dilacera, interfice.*' Every-one torments his neighbour, sons torture their fathers, daughters tear their mothers, brothers rip their sisters to pieces, wives are lacerated by husbands, masters are tortured with pincers by their servants, princes are put on the wheel by their subjects and lovers are cruelly dismem-bered by their loved ones. Paris is filled with hate and lights a great fire to that Helen who lit such a fire of love in him. Infuriated with Mark Anthony, Cleopatra hurls vipers at him in hatred, the same snakes from which she sought poison and death. Intoxicated with rage, Lucrezia pulls out the dagger from her pierced breast, and plunges it into the bowels of Tarquinius. Acab and Jezebel, both already torn to pieces by the dogs, now become bitch and dog to tear each other to pieces. Herod is seated with his daughter Herodiade at a new banquet; she cuts his head off while her feet, whose dancing steps led an innocent head to be cut off, are bitten and devoured. Everyone is shaking, furious, frenzied with mutual hate, persecution, and reciprocal cruelty; between them they excite the activity of the fire and the atrocity of the torments.[50]

Scenes of unprecedented invention from the seventeenth-century 'gallery of images' covered the vile walls of the evil palace; and having subverted the traditional themes, the protagonists ran riot in new and unprecedented acts of cruelty. Devils, furies and harpies now belonged to the archaeology of hell: in the new life–prison it was the damned who massacred each other by tearing and dismembering each other. In the old Dantesque hell the devils, monsters and bitches mauled and skinned the reprobates. But now, in a bloody ballet, it was the damned who, like ravenous bitches, tore one another to pieces.

At the height of the Counter-Reformation a small window began to

open, throwing a feeble light on the dark areas of the Ego, on the uncharted regions which surrounded the latent horrors of the unconscious. In the centre of metamorphoses and subversion, in this 'inverted place' (*locus inversus*), both social upheaval and the repressed individual exploded savagely in a bloody carneval parade, in a threatening feast of violence. Down there in the heart of the earth, in the black centre of the abyss, cruel rites of private violence and social desecration were performed. Masters were seized with pincers by their servants, princes were tortured on the wheel by their subjects, wives massacred their husbands, sons tortured their fathers, daughters hacked their mothers to pieces, brothers ripped open their sisters. Down there, in that unhappy country the frustrations and insults which had accumulated and been suppressed in the world, in the pleasant country of the living, exploded in all their savagery having been repressed by laws, norms, conventions, institutions, regulations, agreements and compromises for too long.

As in the best tradition of the upside-down world, even the animals rebelled against whoever had vilely abused them to satisfy their foul appetites. Pheasants, partridges and noble game, which was habitually sacrificed to 'the most loathsome concupiscence', to the 'lechery and intemperance' of gluttons, like poor creatures at 'the service of sinners', longed for the day when, liberated from the bonds of the law and freed from 'oppression and continual violence', they could at long last vent their anger on their persecutors. When the latter tumbled into the abyss they were 'no longer served by these creatures, but rather tormented, crucified and lacerated by them for all eternity'.[51] This is a chapter of '*De mortibus persecutorum*' which Tertullian did not have time to write.

In the 'metropolis of pain' there was also room for urban dramas, for the difficulties and torments of domestic and matrimonial life. Wives habitually tore their husbands to pieces. One need only delve briefly into the hell which was restructured and reconverted by the Jesuit culture to find the traces of wifely dramas and to uncover officially ignored secrets. The post-Tridentine emphasis on the sacrament of marriage, the cloying and sickly-sweet moralism regarding the Christian duties which formed part of the conjugal state, appeared in a different guise in the light of the sulphurean truths of hell, where repressed hatreds were released and long slaveries were finally broken and revenged. As for the animals, so the hour of summary justice struck for married women.

It is significant that Padre Pinamonti, hoping to give his readers an idea of the punishments which occurred in the company of the damned

re-proposed the 'home' (the *topos*) of the tormented domestic shrew, the husband's scourge, which Francisco de Quevedo considered to be an authentic 'portable hell':

> The Holy Spirit tells us that it is better to live in a desert with wild animals than with an angry and furious woman (*'melius est habitare in terra deserta, quam cum muliere rixosa et iracunda'*, Prov. 21). A poor husband who hears only shouts and complaints at home, is unable to rest in the evening, and is tempted to leave a thousand times. Judge for yourselves what it must be like to stay in the company of the damned for ever . . .[52]

It is surprising that this comparatively inexplicit description of domestic hell, of the dramatic matrimonial game and of conjugal unhappiness, was used as an example to illustrate the horrifying and insupportable torments of an eternal cohabitation with a hateful, foul-smelling 'neighbour' who reeked of iniquity, hate, physical vileness and moral perversity. Likewise, it is surprising that *'mésalliance'* and a woman's bad temper were put forward as a symbol of hell and of its absolute insupportableness.

This hell, which was measured against the norm of a tormented daily existence and reduced to the modest dimensions of a drama of domestic incompatibility, revealed the possibility of a realistic and modern production of the conjugal drama of a shared life, much to the intimate satisfaction of the secular and regular clergy who were protected and immunized by their holy orders.

On the other hand, even the Company of Jesus (like all the regular orders) must have experienced the undocumented suffering among the 'companions' caused by communal living. The 'company of the damned' was not the only one to be traditionally buried in dark places. The cloistered hell represented an alarming territory which had still to be explored (with the exception of certain works which emerged from the feminine Venetian literature of the seventeenth century, such as the clandestine *'Inferno monacale'* (The Hell of Nuns) by Sister Arcangela Tarabotti, who died in 1652). It must have been an irresistible temptation not only to plunge into the dark regions of the 'monasteries' and 'colleges', and into the cruel 'sports grounds' (as they were commonly known) in which bloody disciplinary exercises were performed and sophisticated and cruelly 'austere devices' were used, but rather to penetrate the inner labyrinths, to operate the devices for dismembering the ego, and to enter the deserts of psychic automatisms and conditioning for death.

6

The Laughing God

Even at the end of the seventeenth century, the old play was still put on in the wings of this hell which had been reduced to a domestic tragedy; in it, as both actors and spectators, the family of the blessed and the angelic choirs witnessed the slaughter and massacre of the sinners with delight. It was an ancient drama, first invented by Tertullian, and produced with success over many centuries. However, by the late seventeenth century the sadistic variations had reached a level of vileness which our delicate sensitivity and our charitable post-Council piety found insupportable.

The gloomy fantasies of the Discalced Augustinian hermit Angelo Maria da San Filippo (then Angelo Maria Quadrio, from Como or Valtellina, 1670–1703) were not a solitary monologue or a perverse and barely audible reverie, but the thundering voice of a public preacher which was acclaimed by an intelligent audience.

> The Angelic Hierarchies are seated in the blessed consistory. They hear the grinding of teeth, they know the torments of those flames, and shaking already forms part of their blessedness. 'Do not hesitate,' God said, 'followers of my glory: four young men who have been immersed in carnality will satisfy my justice. You must wait in order to enjoy . . .'[1]

The words which came from God's mouth are supposedly those said by cruel Silla. This was the first time that, to our knowledge, the voice of the Omnipotent was reproduced by a pagan writer, Seneca, and shortly later, by Tacitus.

Likewise, the saints were modelled on those Roman senators who witnessed the massacre of thousands of soldiers torn to pieces at Silla's

orders, whose cruel, mocking words were then attributed to the Omnipotent.

> The screams of the seven thousand soldiers killed by Silla filled the theatre. The senators were already whispering at the sound of such pitiful convoys, when motioning for silence, Silla said, 'You must wait for your enjoyment, Senators. These men are four seditious young men whom I have ordered to be slain. '*Hoc agamus,*' he said, '*Patres Conscripti, pauculi quidam seditiosi meo iussu interficiunt.*' You must wait for your enjoyment, these are four wretched men who have been tortured on my orders...[2]

The 'mouth of the great Lord who laughs' at the slaughter of the damned is like that of old Jehovah whose thirst was assuaged by sacrificial blood, like the sun—lion of the Egyptian mysteries whose jaws were wide open, and like uranic Janus, the god of darkness and light, the god of creative work and destructive fury, who was ironically re-baptized 'Saviour'.

> '*Dominus irridebit eos.* Ah, what intolerable pangs! I sinned through too much belief,' exclaimed the Discalced hermit, 'when I thought that the torments of these wretched condemned persons consisted in seeing the angry face of God Almighty, but I then realized that it was more bitter to see the Lord's mouth laughing. A spell which is redeemed by all Christ's blood suffers in agony in the furnace of the flames, and not satisfied to remain idle, the Omnipotent, without helping it, endeavours to deride it... How much less the mouth of their eternal Judge would torment them with more rivers of fire than with the joke of a laugh. Ottone was called barbarous since he was not satisfied by the sight of Pisone dead, unless he was able to delight himself by gazing at the bleeding wretch's head. Justice has ascended to God. He does not stop watching with pleasure the wretches whom he has chased into the fire suffer from their torments, and while gazing at them he laughs. *Deus irridebit eos.*'[3]

'From his throne in the company of the saints Jehovah laughs and mocks' the tormented and 'expresses his enjoyment by clapping his hands'; he appeared to be more cheerful and satisfied than gloomy Herod who, having summoned the other despots 'to surround him while he dominates them' from his throne, in a scene of oriental splendour,

> ... Seated on his throne, with a dark and bloodless brow,
> He glances thrice round at the assembled crowd,

Before raising his blood-shot eyes to heaven
And then staring immobile at the floor
In such an attitude that at the same time he both threats and
 pines,
Mourning expressed within disdain.
Indeed, he does not cry because his anger is such that,
Like the wind to rain, it stifles tears.[4]

Perhaps even Herod would have felt uneasy in a 'consistory' of this type. In fact, the bloodthirsty tetrarch did not laugh while he planned his memorable slaughter.

This '*jena ridens*' was a strange divinity, and it was a strange saintliness which was evoked by the Augustinian Angelo Maria Quadrio, who, among other things, was a lecturer and professor, an academic and a man of letters, even if, according to the obscure and anonymous words of the preface to his Lenten sermon, the 'rigours of a reformed institute torment his otherwise lively mind'.[5] None the less, he was a man of considerable repute and – so it would seem – was much appreciated when he appeared 'in one of the most important pulpits in Milan and had the good fortune not to offend the good taste of his most experienced listeners'.[6] Following this, he preached in Venice and, even around the Lagoon, he found that 'the most intelligent persons were very kind to me'.[7] His imagination was therefore not a solitary or immoderate example since his Christian audiences accepted and (apparently) approved of sermons of this kind. If, as is not at all improbable, L. A. Muratori, who was two years younger, heard his voice he would have pulled a wry face (at that time the future archivist of the Duke of Modena was working in the Ambrosian Library). Who knows what the future parish priest of Santa Maria della Pomposa would have thought of this direct descendant of Tertullian and of his 'good taste', which was appreciated by the 'most experienced listeners', when a few years later in his *Riflessioni* he called Tertullian 'a fanatic' and made ironic allusions to the bad taste and to the 'noise made by the sacred orators', many of whom 'having transformed the pulpit into a comedian's stage, fearlessly described the slaughter of the reprobates with cries and gestures'.[8]

None the less, Christian society accepted a heavenly emperor and a court of the blessed which those in the West usually attributed to the barbarities of eastern autocrats and sultans, namely a threatening God who was an 'executioner' and an empyrean which was insensible to mercy.

But if no one listens to them with sympathy, there are those who listen in order to make fun of them. *Dominus irridebit eos.* Take note, Your Lordships, that this is a reflection worthy of your great spirits. He who has such enamoured bowels, takes delight in their sufferings and from his divine throne, in the company of the saints, he laughs at and mocks them. *Dominus subsanabit eos.* As a sign of his pleasure, he claps his hands.[9]

Biblical tradition and the sources of the Old Testament (which were thought to be true) were reinvented and reinforced, with evident satisfaction, by cruel insertions taken from Seneca and Tacitus, thus mixing a pagan ruthlessness with Jewish terribleness to obtain a sadistic hallucination which was, however, perfectly orthodox: the Paduan inquisitors who gave their 'approval' found that 'there was nothing contrary to the Holy Catholic Faith . . . and good custom' in the sermons of the Augustinian preacher. It would have been 'metaphysics of the Devil' to use a merciful and Origenist argument to separate divine goodness and clemency from justice.

Oh, what metaphysics of the Devil is it that teaches us to leave goodness out of justice in order to release fear and exempt sin. Every day we see wanton persons butchered in adulterous beds; parasites who breathe out their souls in glasses; Ganymedes, musky with the amber of lavatories, sleeping the sleep of the dead between dances and struck down by God's anger in the midst of the joy. Who sharpens these daggers? Who orders such immediate apoplexies? The good God or the just God? Now, who stipulated the deed which obliged God always to use the finer points of clemency when dealing with you?[10]

The Catholic orthodoxy could not but approve of his lucid, rational, although repugnant, theological argument.

If God were to look at those reprobates with a displeased eye, it might be hoped that, so as not to cause himself eternal regret, he might let a drop of his infinite mercy fall and put out that vast fire; but since the torture of the condemned souls forms part of the sovereign happiness, it is not possible to hope for mercy unless one believes that God wishes to deprive himself of a part of his glory for all eternity and reduce the beatitude which he receives from their suffering by half.[11]

This Neronian God was a frequent topic in seventeenth-century sermons. Much more illustrious voices than that of the obscure Augustinian friar from Lombardy had illustrated the perfect ruthless-

ness of the Canaanite idol who continually thirsted after human sacrifice. The 'wicked will always burn in the fire, and will never do anything but burn there, a great heap of victims, packed tightly together, piled and heaped on top of one another, an unending sacrifice to divine justice: the smoke of their torments will rise for centuries without end'.[12]

The face of the heavenly Nero was silhouetted against this apocalyptic background and it grimaced with satisfaction at the spectacle of the fire which devoured the wicked in eternity.

> And yet when they raise their eyes and turn to the great God who lit the fire, they see that He (should I say it?), they see that He, who now appears (depending on their feelings) like Nero to them, not because of His injustice but because of His severity, not only does not wish to console them, or help them, or pity them, but what is more 'He claps his hands together', and with incredible pleasure, He laughs at them. Imagine into what a frenzy they are driven, and into what a rage! We are burning and God laughs? We are burning and God laughs? Oh, most cruel God! Why do you not fulminate us with all your lightnings instead of insulting us with your laughter? . . . Why does hell not have deep vortexes into which we could flee from the face of a God who laughs? We let ourselves be deluded by the man who told us that our greatest torment would have been the sight of God's scornful face. God's laughing face, he should have said, God's laughing face . . .[13]

Enraptured, Paolo Segneri wrote in his *Cristiano istruito* (The Educated Christian) of the chemist of the 'perfect science', the master of the 'wise fire', 'judicious and reasonable', and of the 'liquidating flames' which scorch the bones after having melted the flesh as if it were 'bronze' and use 'tremendous sulphur', who would have staged a great spectacle of 'fireworks' which would have lit the darkness of hell with the flaming bodies of the damned: 'as Saint Tommaso wrote, "they will be like so many stars imprisoned in a sky of fire".' The Omnipotent would thus have offered his saints in paradise a glimpse of this irresistible beauty, 'a more blessed and beautiful spectacle than the night sky now offers with so many lights'. Perhaps the English unbeliever whom Keith Thomas described was referring to phantasmagoria of this nature when in 1616 he said that, 'the Holy Spirit put on theatrical performances'.

These cruel fantasies, reminiscent of Seneca's later works, were often to be found in the preachers' amphitheatre-cum-oratory and the

public listened to them without showing any particular sign of anxiety, immunized by the terrifying image of divine justice which was reflected in the equally criminal, bloody and violent practice on earth. Contrary to some medieval examples and in particular to the Franciscan model, 'modern' Christianity was enclosed in a dense fog of anti-Christian and anti-evangelical excesses. To take one case out of a thousand, the faithful in Naples could listen to a despicable joke, told by a well-known holy orator: 'If you make fun of Christ, Christ makes fun of you'.[14] For many years the mass of the faithful had become accustomed to hearing sermons which were based on images of Christ which dripped with a bloody and atrocious materiality (flagellations, wounds, spiritual insults and lacerations of the flesh); moreover, they were underlined by holy festivals which, like the celebration of Corpus Domini, often triggered off uncontrollable explosions of violence. The tragic feasts of the divine flesh, the mass itself which celebrated the Sacrifice on the altar (*'lieu d'extrapolation de la violence sociale, tant du côté du sacrifiant que du côté du sacrifié – le Christ – victime dont la messe reproduisait la passion expiatoire*'[15]), the Passion play, the meditation on the Holy Sacrament, the practice of Communion, the Incarnation and the final slaughter, and later the 'new' devotion towards the Sacred Heart, all led to the cruel and palpitating heart of the faith, to the terrifying but consoling 'Mystery of the Body and Blood of Christ'.

These images of the violated and martyred holy flesh, which conveyed a sense of 'Christ's humanity' with vibrating intensity, penetrated the innermost levels of the believers. The very popular and extremely emotive feast of Corpus Domini, 'consecrated to honour the divine flesh', represented the essence and public depositary of a cult which had been deprived of divine substance.

Perhaps not everyone thinks about it, but it is evident that the true and particular object of this Feast is the flesh of Jesus Christ, both because the Church openly speaks about it and because on this day the Church professes to celebrate the Mysteries of the Body and Blood with the divine office of the day. From this one can infer that this solemn occasion was not instituted to honour the person of Jesus Christ, but rather His flesh, His body and His blood, since neither the soul, nor the divinity, nor the person of Christ are the formal objects of this Feast day because they are only indirectly involved, as one might say, by concurrence; but the direct and immediate object of the Feast is the most holy flesh of Jesus in the Sacrament. In truth, it was very fitting that God the rewarder should wish His adored Church to have His holy flesh given the torments and insults that He had suffered for love of the Church.[16]

Accustomed to thinking of God's 'humanity' in terms of blood and flesh (namely the sores, the feet, and the pierced hands and sides), popular piety listened with attentive wonder to the extraordinary stories illustrating extravagant scenes from the final resurrection in which the flesh of the elect, regenerated by a new and prodigious rebirth, flew up into the mystical rose. Re-made and re-modelled without the detestable but indispensable intervention of the corrupt sperm and the abominable womb, the human flesh, made out of 'the flour of the ashes and the liquid of putrefaction', was re-mixed using neither yeast nor oven to produce a new, beautiful and crisp body, which was perfect both inside and out, like an exquisitely cooked biscuit. Like inconsumable bread, the human body would now remain fresh for all eternity.

> When at the beginning of the second (act) the imperious voice of Christ the Judge thunders to the booming of trumpets, '*Surgite mortui, venite ad Iudicium*'. The dead, the dead, all of you, all of you come to Judgement. And to the sound of this divine voice, within the dark cavities of the tombs '*in momento, in ictu oculi*', no sooner said than done, in the blinking of an eye, all the souls descend from Heaven and emerge from Hell. And each soul will find laid out before him by the Angels the flour of his ashes and the liquid of his putrefaction, and will see the material of his body taking shape; and despite the lack of the yeast of seminal powers, without the oven of the maternal womb and without the fire of natural warmth, it will in some way assume the right shape and cooking time both for the crumb of the flesh and the marrow, for the crust of the skin and the membranes, and for the biscuit of the cartilage and bone: thus they will resurrect in the same form in which they lived.[17]

In order to be allowed to sit next to He who is Most Perfect, the immortal body underwent a delicate cleaning process, a cosmetic treatment which eliminated every ugly feature and every imperfection. In order to contemplate, to listen, to smell, to taste and to touch the Inexpressible, all the senses would be heightened and exalted in the definitive restoration of the Great Day to the point at which they could withstand contact with the Absolute. That ineffable absolute from which emanated

> a particular light which is superior to every other and which is invisible to human eye; a particular voice which is superior to every other and which cannot be heard by human ear; a particular smell which is superior to all others and which cannot reach the human nostril; a particular sweetness which is superior to all others and which cannot be

tasted by man; and a particular grasp which is superior to all others and to which man's touch will never arrive.[18]

The House of the Father was the perfect mirror image of the House of the Dead, where all the senses, instead of being sublimated, were insulted and negated. In fact, in hell, as the 'Ordinary Preacher of the Most Christian King Louis XIV' underlined,

the sight will be offended by ghosts and frightening phantoms, the sense of hearing will be overcome by desperate cries and horrible curses; the sense of smell will be outraged by stinking vapours and insupportable fetor; the palate will be beset by the most bitter sauces and the tongue by irremediable poisons; and the sense of touch, which is the only one of all the senses which spreads through the whole body, will feel itself tormented by innumerable tortures, the least of which would most certainly kill the man, if he could be killed.[19]

Even the comforters of the dying, those specialists of Christian charity and technicians of the 'passage' from life to death, tried to make the final agony of death, 'the last of the terrors', less horrifying, comforting the dying with the hope of being able to reach 'the eternal good, the infinite good, which was immeasurable in time and unrestricted by boundaries'.[20] In the eternal good the delights of the senses would be unending and inexpressible.

How many variations of scene for the eyes? How many distillations of spring for the sense of smell? For the sense of touch, how many flattering softnesses? For the palate, how many exquisite tastes? For the ears, how many delightful harmonies of sound and song?[21]

The supreme source of life, the Omnipotent, the 'sum of all sweetness' and 'incomprehensible light', was felt, desired and invoked as the dispenser of the complete life, which although it exalted the soul, could also be embraced, possessed, touched and tasted with the vehement fullness of all the senses.

'Oh, my invisible light,' Saint Augustine prayed, 'let me come within your sight. Give me a new sense of smell, oh most pleasant odour of life, which will run with great haste behind the smell of your most precious sweetness. Correct my taste and let it taste, know and perceive how great is your sweetness, oh my Lord, that sweetness, I say, which you have reserved only for those who are full of your holy love.'[22]

97

In this elect and reserved place a new sence of smell, a new sight, a new touch and a new taste would be developed on the day when the new, fresh-smelling loaves, which would remain crisp for all future centuries, come out of the oven to inhale the 'sweetest scent of life' in the perfection of the flesh. It was no wonder that the bodies of the lame and the hunchbacked would be straightened before being raised to the heights, and that their hair would become soft and delicate instead of rough; likewise, the women's crooked mouths and squinting eyes would be permanently and definitively remoulded. The woman who was predestined to enjoy the delights of heaven 'will rise up again with a mouth of coral and sugar ... beautiful and wonderfully lovable'.

The redeemed will be beautiful and the damned ugly, for all eternity. The Capuchin Father from Como, Emanuele Orchi, who was a fellow-countryman of Quadrio, produced a number of variations on the Augustinian theme of the perfection of the bodies of the elect by creating his own little galley or infernal wax museum.

The theologians and their Father, Saint Augustine, say here that at the resurrection of the elect, they will resurrect with no defect or bodily deformity, which they might have had in this life. *'Resurgent ergo Sanctorum corpora sine ullo vitio, sine ulla deformitate.'* But on the contrary, when the reprobates resurrect, they will rise again with the same defects and bodily ills with which they died, as, from the same Saint, Saint Bonaventura concluded when he said that, *'nulla debet esse quaestio de pulchritudine, ubi est certitudo de damnatione'*.

And what beautiful and strange metamorphoses will be seen coming out on to the stage. If that woman, who lived in a retiring and modest fashion, in this life had a small defect, like a crooked mouth or a squinting eye, then on the day of the resurrection in glory she will rise again with a mouth like coral and sugar, with a brilliant and shining eye, all beauty and lovableness and wonder; but the woman who in a daring and vain fashion dabbled in luxury and intrigues, and in this life covered the ugliness of her face and hair with perfumes and other ornaments and false hair, then she will rise again in hell and have a coarse skin, a bald head, a discoloured face, like an extraordinarily dried, stinking deformed and abominable mummy.

If that youth who lived honestly and soberly in this life, had dull hair or was hunchback or clubfooted, then resurrecting in paradise he would rise again with a well-groomed and attractive head of hair, he would stand firmly on both feet, have square shoulders, and be well-disposed and wonderfully kind. But on the contrary, the sensuous youth who was covered in sores under his clothes, and who hid his syphilitic sores and pus under silken and golden clothes, on the day of resurrection in hell will rise again completely nude, showing the disgusting scars of that

98

revolting disease to the horrified wonder of all. And how many times does one discover that what was sold as the whitest ivory, is nothing but smoked wickerwork? How many birds which appear to be bizzarre parrots, when plucked are nothing but featherless owls? How many who pretend to be Medoro, when their stockings fall down, reveal thighs like monkeys or even like Brunello? That second act will follow after midnight . . .[23]

7

From the Heart of the Earth to the Sun

These descriptions of impossible revenge and of inhuman delight in the complete destruction of the sinner were indissolubly linked to the place of punishment, to the 'universal prison which incorporates all forms of torture, to the cruel earth, which is full of every form of misery, a place of fear and tumult where all creatures are united against the wicked and in their anger and fury are urged to torment them'.[1] And of all these 'creatures', the fire was the most frenzied in its revenge; blazing in a 'high, wide and fearful vortex', Tertullian described it as the subterranean treasure (*'ignis arcani subterraneus ad poenam thesaurus'*[2]).

> whose fury, rolling in wide and ample waves in every direction, horribly burnt him; and not finding any hole through which to escape, the quick and intense flames turned back on themselves, reverberating, twisting and deceiving them in immense fiery whirls, which by pressing against one another increase the temperature and strengthen the violence a thousand fold. What will he be like who enters this fire which is submerged and buried in eternity? What will it be like to be violated as far as the bone, and penetrated as far as the bowels? What will it be like to smell it through one's nostrils, to swallow it through one's jaws, to throw it out of one's chest? What will it be like to have the fire in one's brain, in one's heart, in one's tongue, in one's eyes, in one's nerves, in one's muscles, in one's veins, and to feel the fire in all one's most delicate and tender parts?[3]

Clearly, we have no idea how to answer these questions. As Saint John Chrisostom taught us,[4] all the treasures of human eloquence will

100

always be incapable of rendering even a pallid idea of the fearsomeness of this fire. But, when contemplating these apocalyptic scenes with alarm, it should sadly be recognized that, at least in the past, Christianity was

> more apt to terrify than to console, or to cheer, or to delight, or to feed with hope. In fact there is no doubt that Christianity's influence on men's actions has always been and is still that of a religion which threatens rather than one which promises; likewise, it has encouraged the good and kept evil at a distance, and has served both society and morality more with fear than with hope; similarly, Christians used to observe, and still respect, the precepts of their religion more because of their fear of Hell and Purgatory, than because of their desire for Paradise...
>
> It is also without doubt that without Hell and Purgatory, and with only Paradise, Christianity would not have had, and today would not have the influence which it has had over human behaviour and customs, and likewise it would not have had such an influence, or to a much lesser extent, if it had not threatened a conceivable form of punishment in Hell and in Purgatory...[5]

This 'religion which threatens' had a formidable capacity to terrorize its followers but was incapable of consoling them; it was founded more on fear than hope, on damnation rather than salvation, and even in the Italian provinces it began to show signs of wear and tear in the second half of the eighteenth century. An indication of this change in attitude towards hell was evident from certain perplexities that emerged in the ecclesiastical pastoral.

> And it is very true that this morning I must deal with a subject which is far from our senses, superior to our imagination and incomprehensible even to our powers of reasoning, about which faith barely gives us a vague idea and a hazy notion.[6]

In the previous century no preacher would have publicly admitted that there might only be 'a vague idea' and 'a hazy notion' of hell. And nobody would have found it necessary to contend with those who 'call what the evangelical ministers say about hell, hyperbole, and attribute it all to deliberate exaggeration.[7] The reformed Minorite Pier-Maria da Pederoba, known as Pietrarossa (1703–85), realized that 'the faithful have a certain inclination which makes it awkward to speak of hell rather than of paradise'.[8]

This uneasiness insinuated itself into the orthodoxy (but obviously not into the circles of unbelievers or atheists) and the popular preacher

became its interpreter. Whenever hell was spoken of, the symptoms of 'distress' became more pronounced:

> my illusions vanish, my courage deserts me, I cannot find thoughts and words . . . thus, it is always difficult to speak of those things about which we have no clear idea, nor sensitive experience, such as the rewards and punishments of the next life.[9]

The imperious certainty of those, especially in the seventeenth century, who had become specialists in the minute description of the place of punishment, even to the extent of measuring its precise volume and circumference, and the number of the damned, now seems far off, as do the hyperboles and the 'deliberate exaggerations' of those explorers of the unhappy country.

And none the less, in spite of the doubts and perplexities which had arisen, the 'magnification' of the fears of hell was, if anything, in danger of underestimating the horrific reality. After many hesitations and uncertainties not only regarding the reality of the 'formidable kingdom', but regarding the quantity and quality of its torments, there was a peremptory call to order, since 'whatever degree of magnification you allow, you will never be able to understand the ineffable anguish of the damned'.[10]

But, the preachers would never have openly been able to recognize the fact that the 'excessive fear of hell' (Muratori) was exorcized in a discreet and silent fashion by Christian rationalism which was used to deflate 'the marvellous workings and the phantoms of superstition and terror'.[11]

The sacred eloquence which had so powerfully contributed to the spread of the terrifying fascination of hell, and the flaming visionary fantasies and cold mathematical abstractions of the Jesuits were impassively re-dimensioned by the pious, learned and clear-headed canon from Modena, L. A. Muratori, the arcadian Lamindo Pritanio. The vibrant and sensual poetry of the Baroque epoch was dampened by powerful, therapeutic jets of water and nourished by intellectual diets with fewer calories and fewer drugs. Hell exists, so Muratori thought, because the Church wishes it to do so. But the dramatic descriptions of the underworld with all its lurid scenographies and livid lights must none the less come to terms with good taste, with moderation, and with the orderly piety of the quiet and placid soul. Instead of acting like the irresponsible stimulator of monstrous fantasies, religion must appease and mitigate the dark terror of the invisible:

the fear of invisible things has a strange effect in the predominant fantasies. It is certainly a matter of faith if one believes that there are spirits called demons and that in various guises they have come among men and by divine permission can take possession of them. The existence of hell and the fact that the souls of those who die in sin are condemned to go there are certainly questions of faith. These truths, accompanied by the false ideas of stupid women and of the credulous lower classes, make their way into the sprightly imagination of a person with little sense of judgement and for this reason he has an exaggerated fear of these things. It would be positive if only this fear served to keep him from sin, but his imagination does not usually stop here. Even while he is awake, he dreams of thousands of phantoms, spectres and monsters, all of which he believes to be real and certain things. He fights hand to hand with demons, and sees the punishments of the damned with his own eyes . . .[12]

The tensions of the Baroque era now diminished; the spiritual setting became less agitated by the appearance of the fearful face of night, was made less gloomy by shadows and nightmares, and became more relaxed, illuminated by softer lights reflected against a less turbulent backdrop. The arcadian pastoral began to cast a light veil of restrained hope over the dark pool filled with phantoms and over the gloomy heath where the deathly apparitions roamed. The forces of reason began to purge the body of these imaginary fantasies and the arrival of new ideas acted as leaches which sucked out the obsessive extremes which had polluted and swollen the great century, the golden age of fears. The fires were gradually extinguished, the pyres cooled, and witches began to be pitied as being poor 'sad women, with a lively imagination and the spirit of a wild animal',[13] even if they had led 'bestial lives'; they were merely old women who were 'consumed by filthy lechery and who stimulated themselves with generous liquor'.[14] The women who had been regarded as the treacherous mistresses of evil a few decades earlier, had now ingloriously degenerated into chronic alcoholics, the victims of 'base humours', 'obscene fantasies' and 'impure thoughts' which were distilled by the imagination, the 'principal workshop of deformed lechery'.

The liquidation of their 'nightly journeys through the air'[15] and of the 'brutal outlets of their lust'[16] advanced in parallel with the bridling of the disorderly imagination. Disgust for their 'foul deliriums'[17] also affected the morbid fantasies of hell and even the 'heart of hell' itself.

Together with the growing infrequency of famine and the extinction of that other divine punishment, the plague, the European desire for life, which was reflected in the demographic increase and the rebirth of

Christian hope in the form of a less absolute and tyrannical, less cruel and severe justice, laid the foundations, under the long influence of rationalism, for deism, pantheism, and for an anti-dogmatic historical criticism and scepticism; it even led to the dismantling of the dark city of punishment and to the gradual emptying – through the filter of a deliberate mental reform – of the life–prison of the damned. This 'orderly devotion' within the new Catholic spirituality helped in the task of slowly setting aside and demolishing the terrible building. The ghost of Pierre Bayle, who had 'scorned heaven and the dark kingdom',[18] could now smile from that uncertain and dark under-world which he had, 'in a libertine fashion', tried to illuminate.

Even hell, like the Bastille, could not avoid being attacked by persons of little scruple and with little respect, by those opposed to torture and inclined to tolerance. This spectacular scenario, this grandiose and chilling 'underworld' dense with shadows and horror, the 'different country' invented by ancestral fears, re-invented and perfected by indefatigable theologians, and enlarged and ornamented by hallucinated visionaries, was placed in the centre of the entire system of fears and at the farthest edge of all joy; it was 'removed farther from the glory of paradise than all other places', and 'on account of its vileness' it was enclosed in the heart of the earth, in the stomach of the most abject of the elements, since the 'earth is a vile substance' (Bono Giamboni). The underworld was placed in crisis by a handful (which rapidly became a legion) of unprejudiced readers, who were, as was fashionable, liberated, cynical yet ambiguous, courted and encouraged by elegant, conceited and gossiping women, by gallant heroines with soft and sensitive hearts and inquisitive minds. It was attacked by persons who wanted a 'political system without divine right, religion without mystery and an ethical code without dogmas'.[19]

The *'inania regna'*, whispered the pre-Christian scepticism, *'verbaque inania, et par sollicito fabula somnio'*, was like a child's fairy-tale, an importunate dream. And that dark realm of fear now appeared empty, useless and vacant (more or less like the empty Bastille must have appeared to its breathless invaders), and the cruel earth was devoid of its eternal sufferings.

While atheists, libertines, deists, Socinians, free thinkers, strong spirits, *'nouveaux philosophes'*, soft abbots, overdressed curates, adven-turers and cabalists, freemasons and erotomaniacs, cynics and Pyr-rhonists spoke of the infernal flames with smiling and incredulous off-handedness, others hurried, with growing scepticism, to find a new setting for the now antiquated hell. In 1714 the Anglican theologian

Tobias Swinden published in London the summary of his studies on the subject (*An Enquiry into the Nature and Place of Hell*) in which he asserted his firm belief that up until that time everyone had erroneously located hell underground. According to his calculations and theories, hell was precisely situated in the sun. This sensational opinion, which was not without a certain logic, gave rise to lively interest and amazed curiosity. The millenary tradition was abruptly overturned: not only was there not enough combustible material in the heart of the earth to feed the flames of hell for eternity, but there was also not enough oxygen. On the other hand, the hundred thousand million souls who, according to the calculations of Jeremiah Drexel, were crammed into an underground space of little more than a square mile, would have had plenty of room in the sun. The situation would have been even better after the Last Judgement, when the souls, being reunited with their flesh, would expand into a horrifyingly large number of bodies.

The old image of the sun, as the uncontaminated celestial symbol, 'God's profile', the 'immortal and uncorruptible image of God',[20] was transformed into a cosmic oven, into a punitive furnace whose mouth, opening on to an incandescent stomach, swallowed and incinerated the earth's leprosy. Until then no one had thought that the black sun and the judicious and flameless fire of the underworld could be substituted by a common astral body. Likewise, until it was proposed by another Englishman, the astronomer and demonologer William Whiston (1667–1752), an Anglican priest who was assistant and from 1703 successor to Isaac Newton at Cambridge, no one had ever imagined that the comets might represent infernal vehicles whose principle mission was to ferry the damned close enough to the sun's edges to be sufficiently roasted before taking them to certain fearful, cold and dark regions beyond the orbit of Saturn.

In the last two decades of the seventeenth century and the early years of the eighteenth century, heaven and earth, and hell and fire became the objects of singular intellectual reflection. Hell and its enigmas offered new starting points for scientific curiosity and for hypotheses regarding other places, other spaces and other planets. These conjectures about hell formed part of the same intellectual climate which looked with extreme interest to the multiplicity of worlds, to the comets, and to the possibility of there being other far-off and diversely inhabited worlds in the most eccentric places. The Utopian, parascientific and Casanovian novel, '*Icosameron*', formed part of this new Voltairian taste for the make-believe novel. Instead of hell, the Venetian libertine and Catholic author placed a country

which was still different, but happy, in the centre of the earth (*'au coeur de la terre'*); having been shipwrecked, Edoardo and Elisabetta quietly spent eighty-one years there among the drinkers of milk, the *Megamicri*, and among the 'aboriginal inhabitants of the Protocosmos in the heart of our globe'. Like a great magnet, an artificial sun radiated life and temperate warmth where before, the lurid dark flames of the revenging fire had raged.

Both Catholics and Protestants, men of different confessions and communions, took part in the debate of hell. Tobias Swinden went as far as to conjecture that 'the body of the Sun is Tartarus, or the setting of hell' on the supposition, which was officially accepted by Catholic theology, that since the punishing fire was both real and embodied, it would have been able to fulfil its institutional function more rapidly in an enormous aerial furnace which was incomparably larger (and hotter) than the heart of the earth, which was enclosed and lacking in oxygen:

> I am thrilled to ecstasy and filled with astonishment, above all when I think how many of the Pyrenean mountains of sulphur, and how many Atlantic Oceans of tar are needed to feed such powerful and such quick-burning flames.[21]

There was no doubt that the fire was real since, if it was to be understood in a metaphysical sense and interpreted in a symbolic light, it would have given further foundation to the sceptics' arguments and new material for *'outrageantes railleries'* and additional scorn to the atheists; in fact, the latter would have arrived at 'the just and natural conclusion that since hell is nowhere, it does not exist at all'.[22]

In the penultimate decade of the seventeenth century, the crucial years for the birth of the new European conscience, Lorenzo Magalotti, the ex-secretary of the *Academia del Cimento*, and a gentleman in the service of the extremely bigoted Cosimo III, that 'stubborn, proud and ridiculous stick-in-the-mud' (Antonio Zobi), had re-confronted the difficult question of the 'immateriality of the human soul and of its susceptibility and capacity to receive the imprint of material things, even after having been separated from the body', in a much more delicate manner than the good Anglican curate from Cuxton in Kent, a doctor of theology whose softened and moderate Catholic dialectic was grafted on to the branch of the new Galilean science. In the context of this physico-experimental verification of the scriptural truths, Magalotti's attention turned, with a lightness of style worthy of the Italian tradition which manages to tone down and mediate the

most serious ultramontane modernisms with refined and, one might say, 'delicate' irony, to the quality of the infernal fire; in the light of the meditations of 'some of the most serious theologians' the fire should be interpreted as being selective and 'discursive', and its 'anger' should be understood as being a metaphor of movement. The biblical, Pauline and patristic oratory could very well be re-translated into modern and scientific language and transformed into a 'very sustainable theorem of good philosophy'. The speed of the fire, or its 'anger', should be measured against the gravity of the sin, since the 'measurement of the movement' and the aggressiveness of that unconsumable fire depended on the 'different types of sin, in the same way that sin is on a variable scale of desire'.[23]

In an arduous yet delicate attempt to square scientific hypotheses with matters of faith, these difficult questions were brought out into the open by the Catholic culture, which had become more aware of the European circulation of ideas: they opposed the spreading advance of atheism in an attempt to discover, in the light of the Galilean physics, the hidden mystery of the 'fire of Gehenna', and to unravel the enigma of an Aristotelian God 'who was incapable of desiring, being and understanding anything other than himself; in other words, whose manner of dry and sterile intellection was incapable, to our way of thinking, of giving blessedness to any other person than a similar kind of God'.[24]

8

The 'Soft Life' and 'Weak Sinners'

The 'young gentleman's' awakening in hell was made even worse by the enormous difference between the 'high society' which he had relinquished, between the refined and soft luxuries which he had left and the repulsive setting of the desolate depths of hell in which he found himself. And, whereas the passage from one to another was very rapid (it usually took place after an elegant soirée), it took some time for him to become aware of his new status in the darkness of the sewer.

The old evangelical *topos* of the death of the glutton was reinstated and highlighted by those eighteenth-century sermons which with mocking emphasis described the abyss between the sweet, tender and perfumed world from which the weak sinner had been brusquely evicted, and the sordid filth of the world into which he was thrown.

The idea of waking up in the underworld provoked a feeling of stupefied amazement and of hopeless incredulity in the nobleman: having been catapulted into a milieu which was so far removed from his own, into an impossible setting whose existence he, the shrewd sceptic, had often denied, the unbelieving *viveur* was transformed into a puppet-like and despairing ghost:

> That evening, in a blithe and cheerful mood, he lay down on his bed, and after a turbid and long sleep, he suddenly awaked and, turning over on to one side and then the other, he stretched out his arms, and oh God, he could not feel the soft feathers any more, he could not find the bolsters, or the linen; but with one hand he grasped a fistful of worms and with the other he found a toad's hole. He felt other equally repulsive insects crawling over his body and realized that he was covered with

108

disgusting rotten matter. Terrified, he turned up the lights, but only found darkness; he cried out in fear, but heard that, barely had it come out, his voice immediately became muffled and was drowned; he called the servants, his sons, his wife and maybe even his mistress, but heard nothing but the reply of a fearful echo. He tried to stand up, and feeling his way with trembling steps, here he bumped into a corpse, there he came up against a crumbling and dripping wall; here he trod on a pile of picked bones, there his foot sunk into a sewer of rotten guts. From the stench, from the loneliness, from the darkness, from the horror, he finally realized that he was enclosed in a deep tomb: he was buried.[1]

The fall was sudden, the move very exacting and the transformation intolerable. The new eternal tenant of the world without light woke up half dead in a suffocating 'boudoir' of horrors, shut in by 'crumbling and dripping walls' and surrounded by decomposing, slimy cadaverous objects and by repulsive 'insects'. After the lights of the fashionable soirée, the darkness of the abyssal tomb made the irreparable loss of the bright, perfumed and dissolute night in high-class drawing-rooms seem even more bitter.

Catapulted into the 'miserly kingdom' which only takes and does not give, he would have to attend the desolate 'ghostly reunions' for eternity, to which Giuseppe Parini, having transformed himself into a tutor-bat, planned to bring the 'life-giving master'. After the 'hero's' death and after his 'funeral and apotheosis', Parini's brief notes foresaw a guided descent into the subterranean palaces: 'Hell, monsters, pallid ghosts, all the same.'

Perhaps it is not entirely correct to deduce from these brief outlines which have survived how the abbot from Brianza would have staged the deceased 'semi-God's' journey into the 'valley of hell'; none the less, it would appear that the Virgilian model would have lent an elegiacal glaze, a soft touch, to the classical ultramontane settings of the underworld.

Father Antonio Valsecchi (1708–91), who was a Dominican and a follower of Parini *'malgré lui'*, did not use much poetical licence or lightness of style when he threw his glutton into hell, following an imprudent and sudden death (perhaps from an excess of eating or drinking) in bed at night, while he lay 'resting his guilty soul'. And yet the unrestrained moral atmosphere (the desperate shouts for both his wife and his mistress), the 'luxuries' of the gentlemanly way of life in the late eighteenth century, the bed with its 'soft feathers', the 'bolsters', the 'linens' which automatically remind one of the 'soft bolsters' and the 'white bedlinen' of the 'Mattino'; the 'stench' which by contrast bitterly evoked the sweet and lost smells of paradise, and the

'scented rooms' where one breathed the invisible, aromatic delights, all seemed to recapture, by analogous suggestion, the 'balsams' which sweeten the 'celestial nostrils' of Parini's youthful glutton, the 'sweet-smelling wave' of jasmine, orange blossom and jonquils, and the 'new delights' of drinks from the Indies. The miasmas of hell and its 'stench' and 'filth', all of which were used as threats by the preachers, cannot have been much appreciated by these 'weak sinners', or by the 'soft and delicate Christians', and even less by the 'very affected and delightful ladies'[2] of this exquisite century. These highly scented and elegant sinners cannot have found the prospect of remaining in an unlit and, above all, stinking eternity a reasonable alternative to their pleasant days on earth.

> What would you say? What would you suppose? What would you think, my Lords and Ladies, if you were suddenly transported from your perfumed rooms, from your abundant luxuries and from your genial conversations and you found yourselves in such a blind and horrendous prison with such foods, such companions and such entertainments? And who will give you, the weak sinners of this century, courage in order to tolerate so many merciless, penetrating and universal punishments . . . ? Could you perhaps, you soft and delicate Christian, you who cannot even observe a short fast which the church has commanded you to perform on account of your sins? Could you perhaps, you affected and delightful woman, you who are incapable of kneeling for half an hour crying about your follies in front of a Crucifix? *Qui poterit?* Could you, oh man, you who live in a state of agitation if you do not enjoy all your amusements, and if you do not tempt your flesh with the most obscene licentiousness? Could you, oh lady, you who live amidst affectations, breathing pleasures and resting on feathers, you in whom the mere word, penitence, causes horror?[3]

The 'softness' and the 'sensuality' (Pederoba) of the life of the eighteenth-century gentleman and nobleman were assiduously scrutinized and continuously and repeatedly condemned in the sermons addressed to the 'rich' and the 'great'. The refined tastes of their spoilt and bored throats, their exotic and exquisite drinks, the costliness of their desserts, the sparkle of their silverware, the delicacy of their porcelain, the inconstancy of their fashions, the indecency of the women's clothing, the 'dressing gowns' painted with 'frivolous trifles', the 'chinoiserie', their 'elegant and fragile bagatelles', their 'strange gallantries', the 'perpetual round of visits and gossip', the 'lamplight women' who 'never slept at night', their 'graceful metamorphoses', the 'delicate little clothes' of the dandies who were like elegant

'butterflies',[4] the omnipresent *'parfum du plaisir'*,[5] the continuous research for 'voluptuousness' and for 'worldly dissipation' were all criticized by moralists and chastised by the Lenten scourge; likewise, their liberal, daring and 'impious' conversations and their way of exchanging ideas were the objects of perpetual disapproval. So was the libertines' unbridled 'freedom of thought in religious matters',[6] together with their 'unrestrained and lecherous glances, their theatrical productions', the 'satisfaction brought by obscene songs', 'their card games', the 'companies of pleasure', the 'vigils', the 'flattering looks', the 'half-finished sighs', the 'tender compliments' of 'merry youths or women whose lives were full of luxury and idleness', the 'open sale of voluptuous objects', the 'vain ornaments', the 'muddied coaches', the 'common furnishings', the 'indecent and outmoded luxury in every house', the 'pompousness of clothes and entertainments', the 'silks', the 'ostentation of furniture and appearances', the 'sumptuousness of furnishings and carriages', the 'fashions, the materials and the precious stones', the 'hairstyles', the 'ribbons', the 'ornaments' and the 'jewels' which were worn everywhere because of the 'vanity and capriciousness of a single woman'.[7]

This was the world which Parini described without the indulgent irony, without the exquisite style of the ambiguous son of the silk merchant from Bosisio; a glimpse of the society of the second half of the eighteenth century (the roots of the most unrestrained hedonism of our modern society date from this epoch) which in a euphemistic spirit had called several red-hot truths and many irresistible temptations by other names. 'Custom changes even the names of sins', underlined Pier Maria da Pederoba, also known as 'il Pietrarossa' (1703–85), who often spoke from the pulpit in the elegant city of Turin under Vittorio Amadeo III, 'and calls vanity decency, luxury policy, petulance endearment, fraud industry, love admiration, deceit the use of money, betting commerce, prodigality intemperance, and impiety a joyful way of life'.[8]

This Minorite monk from Treviso, like many other preaching friars, had the penetrating eye of the sociologist, and was an acute observer; he was a severe judge of customs and a historian, in his own way, of the social changes which were rapidly transforming the old feudal set-up. The 'gallanteries', or rather 'promiscuous courtesies', the 'effeminate, soft, intemperate and voluptuous way of life', the 'unconstrained habits', the 'modern way of life', the 'promiscuous familiarity of dealing, the liberty of visiting, the passionate services, the genial conversations, the assiduous courtesies are inventions exclusively of this century and were unknown to our fathers'.[9]

Addressing himself to his noble listeners, the austere Minorite projected examples of the way of life of the elegant society, of the etiquette of modern society in this enlightened century, and of all the misdeeds of intellectual libertinism and moral libertinage on to the opaque screen of their consciences; at the same time, the lay preachers proclaimed that 'faith was an imposter, morality a fairy-tale, and God a phantom who had been invented by man himself'.[10] Apart from the spread of 'pomp, vanity, immodesty and scandalous nudity' among the 'impious' and the 'libertines', there was growing 'temerity and impudence' which 'overturned public laws and removed all respect for venerable and sacred things'; 'nor was there any dogma, truth or doctrine of Christian religion and morality which was not the object of contempt, jeers and oaths, or of the blasphemies of some brazen and sacrilegious libertine' at clubs, or discussion groups or other profane meetings.[11] Disbelief, ungodliness and intellectual libertinism were coupled with weakness, effeminacy of taste, the reversal of roles and the ambiguity of the sexes:

> today, almost more than against females, this criticism may be levied against men, against those young and well-dressed gallants who, in order to entice the weaker sex, imitate their softness, their vanity and their gait. The moment they reach adolescence and have received a smattering of education at school, they shake off their timidity for their superiors, and abandoning every serious, studious and useful occupation, they run riot and live according to their whim and fancy. They rot in vile idleness, and apart from the time which they throw away in games, theatre, courtships, reunions, impious books and dishonest novels, the greater part of their days is consumed in idleness . . .[12]

The complaints of the preachers are very comprehensible; they watched with horror while the old feudal and 'Confucian' society was eroded by a profound decay of manners, intoxicated by new poisons against which the old vaccines were ineffective, and possessed by subtle demons and by intellectual evil spirits who overturned morals and norms, principals and practices, usage and customs.

> When, apart from today, has such a lazy, soft, idle and sensual manner of living, which overturns the foundations of Christian penitence and banishes the austerity of the New Testament from the world, ever been seen?[13]

The Discalced Carmelite Pier Luigi Grossi (1741–1812) described 'our century' as 'an inversion, an overturning of the centuries which

preceded it: in the place of austere roughness nowadays there is a seducing culture, instead of bloody ferocity there is now soft effeminacy, instead of ignorant credulity there is now philosophical unbelief'. The triumph of 'today's refined good taste' increased the numbers of the 'disciples of these modern depravations' by bewitching them.

> This change of scenery, this reversal of appearances, only lasted for a brief period, and we ourselves were for the most part its astonished admirers . . .[14]

A 'strange metamorphosis' had come over the face of 'civil society': the 'dominating and overpowering culture of clothes and manners', the 'perverse doctrines', the 'dominant disbelief of fanatical, much applauded writers ... favoured the passions, flattered the senses, caressed the flesh, unbridled libertinage and taught humanity the rituals of love-making'. The 'philosophical misbelief' and the 'impiety' of this 'century which was not only corrupt, but seditious and fatal to the Church', the 'deism', the unrestrainable 'intemperance of philosophizing' and the 'perverse doctrines' had caused the 'place of torment', with its 'interminable unhappiness', and the 'salutary fear of eternal tortures' to appear as a dismal spectre which had been produced by the 'fabulous reveries and bogeys of the educational system'.

The 'fascination of cajoling manners', the 'vivaciousness of the spirit', the 'rites of love making', the 'modern and pretentious effeminacy', the 'feeblest form of effeminacy', the canonization of the 'most lascivious impudence', the 'passionate love affairs' of the 'basest slaves of sex', the 'elegant and grandiose manner of dressing', the 'clothes' of the women who groaned 'under the weight of immense mitres, like towering helmets, under crinolines, loops and ribbons', and the 'exaggerated and pompous display of clothes' in which even the men 'dressed with feminine ostentation', were all signs of the universal accord which these 'perverted customs' gave to the logic of pleasure and voluptuousness, and to the uncontrollable, shameless and sensual seduction of 'these entranced and desirous young persons'.

It was impossible to resist 'the clothes which enchanted the heart' or the seduction of voluptuous sandals and irresistible little shoes which, having taken the soul by storm, caused it to plunge into hell.

> And why does the number of seductions not increase nowadays among Christians given the infinite number of feminine garments, the lasci-

vious ornaments, and the snares which are set using sex as a bait . . . ? If one adds the fascination of good manners to pomp, which attracts so many clothes, oh how much more pernicious and fatal the excessive refinement of modern culture would be! Do not merely the beauty aids on the dressing table, the changing styles of hairdressing, the diverse perfumes and vermilions, the miniatures of faces, the vastly assorted wardrobes of clothes and quilts, a hundred other refined, trifling components, that minute arsenal of plasters, pendants, pins and needles, and that portable haberdashery of jewellery, little hats, plumes, veils, lace, bands, and an infinite number of stylish little things . . . represent the most flattering enchantment?[15]

'Christian simplicity' and 'discretion' appeared to have been banished for ever by this society which was so soft, effeminate and corrupt that it succeeded in contaminating even those who had enrolled in 'the Church party', the clergy themselves; in fact, the undisciplined, mundane and socialite members of the clergy were found 'among the mirrors and the skirts, at theatres and behind the scenery, among the card-players and at all-night routs', and they exchanged their robes (the 'uniform') for 'lay clothes and behaviour, and feminine courtesies'.[16]

The emancipation of women 'in this very feminine century',[17] the massive entry of women into drawing-rooms and male preserves, the new role of the weaker sex which became the salt and ornament of social life, the motor of change and the agent of subversion, also led to a feminization of hell. It was no coincidence that prompted Antonio Valsecchi in a sermon to split the classical stereotype of the glutton in two and to introduce the figure of a 'very pretentious and delightful woman', a partner in futile, lecherous weakness; nor was it by chance that on awakening in the horrifying underworld, the rich sinner desperately called for both his wife and his mistress. It was only because of an inveterate loyalty to the evangelical tradition and to the patterns of the literary genre that the parable of the death of the rich man did not become a commonplace tragedy whose protagonists were the voluptuous, immoral and very curious ladies of the enlightened eighteenth century. None the less, the feminine presence in the eighteenth-century hell was felt everywhere, and could be seen in several aspects. Up until the previous century, the sermon for the 'Thursday following the second Sunday in Lent', which was dedicated to the death of the glutton, described a totally male drama centred on the well-known themes of unrestrained sensuality and unbridled immorality. The sermon described a solitary fall, a tragedy for men only, as the sinner, a victim of his own excesses, plunged into a hell for

debauched men, a club reserved for those who were damned on account of their intemperance. There was no sign of women. On the contrary, there was a vague sensation of the corruptness of both gentlemen and prelates, and of the excessive sensuality and exclusive refinements practised by cardinals and those in positions of power. Greed was predominant; but with the strong support of a voluptuous sense of smell, the nose conspired egregiously to bring about the ruin of those who had used and abused their five senses.

The first thing which the Baroque glutton glimpsed on waking, in a passing return to life, was his 'palace', and immediately afterwards, the tormenting sight of unattainable banquets:

> 'he saw an extremely long succession of decorated rooms,' wrote a Jesuit preacher who died at the age of 34 in 1656 while "helping the sick in the city of Barletta". It was 'only a glimpse, since it disappeared in a flash ... He saw those tables laden with game and fish which was still steaming, and he sighed in his misery ... He saw the rich litters curtained in silver in which the gluttons used to digest until midday ... Having enjoyed the perfect air of these regal villas, he now breathed suffocating air and waves of fire! Having seen the belvederes of the richest hunting lodges, he now saw horrendous spectres and frightening visions. Having been entranced by the music of young human angels, he was now horrified, and could not get a moment's sleep because of the demoniacal screams and blasphemies! Having smelt amber on his gloves, liquid amber of Messico in his food, distilled rose water in his baths and balsams in his lamps, he now had to suffer the infectious aridity of corrupted bilges in that enormous sewer!'[18]

The pleasures of the villa's 'perfect air', the voluptuousness of banquets, the voices of the castrated singers, the delightful views from the belvederes, the numerous 'inventions for caressing the body' and all its senses, form a gloomy antithesis to this 'cesspit of flesh', to the 'corruption which sparkles in the ground', to the brief enjoyment of a 'weak and fleshy light'. Amidst the other delights of the villa, the eye was flattered by 'the most transitory inventions' of architecture, and by painting and sculpture; profane pictures, lascivious mythologies and the agitation caused by sacred works of art invaded the scented bathrooms of purple-clothed collectors who were enchanted by the 'sense of invention' and by the glance which penetrated the most reserved spaces, and even their 'most private studies', to 'invent new titbits of unrestrained lewdness'. Precious furnishings and cups, which at such large 'banquets were drained to a scandalous state of drunkenness', and 'dishes with specially concocted sauces', invented by the

'many cooks trained in the philosophy of gluttony which taught how to whet an appetite in stomachs made listless by overeating' accompanied these delights of the basest 'sensuality'.[19] And, as a side-dish to this intellectual lust, there were 'novels which lit real fires with false flames',[20] 'love poems', 'verses filled with shameful obscenities' and readings which either acted as substitutes for other pleasures or were conducive to additional delights, the equivocal instruments of eroticism and mediators of the licentiousness of the senses. But these were not such indispensable aids to intellectual libertinism as were the impious and blasphemous books of the new philosophers of the eighteenth century. The 'unimpeded freedom of thought in religious matters'[21] had not yet spread to the palaces, with the exception of small groups like the 'Lucretians' or the 'Incognito' Venetian libertines. The female figure was virtually absent from this universe of sensual lewdness, from this 'small paradise' transformed 'into worldly flesh' in which the 'pleasures of carnality' triumphed while the soul was in 'hibernation' (partly as a result of the 'aromas, ointments and other delights from Asia'[22]). The female form played a marginal role as the important but vicarious, live, tasty mouthful which was added to the innumerable allurements of this overflowing sensuality, bursting with all forms of worldly seduction. Alternatively, as a sinister flame which roused tumultuous passions, this voluptuous siren incited bloody crimes (the Jesuit Zuccarone reminds us that 'passion was often a motive for murder'[23]), even in ugly, perverted flesh which was driven to commit atrocious abortions. On the other hand, in the velvety society of the eighteenth century there were neither amorous passions nor crimes of passion, since the ancient code of honour, which had made the men of the seventeenth century act like 'filthy barbarians', as wild in their feasting as in their love-making at a time when the female figure had not yet become the pivot of society and man had not yet been reduced to a slave of feminine vanity, had been abolished. In the seventeenth century marriage was still respected, adultery was not institutionalized and ladies' men were still unknown.

> What choking, furious desire for softness, for companionship and courtship is it that agitates these idle and well-to-do women, to whom an hour seems wasted if they have not enjoyed some new amusement? They passed from soft, tender feathers to splendid, sumptuous tables, from family visits to public gatherings, from balls to theatres, from foyers to little parties, and the quantity and variety of these pleasures was a substitute for their vanity and stupidity. There were ordinary pleasures which lasted the whole year round, and extraordinary ones for each season. Apart from the pleasures of their own homes, they also

wanted to share in those of others; the night changes, but does not interrupt their amusements: parties are designed to continue their pastimes, not to cut them short . . . And the promiscuous familiarity of manner, the freedom of visiting, the passionate bonds, the genial conversations and the assiduous gallantries are the inventions of this century, and were unknown to our fathers who, in their time, did not even know their names.

The holy obligation which binds couples to reciprocal and indivisible love, is violated with the tacit and sometimes express agreement of both parties; it is violated, I mean, in order to divide it with others: the insoluble union, which one struggles to continue in neverending domestic society all one's days is broken with the help of extraneous, pleasant objects, with which one wastes time in a pretentious way; and often, those who talk the least among themselves and do it with greater indifference are the husbands. Grace, vivacity, sweetness and loveliness are never better displayed than among persons who have no blood ties, are of different sexes and have only youth, attractiveness and high spirits in common; and who spend their time together in games, in walks, at the theatre, in the drawing room and even in church.[24]

In order to impede such an insidious mental development, to oppose this new rationalist, anti-dogmatic, Voltairian culture, which leant towards scepticism, relativism and tolerance; in order to erase these profane 'pleasures from the imagination' and to weigh down and deform the delicate and hazy horizons of the arcadian pastorale; in order to horrify these sensitive, soft and delicate spirits, there was no other alternative for the Church but to resort to the old terrifying phantoms of the imagination, to the tried and tested repertoire of horror. Although the wings of the theatre were changed and certain scenes were altered, the principal features of the backdrops of hell remained the same: the painful kingdom might crumble but could not change. The fire continued to be a good subject of discussion and a well-respected deterrent; the avenging flames inexorably tortured the carefully tended flesh, the body which was smoothed and softened by the delights of the 'soft century'; the fire devastated the delicate and voluptuously powdered skin of the man–woman of the eighteenth century.

And is it possible that since we show no compassion for our souls and bodies, and since we are so quick to defend the latter from the slightest discomfort, that we have no fear of exposing it through sin to the manifest risks of the eternal fire? We are, dear men and women of faith, in a century which looks for nothing but riches, pleasures and honours; nor does it think of anything but inventing new ways of making the

117

dishes at table more delicious and flavoursome, of making the fashions of dressing more magnificent, the freedom of conversation even greater, and the soirées, the comedies, the dances and the parties more prolonged; so that one passes from one amusement to another and one pastime is used as the interval to the next.[25]

An 'excruciating pain'[26] lay in ambush in the 'prison of despair',[27] amid the 'nauseous refuse',[28] for this 'effeminate, soft, intemperate and voluptuous life', for this 'promiscuous gallantry', for this 'vanity, immodesty, and scandalous nudity', and for this 'sensuality and softness'.[29]

> while you are burning, the nature of this pain will make you feel all at once the intimate sufferings and ills of which the wretched human body is capable. So that, having gathered them all together in your mind, imagine that you have become the victim of all these infirmities; you will feel yourself all of a sudden assailed in a single place by the most acute toothache, headache and earache and by pains in the eyes; and your hands will be pierced by the painful knots of cheiragra and the feet by gout; you will feel your temples being hammered by tortuous migraine; your convulsed intestines being twisted by violent colic; and your lacerated kidneys being torn to pieces by the barbarous pain of gall and kidney stones ...[30]

Perhaps a more philosophical, more ingeniously subtle and wickedly rational argument was needed in place of a banal, albeit very painful, toothache, or the threat of an attack of colic, although of unusual violence, in order to throw this new, difficult and experienced public into panic. The knowledgeable and rational fire which, like

> uncorruptible salt, will never decay but in a molten state will infiltrate, penetrate, season and preserve animal flesh from decay and from corruption ... it will percolate into and pervade the innermost parts and enter the limbs, the breast, the arms and the head, the stomach, the brain, the lungs, the heart, the liver and the intestines ... thus preserving the living bodies of the damned sinners from corruption';[31]

the evangelical fire, on whose essence and inexplicable power Saint Gregory of Nyssa, Saint Augustine, Saint Bernard, Saint Thomas and innumerable other fathers of the Church, apologists of the faith, controversialists, mystics and theologians had meditated, must have seemed like a papier mâché fire, an infantile fairy-tale to the 'presumptuous and impious spirits'[32] of the century which had buried its dogmas and scholastics, the patristics and the medieval ages under the

118

bitter salts of the new encyclopedic exegesis. Perhaps they thought that its only use was as a deterrent for rascals and scoundrels, an instrument of restraint and conditioning for the slow-witted and brutal plebian (like the flames which were hand-painted on the walls by the naive and clumsy daubers who remained faithful to the old popular piety).

'We must succeed with a crowd of rogues,' Voltaire concluded in the heading on *Hell*, 'who have never meditated about anything, with a crowd of brutal little men, drunkards and thieves. Preach to them if you will, if you so desire, that hell does not exist and that the soul is mortal. For my part, I will shout myself hoarse by yelling down their ears that if they rob me they will be condemned for ever. I will imitate that country parish priest who, having been shamefully robbed by his flock, announced from his pulpit: "Truthfully, I do not know what came into Jesus Christ's mind to die for scoundrels like you".'[33]

These 'honest philosophers', unaccustomed to peculation, robbery, break-ins, theft and unjust pilfering, can only have accepted this hell from medieval folklore as an antidote to the outrages against private property which were commonplace among the rogues, robbers, drunkards and *'canaille'* of the streets, or as a measure of preventive security and a useful means of preserving the size and integrity of inherited property.

'They will feel every torment in a single fire,' Saint Girolamo assured his readers. None the less, in spite of the scepticism which was diffuse among the upper classes (or perhaps because of it), and in an attempt to isolate the libertine infection with a curtain of fire, during the Enlightenment the preachers continued to fan the flames and to use them as a threat against the entire damned multitude, without exception; they continued to invoke the fire and to threaten that it would engulf the reprobates who, like a 'herd of sheep', were destined to become the 'victims of divine anger'.

Old images of tortures and appalling pains, horrifying anatomies, details from mortuary chambers or cross-sections from the meanest butcher's shop continued to be projected before the astonished and ever more puzzled gaze of Christians. The igneous desolation, the outrages and the havoc wrought by the 'supernatural and incomprehensible fire', and the 'pains and unpleasant diseases' attacted attention to this newest form of hell; but regarding the same ecclesiastical argument, one could already hear many 'enlightened' voices deploring the 'ignorant credulity which approved of these sacred illusions and such romantic miracles and devout fairy-tales, contrary to common

sense, and which were neither subjected to a critical examination nor authorized by the Church'.[34]

This was, after all, the revenge of the Muratorian tradition which, strengthened by the pontificate of Benedict XIV, accepted the 'refined good taste of the times'.[35] Pier Luigi Grossi, a Discalced Carmelite who denounced these 'modern depravations' with great firmness, wrote:

> It seems incredible that in our modern age so many fabulous legends about apocryphal saints are spoken of in Christian cities, and so much is written about fantastic apparitions, purported miracles, and ascetic abortions which is repugnant to good sense, and proscribed not only by the Vatican, but by all those who have a basic knowledge of ecclesiastical erudition and who have set themselves the tedious task of studying them with a critical eye. The pious intentions of so many foolish and insignificant authors can be pardoned for this sacred illusion which is more suited to whet the curiosity of idiots than to convince the enlightened; and thanks to the most learned Pope of our century, to the most serious compilers of the Acts of the Saints, to the erudite apologists of Religion, and to the many illustrious modern theologians who, having used their elegant and severe criticism to separate the wheat of the elect from the tares of the damned, have mixed pious devotion and devout ignorance on the mystical threshing-floor of the Church.[36]

It seems incredible, however, that before disappearing into doubtful silence instead of into a universal fire, like in a Nibelungen saga, even the Catholic hell, having arrived at the last step of its millenary and triumphant journey, passed through a period of renewed corporal violence. These were the final act of the spectacle of 'the prison of fire', the last reverberations of the 'bed of fire' and of the air of fire, the last full oven in the underground cavern where the lost soul felt

> his blackened skin burning little by little in the slow, intense heat, and he felt the roasting flesh frying on him, and the burning fat boiling under his skin and swelling his veins, and the blazing heat of the fire enflaming his blood and cruelly penetrating all the painful muscles and agonizing nerves in his body ... Down there the fire will be his clothes ... the fire will be his food and his drink. It will pass through his mouth to enflame his stomach, his intestine, his bowels, and then it will rise up to burn his heart. It will run through all his veins and arteries mixed with blood, and as it circulates it will make all the burning humours of the body boil ...[37]

By burning the eyes alone that cruel fire will spread the most atrocious burns and spasms and pain through the nervous membranes

and bubbling humours; at the same time the power of vision will be blinded by flaming darkness and the minute fibres and tender nerves will be hurt by bitter, burning smoke, and horrendous spectres, terrifying phantoms, and all forms of monstrous and terrible objects will be depicted inside the pupils which are suffering in agony. Not only will the fire agonizingly burn through your nostrils, but you will suddenly become aware of the foul smell of all sorts of stinking breaths, as many as could be given off by the disturbed sewers and fetid drains, by putrified corpses and gangrenous bodies, and by the filthiest and most disgusting carrion . . .[38]

These were the last fires of an intolerable anatomo-physiological exhibitionism; they were the last moments of a sad and incontinent speech brought out to air by a lugubrious, claustral arcadianism which had added the gloomy fascination of sepulchral literature, whose 'gothic' nights were full of 'horrendous spectres' and 'frightening phantoms', to the old terrors.

Two generations later, during the grievous and leaden pontificate of Gregory XVI, a Ligurian Dominican, Tommaso Buffa, was in the middle of one of his sacred orations in Rome. Giuseppe Gioachino Belli may have entered the church while the Lenten preacher was illustrating the state of sinful souls 'after death' to an audience of cardinals and monsignors, or, an aspect which worried his listeners even more, the 'condition of their bodies'. The prospect was even more depressing than usual: the rich and persons of standing were mixed together with 'artisans and servants', gentlemen were coupled with the 'turd-like faces' of stinking plebians and with poor employees 'covered with shit and refuse'. Down in the 'devil's house', social barriers were non-existent, hierarchical fences were overturned, the differences of blood and rank were removed and the 'due distances' were abolished; all the sinners lay in a jumbled confusion, 'in a heap of faces, arses and bellies'.

All the precautions taken in the tomb were useless, and the last deterrent of separating the 'honorable bones of the great' from the 'ignoble and vulgar ashes' with 'everlasting sepulchres' and 'precious urns' was derided; plebian and noble vulgarly embraced one another in the underworld of sinners, 'like diseased and dying sheep in a narrow, crowded ditch':

inside the tombs the corpses of persons of standing are not normally placed in a pile on top of those of the wretched and the poor, since everlasting sepulchres and precious urns usually divide the honourable

bones of the great from the ignoble ashes of the poor. But in hell the damned are not treated like this: down there the rich and the poor, the great and the humble, the noble and the plebian, the scholar and the ignorant will be thrown together, in confusion, and divine justice will bind them up into a single bundle and throw them into the flames to burn for ever.

What an infamous and desolate affair! To lie on top of one another, trampled and restricted on every side, like grapes in a wine press, or diseased and dying sheep crowded into a narrow ditch . . .[39]

In what was by now the restored State of St Peter no hell could have seemed more hateful than one in which due distance and respect and 'the merit, the dignity and the greatness' of gentlemen were not observed; in which the 'two types of mankind' were scandalously mixed together. One had to accept death and one could even run the risk of damnation, but the idea of such 'devastating infamy' could not be supported. The return of the Baroque hell, whose noble haughtiness was sullied by plebian promiscuity, fell like a heavy, bitter manna on the full-bodied, sumptuous city of Rome which was inhabited by eminent figures, great cardinals, lords and princes.

PART II

The Host

9

The Stolen Ciborium

In the early hours of 21 July 1723, on the vigil of Saint Mary Magdalene, the sacristan of the Discalced Carmelites, having, as usual, to prepare the exposition of the Host on the altar of the Virgin Mary, headed towards the tabernacle of the main altar. Opening the small grating, he saw the sphere of the ostensory in its usual place, but when he stretched out his hand to grasp the ciborium containing the consecrated host, he was shaken by a deep tremor of 'horror and fright'.[1] The ciborium had disappeared. The whole city was dumbfounded and shaken by an event of 'such abominable excess' and the church was shortly afterwards invaded by a crowd of the faithful, 'shedding tears'. The whole of Carrara echoed with 'shouts, exclamations, sobs, tears and painful confusion', while ecclesiastics and citizens hastened to repair and to expiate the damage, abandoning themselves to 'austere penitences', initiating 'vigils' and preparing to withstand severe, propitiatory 'fasts'. Public processions began to move from different parts of the city.

The Omnipotent, although 'indignant after such an enormous affront', was moved by the 'singular sentiment', by the universal affliction and by the 'forceful' tears of the faithful, and deigned to 'illuminate the pious and zealous soul of the city's patron, the Duke, so that the culprit would not remain unknown and would be punished for this atrocious misdeed'. One of the Duke's subjects, a certain Niccolò del Medico, familiarly known as Cavanella, *nullo praeveniente inditio*, was immediately arrested and that same evening was taken to gaol. The ducal inspiration appeared (so it seemed) to be right. The machinery of the Holy Tribunal was immediately set in motion and the Inquisitor General of Genoa, under whose jurisdiction the ducal city fell, made a lightning entry into the bewildered city. The inquisitor, Padre Andrea

Reali from Forlì, set to work straight away and soon threw light on the circumstances surrounding the 'sacrilegious and heretical' theft.

It was thus verified that

> the prisoner, Cavanella, on the stated day and hour, having, in a daring and bold manner, forced open the grating of the tabernacle containing the key, had lifted up and stolen the ciborium inside which was the consecrated host. And having left the church, clutching the ciborium to his breast, he had gone to a certain wine store or tavern. And from there he had made his way home and, having opened the sacred ciborium, had, with unheard of impiety, emptied the consecrated particles into a filthy handkerchief which was itself then wrapped in a foul canvas cap; the sight of these articles was horrifying to behold and they emitted a fetid smell, both of which things are repugnant to the most pure body of Jesus Christ, our Redeemer and immaculate Lamb. And following this, while invoking the hell of hells, he had broken the sacred ciborium into four parts and had hidden them separately in the straw mattress of his bed. And then, having left the house with the consecrated host in his breast pocket, wrapped up as has been described, had himself condemned the sacrilegious theft and had said that whosoever had robbed the Lord had committed a great infamy; and having approached the Church of the Carmine, which was crowded with persons weeping for the loss of the spiritual food of their souls, this disgraceful character was not even moved to compassion or contrition. And finally, having been shut up in gaol on the same day as he had committed the abominable excess, at daybreak the following morning he had eaten, consumed and devoured, with his infamous and sacrilegious mouth, all the sacred particles, counting them one by one up to the number of 215 or more'.

If the theft of the ciborium appeared 'sacrilegious, heretical, atrocious, horrendous, abominable and enormous', the contamination of the most pure by the most foul caused even greater dismay. Even before the official sentence had been issued, the tribunal of the senses (sight and smell) and judged as horrific the ignoble proximity of the uncontaminated body of Christ with the 'filthy handkerchief' in which it had been wrapped, then placed in 'the stained canvas cap', belonging to the callous drinker who, immediately after the robbery had first of all made his way to the wine store to refresh himself (it was July). Perhaps the indignation would have been less if the consecrated host had ended up in a silk cloth or a scented brocade. The nature of the crime, the broken ciborium, the notorious handkerchief, together with the unclean and foul-smelling cap, which were attached to the records of the trial, bound Cavanella to his weighty responsibilities. The guilty party, having been suspected, interrogated, convicted and accused,

126

was transferred for reasons of security from the prison of Carrara to the stronger fortress of Massa where he was guarded in the name of the Holy Inquisition. However, a serious doubt continued to torment his inquisitors even after his confession: had Niccolò del Medico carried out his sacrilegious and heretical act 'on the advice and suggestion of others', or had he acted spontaneously from special personal motives? They finally heaved a sigh of relief when the hypothesis of external incitement or instigation, of a commissioned robbery or, worse still, of a latent heretical plot was demonstrated to be unfounded. And, accepting Cavanella's confession, they were persuaded that this disconcerting character had been 'guided by a diabolical spirit' and by 'his evil will', or rather 'by his own malice'.

At this point the case was closed since there was nothing further to verify. The time had arrived to pass from the secrecy of the interrogations to an open trial. The spectacle could now commence. On 12 December that same year, 'a large stage' was erected in the church of Saint Francis belonging to the Observant Minorites of Massa, and 'the whole area was covered with funeral hangings, and the chairs, carpets and cushions were covered in black material. On the stage sat the Holy Father Inquisitor, assisted by his magistrate, who acted as lawyer to kings and chancellors; a simple cross, without the figure of Christ, was raised above the main altar which was also covered in black; the tribunal in which the Lord Duke was to sit was likewise decked out in mourning.'

Outside the presbytery in which the principal stage had been erected, the gloomy benches had been set out in rows of chairs and armchairs, reaching as far as the sumptuous marble chapels, and, according to the ranks of the ecclesiastical and noble hierarchies, they were reserved for the 'Inquisitorial office-bearers', for the officers and gentlemen of the Duke's household, for the knights, nobles and 'regular' clergy. The Commissioner of Massa installed himself in one of the two chapels attended by his criminal chancellor and by members of the secular clergy. The other chapel, which lay opposite, was reserved for the ladies of court and for the noblewomen of the city.

In front of an 'innumerable crowd' which had gathered on the morning of that same day, while the largest church bell tolled, the offender, holding an unlit candle in his hand and escorted by German guards, was made to climb on to another small platform, also covered in black cloth, to the left of the pulpit from which the summary of the trial and the sentence would be read. The Holy Inquisitor stood up to speak and his fervent but erudite speech so deeply moved the audience that they broke into 'the most uncontrollable weeping'. The only

127

person who did not shed a single tear was the culprit, Cavanella, who showed no sign of emotion, nor the smallest trace of contrition or repentance.

A week passed. On 19 December, after darkness had fallen and the second hour of night had just struck, at about six o'clock in the evening, twenty brethren from the Confraternity of Saint Rocco, the confraternity of death, made their way in the direction of the fortress. They were dressed in black sacks, their hoods hanging over their faces, with 'ugly hats' on their heads; each of the brethren carried a small crucifix draped in black, and they were preceded by a majestic Christ on the cross which was illuminated by the four black torches. This lugubrious procession, which made the entire population shudder with fear, was formed by the comforters as they headed towards the prison with 'balsams, cordials and everything else that the condemned man might have needed'.

Two Capuchin fathers, two Observant Minorite friars, three canons, an abbot and the rector of the ducal pages followed the twenty collegiate 'comforters'. In the freezing fortress the condemned man passed the long night slowly and without sleep. One by one the comforters took their place beside Cavanella, who was condemned 'to be hung on the gallows', in order to persuade him to die, if not willingly, at least serenely and as a good Christian. Such a large number of persuaders was justified by the extremely delicate nature of the case. It was not unusual for a man condemned to capital punishment to react in an unseemly fashion even in those last, tormented hours. The 'comforters' assistants were often sorely tried by the dying who refused to leave this world as Christians and preferred to pledge their souls to the Devil rather than to the Redeemer. Popular ballads adopted these sad heroes of evil and passed on the tales of their impiety to posterity. For example, the death of Angelo Secchiarolo, known as Bigaratto, was described as 'shameful': this mass-murderer obstinately refused to plead for the mercy of God and the Madonna, and pushed the crucifix which the confessor waved in front of his eyes away in disgust, saying in a loud voice, 'It's revolting',[2] much to the horror of those present.

Even the last hours of those who did not pass on such a blasphemous memory of themselves, those who agreed to abandon themselves serenely to God's mercy, were disturbed by the shadows and fears of profound uncertainty. At this stage they had been reassured that in some way their souls would be saved, but instead they were concerned for the fate of their bodies which, once they were dead, would be cut down from the rope. The thought, which was not far from the truth,

that they 'would be given to the doctors for anatomical studies and that the hangman would remove the fat' was a cause of 'great anguish'.[3] Those who believed in the final resurrection of the body were more subject to crises of depression. It was well known to all that, 'by custom', the corpses of hanged persons could be handed over to the knives of the anatomists for experimental dissection or teaching purposes, in which case the medical students were in the habit of 'celebrating a certain number of masses, and this – as a professional comforter of those condemned to death observed – must be a great comfort to these wretched persons'.[4] But not all those unhappy individuals shared his point of view, and even fewer appreciated his opinion regarding the free circulation of human fat which was widely used by seventeenth-century apothecaries. The Jesuit Giacinto Manara, who had no objections against the therapeutic use of the fatty tissues of the hanged man, was instead worried that the flesh, bones and hair of the deceased would end up in the hands of untrustworthy persons, who were 'suspected' of using them for abominable deceptions, and for 'the most powerful witchcraft'.[5]

> If he can, the executioner removes their fat in order to sell it as medicine for other persons' bodies, since it is a cure for aches caused by the cold, and this seems to be quite barbarous, at the most since the fat must be poured and liquified, like that of other animals; but in spite of this, since it was seen that the executioners removed the fat, purged it and sold it, and because it was of great help to these aches, they were allowed to do so. The confessors were warned, however, when these rascals confessed themselves, to tell them seriously to take care not to give such fat to suspected and untrustworthy persons, because many unworthy deeds can be performed with the fat and flesh of human bodies . . . So on these grounds, the poor condemned men had reason to complain that their flesh, bones, blood and fat might be used in witchcraft when their bodies were hung from the gallows, or that they might be given to the anatomists.[6]

It was not easy to console these doubtful individuals, but none the less the 'prudence' of the confessors and 'brethren' (the members of the 'Confraternity of Good Death') could resort to two well-founded arguments. The first, an expanded variation of a bitter Ciceronian reflection, consisted of accepting the distressing truth that it matters little if

> a corpse decomposed in the earth, or out of it, when it is deprived of senses, it can be broken, cut up, divided, eaten; in any case inside the

tomb the conditions would not be any better: the flies, worms, rats and spiders would dissect it, and then the teeth of these little creatures would pick its bones, pulp and marrow.[7]

According to the second inconfutable argument, these individuals should be persuaded that 'although their corpses were cut up by anatomists, they would still be resurrected'.

Since it is a matter of faith that these bodies will resurrect on the day of divine judgement, they have no reason to complain that they are cut up and broken, since this will happen to them in any case in the tomb. One can support the faith of the condemned men with the example of the Saints who were devoured by wild animals, which is much more than having their flesh stripped by anatomists, yet without exception they hoped for the resurrection of their bodies.[8]

It seems that Niccolò del Medico, alias Cavanella, did not cause the formidable team of charitable assistants too much trouble. He was not particularly worried by his imminent fate, and was detached from and indifferent to the emotional excitement of his co-citizens. He accepted the merciful aid of the twenty-nine comforters with quiet compunction. Although a frequent visitor of drinking taverns, he refused (perhaps for the first time in his whole life) the wine which was offered to him; he allowed himself to be repeatedly confessed, listened twice over to the recitation of the rosary and, towards dawn, partook in the mass. Finally, he took holy communion, or in other words he was 'restored by the most holy sacrament'. The impious and sacrilegious eater of the host (as had been proved, he had devoured at a single sitting at least 215) swallowed the holy particle with apparent joy, consolation and ecstasy. In truth, towards midnight, a strange metamorphosis had begun to take place in the inveterate sinner: he began to feel himself a disciple of Christ and tried his best to emulate his actions. As the Redeemer had been led barefoot to Mount Calvary, so he too succeeded, after much insistence, in having his shoes taken off and his legs left bare so that he could reach his little Golgotha barefoot. In an almost ecstatic reverie he began to shine with joy, talking of celestial delights and dreaming of Paradise. At last, as the first light of the wan December day broke, the 'patient' together with all the confraternity and the emergency assistants, emerged from the fortress and headed towards an open place next to the Grandini Canal where the gallows had been erected. Between *Miserere* and psalmody, *De profundis* and generous aspersions of holy water, he was handed over to the executioner who, according to customary procedure, carried out

the death sentence. Cavanella was left dangling from the gibbet until darkness fell. To many observers it seemed that 'while the prisoner's body was hanging from the gallows, his face (was) livid, black and terrifying; but when it had been cut down it appeared to be very handsome and ruddy, which was commonly attributed to be a visible sign of the salvation of his soul'.

Much amazed by the different faces of the hanged man, the people thought that the journey to the last shore had not perhaps been without various drawbacks and difficulties, but at last he had made it. These popular conjectures would no doubt have been confirmed by the opinions of those expert comforters who, like Brother Carlo Verri of Cremona, were able to remove all 'doubts concerning the state and salvation of hanged prisoners after their death'.[9] The hanged man's 'handsome and ruddy' face was the assurance, the 'sensitive indication' that poor Cavanella had succeeded in avoiding the house of the Devil; a hanged man who had not repented and had not died a good Christian would have been like Judas, 'pale, bloodless, verminous, leprous, stinking, dirty, abominable, injured, aching and afflicted'.[10] Although he had perhaps not died a saint, that classic question was very nearly asked of Niccolò del Medico: how and 'why is it that many of those who are condemned to death by the law, because of being thieves and cunning, evil men, none the less die like saints?'[11] If the truth be known, the 'charitable and patient' comforter had an almost always infallible trick up his sleeve with which he comforted the 'hardened and obstinate' condemned man: hell.

> There is no toothache, or pain from colic, gout, or kidney stone in this life which is not a mere joke compared to the pains of hell. The heat of the highest fever, the punishments which are dealt out to evildoers in this life, torture, thumbscrews, the prevention of sleep, the rack . . . are mere games and amusements compared to the crucifixions which exist in hell.[12]

Christmas was drawing near and the Duke's subjects could now think of celebrating the birth of the immaculate Lamb in peace and joy, and happily wait for the imminent arrival of the year seventeen hundred and twenty-four.

In eighteenth-century Italy fires had not been lit to burn witches or heresiarchs to ashes for a long time, but the gallows were still used for sacrilegious robbers and for the desecraters of the consecrated host. The punishing flames still rose to incinerate those who had used the

sacred host for illicit dealings, as in the case of the false priest Domenico Spallaccini who was burnt (immediately after having been hung and therefore he was presumably already dead) in Campo dei Fiori, Rome in 1711.

The existence of capital punishments did not, however, prevent peculiar cases, like that which took place in Carrara, from occurring. The story of Niccolò del Medico appeared almost incomprehensible since it was hard to imagine that anyone could be willing to risk being hanged for the sake of possessing a fistful of consecrated wafers. That Cavanella was not a common thief of sacred objects, and that he had set his eyes not on the ciborium but on the host ('he held and took away the sacred particles out of his own wickedness') seemed to be an irrevocable fact. But it is precisely the object of the robbery which makes the episode so obscure, since it is difficult to understand what the motive was, for what purpose the host was to be used. At this point, everything becomes confused and inexplicable. If a person, even a poor devil from Carrara (who was probably prejudiced), was ready to risk his neck to lay his hands on the sacred wafers, they must have had not only an exceptional symbolic value but also a considerable market price; the demand was sustained – as one might say in impious modern economic terms – by a very reduced, indeed virtually non-existent supply.

It may have been that the unfortunate Cavanella had been entrusted to act on commission (even if the inquisitors had excluded this hypothesis) and that the purchaser of these red-hot and extremely risky goods may have been someone who had particular connections with 'witchcraft'. But one might also suppose that Cavanella had decided to keep the host for himself, perhaps placing any extra on the market. However, given the impossibility of knowing his intentions, one is forced to reach the (not very arcane) conclusion that the consecrated host was such a precious (and therefore requested) object that it was worth risking one's life for it. Given this premise, one can deduce that there must have been a clandestine consumption of the sacred unleavened bread, a network of dealers and sellers and, obviously, a market of consumers.

It is difficult to envisage today the irradiating power of the 'bread of life', the fascination of the particle into which a hidden and invisible god had prodigiously fallen; likewise, it is almost impossible to measure the suggestive power emanating from this concentrated source of divinity which was miraculously imprisoned in a fragile wafer of holy bread. In this way the supernatural came within everyone's reach, the infinitely great was shrunk into a fragment a few centimetres wide, and

an immense force was enclosed in an insubstantial and aereated disc. This divine energy could be subjugated, exploited and utilized, in a perverted sense, in worldly tricks and magic spells.

The 'most holy body' and the 'most precious blood',[13] the food and drink of redeeming salvation, constituted the principal sacrament on which 'the Apostolic Roman Church' had been founded; and the Church acted as its intransigent custodian, 'duly engaged in ensuring that both the greatness of such a benefice and the holy veneration which was owed to it excelled at all times'.

The Roman Church, which was tolerant and sometimes indulgent towards other transgressions, retained an inflexibly rigid position on this cardinal principle throughout all centuries. The criminal violators of the sacred eucharist had to be severely punished. The guardianship and exclusive monopoly of the host by legitimately consecrated priests were jealously defended using the strictest methods.

It was not possible to use the sacred particle in secular matters with impunity: 'the venerable yet terrible Tribunal of the Holy Inquisition', 'the most powerful shield' of the faith and 'the most severe judge of those who arrogantly attempted to offend the host, guarded those convicted of sacrilegious crimes with the utmost diligence'.

On 18 July 1711, a false priest, who had treated the host with improper confidence for too long, was handed over to the Tribunal of the Governor of Rome, having been found guilty by the Inquisition. The day before in the hall of the Holy Office, a priest, who was also a chorister at the Minerva, had publicly read the proceedings of the trial and the final sentence in a 'loud and clear voice'.

Having been condemned to death and handed over to secular justice, he 'was hung and his corpse was then lowered on to a stool bound to an iron stake on top of a pile of wood where it was burnt and wretchedly turned to ashes before the whole population . . . on the Piazza of Campo dei Fiori'.

The corpse which had been burnt and incinerated using this extraordinary 'device' had belonged to the unfortunate soul of Domenico Spallaccini, from Orvieto, alias Giuseppe Bonifazi, self-appointed Roman citizen, alias Domenico Spadaccini, alias Andrea Rosignuoli, a sly criminal who had been in trouble with the law since 1698. Having been imprisoned for the first time in Orvieto, accused by the episcopal court of procuring and then by the secular court of theft, he had escaped from prison and was condemned *in absentia* to five years in the galleys of the fleet of Saint Peter. Having been captured a second time and condemned *ad opus*, he succeeded in escaping again after fourteen months and wandered around the world inventing new illegal tricks.

Expertus in truffis (expert in fraud), this ex-procurer placed a higher and, all things considered, more hazardous stake on the precarious card-table of his existence. Being gifted with various talents and a quick and ingenious imagination, he disguised himself as a priest and began to perform his delicate ministry in the shadow of the holy Roman palaces themselves. According to the accusation, for five long years he regularly celebrated the tremendous sacrifice of the mass every day. Nor did he take mass in little-known churches or in out of the way parishes. On the contrary, he recited his first unlawful mass in the Paoline chapel of Santa Maria Maggiore and gradually, day after day, he recited others in the principal churches and basilicas of the papal city. He was an excellent imitator and a first-class actor, and he slowly succeeded in identifying with the role which he had discovered, performing it with passion and dedication. He may perhaps have been fatally attracted by martyrdom, by a ruinous and secret vocation. He was not what one might commonly call a good shepherd, but undoubtedly he had a profound knowledge of his profession.

As chance would have it, one day he was inexplicably induced to travel as far as Loreto where he had sworn never to return since some years earlier he had carried out a series of robberies there. Having acquired a 'dimissory' letter, which had been falsely extorted, he succeeded in saying mass twice in the chapel of the Holy House, and on another occasion at the altar of the church of Saint Anna. In Loreto, as elsewhere, he succeeded 'with a sacrilegious hand' in 'celebrating the Holy Sacrifice more than once' and in communicating 'several persons sometimes with consecrated particles and at other times with non-consecrated particles'. But the acrobatic tricks of the false priest were performed for the last time in Loreto. Having probably been recognized, the impostor was finally arrested. He was taken to prison and when searched he was found to be without a breviary but with a 'box full of the host'. He was then taken to Ancona where the Inquisitor sent him back to Rome. On 17 July, after the proceedings had been read, the sentence was heard. All the sacristans of the basilicas, churches and oratories of the Eternal city had been summoned, on pain of imprisonment to attend the audience in the hall of the Holy Office.

10

The 'Stupendous Excess'

The Church guarded the sanctity of the host, the 'venerated sacrament which contained the truth of the world',[1] with particular severity. In an inexplicable fashion, the greatest of prodigies was condensed in this white disc, and it hid the 'truth of the world', the secret of all secrets, the greatest mystery. The sensation, or rather the conviction that the most potent invisible powers were concentrated in this divine fragment—totality, *immensum in parvo*, was widespread at all levels. Faith and superstition found a meeting-point in the host.

If, on the one hand, the host was considered to be a portentous talisman, on the other the consecration of the eucharist was often listened to as if it were a spell.

In the same year that the corpse of the self-styled priest Domenico Spallaccini was burnt in Rome, a theologian of the cathedral in Cesena, Giovan Battista Turrini, expressed the profound fascination of the consecratory formula in verse. In his opinion the transmutation of the substance, the metamorphosis of the species and the mystery of the transubstantiation were inexplicable marvels, and examples of the most powerful and most unattainable magic. 'Oh, divine miracles in the form of bread and wine!'[2] The Catholic priests themselves regarded the 'consecratory enchantment', the incomprehensible spell which radically erased the substance of the bread while conserving its outward appearance with amazement:

> Thus, in the consecratory enchantment of a God,
> The substance of the bread is consumed in a moment,
> And the species is saved under a fragile cloak.
> The wonderful Wheat penetrates the Elect and,
> In the meanwhile, within the Bosom of the Accidents
> A thousand prodigies transform it into a single miracle.[3]

135

These miracles of divine birth and death could be reproduced at the altar daily, in any number, anywhere and at any time. In this uninterrupted sacrifice which took place inside a small piece of bread, an earthly fragment was transformed into heavenly flesh:

> . . . Every day a God is thus born and dies in the Host,
> Multiplying the number of dawns and settings.
> At the sound of the Word, the Word is born in the Bread
> And dies representing its torments,
> Uniting tomb and swaddling bands on the altar.[4]

The act of faith, by means of the bread and the wine which became flesh and blood, was transformed into a cruel scene:

> The venerated Synaxis is a sea of blood.[5]

As the only sacrament which did not influence the soul alone, but which also had a very powerful effect on the body, the sacrament of communion represented an intimate fusion between the flesh of man and that of his Creator.

> Oh, the final end of all prodigies,
> The limit of an infinite hypostasis.
> The Crown of the Word will be united
> By your very same bonds to Adam's body.[6]

'Our miserable flesh' absorbed the 'properties of the Redeemer's blessed flesh' and was regenerated and strengthened by this magic contact. A disturbing trauma, a blast of divinity, a draught of paradise surged through the communicant's veins:

> whereas the other sacraments normally only sanctify the soul, the Lord wishes that the Eucharist should sanctify both the body and the soul: thus, He ordains that the body should assume a role in the miraculous marriage which through the holy communion He intends to contract with the ever faithful soul. So that in this way the whole man is deified by this divine union. This is the case not only in those truly bodily functions which must be performed by necessity, such as eating, digesting, and nourishing ourselves with the sacramental species, but much more so in that sublime, spiritual union by virtue of which the powers of the blessed flesh of our Saviour become part of our wretched flesh.[7]

The effects of the 'most sublime conjunction' with the Saviour's 'triumphant flesh'[8] were twofold and involved both the present and the

future. In the present, its therapeutic effect on the short-term physiological pattern was similar to the balsam which acts as an antidote to snake venom, since it diminished or moderated the 'dissoluteness of the sensual appetite'[9] and mortified the 'evilness of iniquitous clothing'.[10] In the future, which was certain despite being very remote, the host endowed human flesh, the sole possessor of 'such great privileges in our body',[11] with a 'special right'[12] to resurrection:

> if it had not already been ordained by almighty and eternal decree, that every man, on the Last Day, would start to live again in his old limbs, none the less, whoever had once worthily partaken of the most holy eucharist, even only once, would start to live again, since it was not fitting that his flesh should remain in death's clutches for ever once it had been so intimately joined to the triumphant flesh of the Redeemer.[13]

The new eternal life for the 'old limbs', the resurrection of 'our miserable' flesh through the 'triumphant flesh of our Saviour', the redemption of the body which at long last became immortal and at one with the divine, the final sublimation of the body, the desire for eternal stability and 'freshness of the flesh'[14] after all the misery, suffering and turmoils of earthly life, and far from the 'punishments of this world', 'which are said by the saints to be a shadow and foretaste of hell'[15] (where 'nothing is stable'[16]) and all the desire for and dreams of a heavenly 'after-life', immune from corruption, deterioration and change, were concentrated in the mysterious particle, the viaticum for the journey to the other world, the country of light and perfect beatitude.

The resurrection of the flesh, the reconstruction of the body ('this most astonishing form of dogma' in which 'Adam's corrupted and poisonous flesh' which 'stank of sin' and contaminated the soul with its poisons and miasmas, was united to 'Christ's redeeming and life-giving flesh', which even when chewed remained intact ('Christ . . . is eaten in portions but remains whole') (Ugo of San Vittore)), had already begun on earth with the aid of the 'divine food' which strengthened not only the soul but also the body after it had been 'improved' by 'the bread of life'. This divine bread with boundless powers was the miraculous device which led to the 'glorified body', to the fruition of those four heavenly 'gifts' of the glorious and triumphant flesh: 'radiance, impassibility, fineness and agility', and to the 'well-being of body and soul'. These were the gifts of nature of which the damned were deprived for all eternity, condemned by divine justice to suffer the outrages of similar but negative gifts (the over-

turned and opposite forms of the heavenly gifts): 'the qualities of darkness, passibility, liability to touch, weight'.

The 'supersubstantial bread' with its immense powers, the 'bread born in the Virgin, risen in the Flesh, kneeded in the Passion, cooked in the oven of the tomb and seasoned in the churches' (Saint Pier Crisologo, *Sermon* 67), contained invincible, uncontrollable and bivalent forces. It had always to be handled with 'fear and reverence'.[17] Whoever guarded or used it was obliged to follow precise rituals, and to perform a series of emergency countermeasures if by pure accident, and not through carelessness or negligence, it slipped from their hands.

> Wherever the most Holy Sacrament, or part of it, fell, one must immediately and with reverence pick it up and replace it where it was before. Then one should look very carefully to see if there are other fragments and, if any are found, pick them up with equal reverence from the place where they had fallen. And, if possible, the place should be shaved and the razor should be burnt and the ashes placed in the Sacrarium; or instead, if the place where it fell is not disgustingly dirty, one should first lick it since there is no danger of nausea. And if the place is such that it cannot be shaved, in the most respectful fashion one must clean it and then cover it, until it can be conveniently washed and the washing water poured into the Sacrarium . . .[18]

Not through the will of the celebrant, but on account of the perversity of the communicant, the host could be corroding and deadly to whoever approached it with impiety and whoever swallowed it without due reverence:

> There is always ruin and execration for those who take it unworthily, not because of the institution itself or because of the will of the celebrant, but because of the perversity of those who take it. Let him believe that there is no salvation who does not believe that under the form of bread there is flesh. We believe there is flesh, that there is salvation, but not for every one who takes it.[19]

The bread of life could become a deadly mouthful for anyone who impiously gobbled it up. With quiet violence, Doctor Angelico's verses spelt out the two different destinies:

> The good take it, the evil take it,
> But with unequal results,
> Of life, or of death:
> There is death for the evil, life for the good.

See, how different is the outcome
Of an equal consumption.

The ninth section of the *Dialogus miraculorum* by Caesar of Heister-bach contains a lavish catalogue of the miracles performed by 'the sacrament of the body and blood of Christ'. But, centuries after the death of the day-dreaming German Cistercian monk, in post-Galilean Florence, people still asked how on earth it was possible for 'the host, which was salvation itself, also to be an instrument of death, and moreover of eternal death? How could this peaceful host ever be hurtful? A saintly host? And yet Saint Augustine was right when he said that many having received it at the altar then meet their death, wherefore Angelico, and after him the whole Church, stated in his devout poem, "There is death for the evil, life for the good" . . .'.[20] It was a layman, the academic Apatista Agostino Coltellini, who listed a series of horrifying 'cases' to his pious master, the Grand Duke Ferdinand II dei Medici.

First of all, as proof there is that unworthy priest who, immersed in so much carnal refuse, continued to celebrate mass and as a result his tongue and half of his face became rotten, thus demonstrating, unwill-ingly, by the stench of his decaying face, how much the pestiferous smell of his contaminated heart was abominable to God. Another priest came to keep him company in his misery, since he performed his villainous deeds by celebrating mass daily with contaminated hands, and one morning while he stretched them over the altar, a voracious flame shot down from Heaven and incinerated them as far as his elbows. And what shall I say of that unhappy man who consecrated unworthily all his life, and when he reached the end of his days with such a grave burden, the Devil appeared before him, disguised as the parish priest, to administer the viaticum of perdition to this, the worst of dying men. And the Devil tried to communicate him with a burning patena filled with the flaming host but the man resisted, and the infernal minister, who had presented himself for no other purpose than to kill this victim and to sacrifice him to Lucifer, with a diabolic smile told the man that he wished to remove him from his own body. And putting the particle of fire in his hand with excessive pain it passed from one side to the other; and he was thus handed this pathetic and pitiful assurance of perpetual misery in this way.[21]

On account of this occult power of justice, in the Middle Ages the host was resorted to in cases of '*purgatio canonica*'. In suspected cases of witchcraft or of sacrilegious robbery, or in other obscure circum-stances, the 'consumption of the most Venerable Sacrament of the

Eucharist' was used as a demonstration of truth. The perjurer, sacrileger or defaulting party who had unworthily abused the body of Christ met his end soon afterwards.

Madmen and the possessed were miraculously cured by the sacred particle, and this heavenly medicine also worked miracles in the sick. When applied to the ailing, wounded or ulcerated part the host miraculously healed it. Saint Augustine described the story of the mother of Acaccio who placed a poultice made from the eucharist on the eyelids of her son which had been stuck together since birth. The host also protected the faithful from fire, storms at sea and shipwreck. As the great pastor of the diocese of Milan, Saint Ambrose, recalled in the sermon which he gave at his brother Satiro's death, the latter had been saved from shipwreck by the holy bread which he carried round his neck. This custom was widespread among those of the faithful who had to face the dangers of sea journeys in the early centuries of Christianity.[22]

The number of the host's miracles was even greater against heretics. A pious priest threw the host into a river where it drowned several Albigensians who, by demoniacal witchcraft had been walking on the water disguised as false apostles. Likewise, having been challenged by an heresiarch to demonstrate the true presence of Christ in front of his donkey ('Let us see if this donkey will adore your sacramental bread when it is placed before her'), Saint Anthony of Padua, although horrified 'by such blasphemies and proposals', 'accepted the impious and arrogant test through God's inspiration'.[23]

On the agreed morning he celebrated Holy Mass, and coming into the square with the holy sacrament and accompanied by his fellow ecclesiastics, he carried it in front of Bonvillo's house; Bonvillo, with a scornful air, met him there with the jenny. The donkey had not been fed for three days, and so in the sight of the adorable sacrament it was given fodder. But after a brief exhortation to the large crowd which had gathered, to have great faith and to show great devotion to the Most Holy Sacrament, the Saint called the stupid animal in a loud voice and commanded it to come and adore its Creator hidden in the sacramental species. Oh, what a miracle! The donkey immediately left the fodder, came forward, knelt and lowered its head, and remained in that position of reverence until the sacred host was carried back into the church, since it recognized in the host that Man God whom a similar ass had already seen as a child in the manger. This miracle was repeated by the Saint in France. The triumph of the Catholics and the confusion of the heretics may be imagined.[24]

Heretics and Protestants who denied the transubstantiation, fought over the 'heavenly food', outraging and desecrating it in the most atrocious ways:

> some gave it to parrots to be eaten, others to donkeys, others to dogs; some threw it in the mud and filth, others in the fire, others made holes in it and wounded it in different ways with sharp irons, others trampled on it and othes made it into a target for arquebuses.[25]

In order to prevent these profanations, 'misdeeds' and 'inhumanities',[26] the custom spread of keeping 'the sacred host under lock and key';[27] this precaution was confirmed by Pope Innocent III in a decree.

> We have laid it down that in all churches the unction and the eucharist shall be kept in safe custody under key, lest any rash hand be stretched out to them for some horrible or nefarious purpose. But if he whose responsibility it is, leaves them unguarded, let him be suspended from office for three months and if through his inattention something frightful happens, let him be subjected to more serious punishment.[28]

The morbid attraction for the chrisma (the oil, into which balsam was poured, which was solemnly consecrated in a spectacular ceremony on Thursday of Easter week by the bishop assisted by twelve priests, representing the apostles, seven deacons and as many subdeacons), the seduction of the scented ointment which Greek liturgy enriched with thirty-three different aromas so as to liberate 'a great force and abundance of fragrant qualities' (Dionigi Areopagita) and, above all, the temptation to master the occult powers of the host could lead to forbidden crimes, and to 'horrible', 'nefarious' and impious deeds. The 'holy object' provoked irresistible impulses to commit 'monstrous acts', and prompted sacrilegious adulterations. In earlier ages, the 'abuse of sacred objects'[29] was a universal instigation.

The supersubstantial bread, and in particular the tiny container filled with inexplicable powers, the treasure of supernatural presences, emanated the strange fascination of a magic talisman: it could arouse illicit desires, depraved fantasies, secret manias and impure thoughts in some simple or evil souls.

If one pays attention to the witnesses of that time, it would seem that, in particular after the second half of the sixteenth century, the black wave of sacrileges assumed alarming proportions.

'Today,' observed Martino del Rio, 'toads baptize, even for the purpose of malign poisoning and for them, they display the venerable

141

eucharist for swallowing.'[30] In the memorable sentence pronounced by the Court of Avignon in 1582, in the general censure against witches, magicians and satanic rites (a piece of sabbatic anthology which is repeatedly cited by the classical works of witchcraft, from Sébastien Michaelis's *Pneumatologie* to the *Disquisitiones magicae* by Martino del Rio, and Francesco Maria Guaccio's *Compendium maleficarum*), the host appears at the centre of the satanic rite:

> which is indeed most detestable, the very sacred sacrament of the Eucharist, sometimes taken by you or the holy church of God . . . You keep it in your mouths and then wickedly spit it out on the ground, so you dishonour our true and holy God with a greater display of all manner of contumely impiety and contempt, but you advance and honour the devil himself and his glory, triumph and kingdom, and you dignify him with all manner of honour, praise, dignity, authority and adoration.[31]

Nevertheless, the abuses and superstitions concerning the host were widely diffused well before the golden age of witches and inquisitors, well before the dramatic tensions of the late sixteenth and seventeenth centuries. Often the first to unduly misuse its powers were the ecclesiastics themselves; in particular, they used it in 'love potions'. In *Dialogus miraculorum* the thirteenth-century author, Caesar of Heisterbach, described the story of 'some priestly voluptuary' who tried to seduce a woman; but being unable to overcome her resistance, one day, having said mass, he kept 'the most pure body of the Lord' in his mouth in the hope that should he kiss her with the host on his tongue he would oblige her to fulfil his wishes with the help of the sacred body and the sacraments.[32] This blasphemous and 'vain belief' lasted for centuries and underwent many variations. The most common practice, which was often used in divination and love potions, decreed that the powder of a host which, having been previously decorated with mottoes and scrolls written in blood, had been secretly consecrated (hidden under the linen altarcloths) at one or more masses should be added to the food, either soup or drink, of the person to be bewitched. At other times, the 'most villainous' celebrant himself, wishing to be loved, and having uttered 'foul and abominable words',[33] swallowed only half of the host, taking care that the other half, having been reduced to powder, was eaten or drunk by the woman he hoped to seduce.

It was an unworthy and blasphemous custom, a 'mad belief' (as Jean-Baptiste Thiers, curate of Vibrai and doctor of theology, a punctilious investigator of all sacramental deviations, would have

said), to presume that the broken-up body of Christ, if thrown over cabbages could protect them from caterpillars, or that if placed in a bee-hive would protect the bees from sterility and death.[34] Throwing the powdered host over fields and vegetable gardens to make them more fertile ('that they might remove the bane of sterility of the fields'[35]) was a common practice in the agrarian magic rites performed by country witches and magicians.

The miraculous powers of the heavenly bread were able to straighten the deformed and the lame, and make the dumb speak. Men and women with incurable diseases could be healed if they appealed to the host with confidence. It even served to stop the most obstinate headache, as in the case of Saint Pietro of Chiaravalle. The chains of a prisoner who was taking communion were unfettered, and a gentleman who kneeled in the mud to 'revere the Sacrament, rose without the slightest trace of filth'.[36]

Not everyone tasted a particular flavour when they chewed the host, but many described a honey-like taste, an indefinable 'sweetness' which flowed from the palate to the stomach – as happened to the Abbess of Westphalia – 'in such a way that all her inner being was filled with a wondrous sweetness'.[37] Saint Christina 'filled her soul and body with sweetness when she received the sacrament from the altar ... and said that in partaking of this most heavenly food she experienced a sweet taste and that her body was greatly strengthened and her soul became marvellously joyful'. The saintly Giovanni Berchmans (the very pious Jesuit who died aged twenty-two in 1621) affirmed that 'towards the end of the week, if there had not been a day of communion, he felt a certain type of hunger that could not be satiated except by communion'.[38]

This life-giving bread enabled whoever fed themselves 'on the sacrament alone' to stay alive. One heard talk of miraculous fasts and clamorous abstinences which had been aided from above. The folklore surrounding the host in these tales was inexhaustible.

> While he was staying at that great hermitage of Thebes, the abbot John used to stand upright under the roof of a great cave. Persisting in prayer, he used to take communion there every Sunday, and did not take any other food, since the communion fed his body and soul.
>
> Liberale, a disciple of Heliodorus, Bishop of Athens, took communion every Sunday and during the week did not receive other food ...
>
> The blessed Angela of Foligno, of the Third Order of Saint Francesco, received the body of Christ every day for twelve years, and was satisfied by it and needed no other food.
>
> In France, in the year of our salvation 1322, in the Field of Tullius

there lived a twelve-year-old girl who, having received the holy communion, lived for three years without other food, after which she returned to her normal way of life.

In the same period another girl, a twenty-year-old called Palomba of Perugia, lived for seven years on this most divine food alone, and this was in the time of Pope Innocent VIII who examined the matter very carefully.[39]

Some noblemen demanded a larger host than that swallowed by the common people, while others, of low moral standing, refused to receive the host from poor, ignorant, ugly and badly dressed priests. They expected the priest who gave them communion to be rich, cultured, handsome, well-dressed and well-mannered.

In pre-Tridentine society, and particularly in the popular society of the countryside, the clergy had a very uncanonical, familiar and offhanded attitude to the host. Like the priest of Mont'Ughi, near Florence, who was 'not very devout and in many ways rather wicked' – according to Franco Sacchetti – and who, 'while taking the body of Christ to an invalid, saw a man climbing up his fig-tree and shouted dishonest and unheard of words at him, with little respect for the sacrament which he was carrying in his hands'.

Moreover, this coarse Tuscan parish priest, the roof of whose church was kept 'in poor order, especially above the altar', replied to his parishioners when they asked him why he did not ensure that the roof was rain-proof at least above the altar: 'If he wishes it to be rained upon, the altar belongs to him. He said the word, and the world was made flesh; he could easily say be covered, and it would be covered, so that it would not be rained upon.'[40]

Another clergyman, a parish priest in the Mugello, a 'pleasant and not very Catholic' man, was almost drowned by a sudden flood in the river Sieve while taking 'the body of Christ to a sick person'. When his flock told him, 'Ser Diedato, you have much to thank the Lord Jesus Christ for, whom you held in your hand, because we were convinced that we would have seen you drown if it had not been for His help.' He replied:

'In good faith, if I had not helped Him rather than Him helping me, we would both have drowned, both He and I . . .'
And this story spread as far as Florence and the question was asked, more for pleasure than for any other motive, as to who had helped whom. And, for the goodness of our faith which has spread enormously, most people said that the priest brought both himself and the host to safety; but there were also those who alleged the contrary: 'If you were

in great trouble and were about to drown, who would you prefer to see appear before you, the Gospel of Saint John, or a pumpkin to help you swim?'

Hearing this last part, everyone agreed that they would prefer to have the pumpkin. And thus, Ser Diedato was proved to have been right; and the second choice, where all our faith should be, was turned into a joke.[41]

North of the Alps it was said that 'the Italians are contemptuous of the gods'. But this cynical (and facetious) peasant blasphemy was nothing compared to what was whispered of certain priests – the magicians of the countryside round Caserta. Even in the seventeenth century (as is reported in the *Compendium* of Frate F. M. Guaccio) an old story, first told by Gioviano Pontano in *De bello neapolitano*, was still heard; it was a tale of sacrilegious meteorological spells, in which the desecration of the host reached a level of sabbatical iniquity, almost comparable to a black version of the carnevalesque 'feast of asses'.

While laying siege to a piece of ground, which lay under the fortress of Mondragrone, King Ferdinand reduced it to such penury because of the lack of water, that it was about to surrender at any moment. In order to avoid the danger of surrender, some priests, using diabolic and unhallo-wed arts, thought they would invoke the rain to help the soldiers and the inhabitants. Thus, having placed an ass above the door of a temple, as if it were dying, they sang hymns and funereal verses over it; then (oh horror) having placed the holy eucharist in its mouth, they buried it alive. Hardly had this been done than the sky was darkened by clouds, lightning flashed from storm clouds, thunder roared and the air was shaken by winds with such violence and roaring that the trees were uprooted from the ground and flew through the air; the stones were shattered as if by arrows, the rain fell so abundantly that it made the cisterns and riverbeds overflow, and the flood-gates of heaven seemed to have reopened to reabsorb the world. When the King saw this portent he had no wish to continue the siege, but turned his army to go elsewhere.[42]

11

The Mysterious Food

The 'heavenly flesh', the vehicle of marvellous virtues and the trans-mitter of abstract, impalpable powers which enabled the soul to communicate with the Ineffable, was widely regarded as a mysterious, superhuman form of nutrition: it was likened to a divine marrow, which generously distributed both salvation and health ('*salus*' was the ambiguous term which contained both meanings making it difficult to differentiate between them), a heavenly manna and balsam, a super-natural medicine and the 'health-giving elixir of life from his precious blood' (Giacomo di Coreglia, *Pratica del Confessionario* (The Practice of the Confessioner)). With good reason, the sacrifice was described by Saint Ambrose as '*Tutamen et salus animae et corporis*', the protection and health of the soul and body, and the remedy for all spiritual and bodily ills'.[1] Christ was the great healer who, by feeling the 'pulse of the soul', eradicated the evils which were at the root of the diseases of the body; he was the 'doctor who was able to cure all infirmities' using the remedies of confession, eucharist and extreme unction.

> The doctors admit that the organs and parts of a dead man when applied to the organs and parts of a person with whatever form of incurable disease, by following a certain form of sympathy, have prop-erties which are capable of curing it; that is to say, if one puts head to head, mouth to mouth and hand to hand ... Now, if the body of a corpse can have so much power, what would the body of Christ, which is pure virtue, not be capable of? (Padre Clemente Simoncelli, *Guida de'Moribondi* (*Guide for the Dying*), Naples, Tomasi, 1662, p. 120)

As a *medicina sacramentalis*, the 'little round cordial ... made of the rarest powder' should be taken 'at least one hour before dinner'[2] (according to the spiritual recipe of Saint Francesco of Sales). It was

146

an excellent tonic, 'an antidote against all ills' and a powerful reconstituent; moreover, this 'most heavenly and most precious food',[3] this 'sacred powder'[4] contained the inexplicable virtue of restoring lost energy.

> 'If anyone is wasting away with hunger, or desires to restore his strength in battle,' as the blessed Lorenzo Giustiniani advised, 'let him take faithfully the sacrosanct mysteries of the body of Christ and he will at once be restored for the better to his original state of virtue.'[5]

An even more surprising prodigy was that the 'sacramental food', by suspending the laws of nature and nullifying the fundamental rules of life, was able to nourish the body without the troublesome daily necessity of eating. Blessed Gerardo Maiella, lay brother of the Congregation of the Redeemer, which was founded by Saint Alfonso de Liguori, 'restored his spent bodily forces'[6] with the 'bread of angels', 'a far sweeter and satisfying food' than any earthly nutriment. Not only the saints and the blessed, but also simple men and women of intense faith experienced the effects of this supersubstantial bread. 'The food of life' hid within itself 'multiple forms of strength, not just of the spirit but also of the body'.[7]

Among other miracles, Caesarius of Heisterbach told the story of the rich and deeply devout peasant woman who, having taken communion each Sunday, did not feel any need to feed herself for the rest of the week. 'The food of life gave her such strength that without any bodily hunger she awaited the following Sunday.'[8] The bishop was suspicious of this incredible fast, and advised her confessor to give her communion with an unconsecrated host in order to put her to the test. Unaware of the bishop's strategem, the woman had barely returned home after taking false communion when she was seized by such hunger that she feared she might die if she did not eat something immediately ('As soon as she returned home, she began to be so very hungry that she believed she would die if she did not eat something forthwith'.[9]) Fearing that such sudden and raging hunger was a sign of her sins, she ran to the priest and recounted the horrible situation in which she had found herself, bewailing that the divine grace had been so brutally withdrawn from her. The priest, praising the Omnipotent who alone could have caused such 'a great miracle', immediately gave her the true body of Christ whose prodigious power immediately quelled her ferocious hunger and restored the grace which the bishop – the tempter who had been, in his own way, overturned – had removed by this trick.

147

This artless medieval parable of the occult powers of the host, this example narrated by the candid Cistercian, a collector of prodigies, revealed in melodramatic terms the 'infinite power'[10] of the 'mysterious food'[11] whose 'sweetness removes the appetite of all creatures',[12] quelling their hunger with 'taste and pleasure'.[13] And even in early modern times, the 'effects of the most Holy Sacrament on the body', its 'admirable taste'[14] and its 'penetrating delights'[15] were still considered both striking and marvellous. Both body and soul were profoundly affected and involved.

> 'The most Holy Sacrament was instituted as a food for the soul,' observed one of the most authoritative Jesuits of the seventeenth century, Jean-Baptiste Saint-Jure (1588–1657), 'and primarily and principally it produces its health-giving effects in the spirit; but nevertheless, according to the steadfast opinion of the Holy Fathers and Doctors, it is certain that it also influences the body by its virtue and strength...[16] The same is true of the soul which receives Our Lord in a worthy fashion; it will be like the musky and perfumed man who visits a friend, and embraces him, touches him and stays with him for some time, and when he leaves the room, the friend is pervaded by his perfume and scent, and through them he is obliged to remember the other man although he cannot see him. In the same way, when Our Lord enters or leaves a soul whose body has received Him, He leaves a particular smell of balsam and other pleasant odours as the indisputable signs that He has been there.'[17]

The presence and the memory of the divine visit spoke through the language of smells and both were linked to the blessed aromatic revelation. With its 'penetrating delights'[18] the comforting and inebriating divine flesh narcotized the spiritual flesh of the 'human heart'[19] and brought it to 'a state of rest and wonderful tranquillity'.[20] These sweet-scented ecstasies were the work of the heavenly distiller who descended to inebriate us and, 'to purify our flesh by his sacred touch'.[21]

Like salt which had the 'power of preserving dead flesh which would otherwise have become putrified and a source of worms',[22] so the 'infinitely holy and infinitely chaste'[23] flesh transformed man's flesh with its divine perfume, in the same way as the 'flesh of some birds of the East Indies never decays because they feed on aromatic flowers and grasses'.[24]

The bread of the angels 'excels all savoury tastes and surpasses all sweetnesses which may flatter our senses'.[25] To such an extent that 'the body in whom the Pascal Lamb resides, hears admirable matters,

sees marvellous objects and says unheard of things', while the 'power of the mysterious wine which he has drunk fills his soul with inexplicable joy'.[26]

'Miracle of miracles', the 'most divine sacrament' produced 'saintly and marvellous effects' through the inner workings of the soul, and 'also through outward signs and miracles':[27] the possessed were freed, the lame ceased to limp, incurable diseases were healed, 'prison' chains were broken and warriors and duellists were given strength.

'Before leaving the camp with his army', Archduke Leopold of Austria 'ordered a solemn procession to carry around the Holy Sacrament in order to ensure the aid and protection of the God of victories; moreover, he used to fortify himself and his soldiers with what the Scriptures call 'the bread of strength'.[28]

The magic particle usually inspired 'joyfulness, sweetness and spiritual tastes';[29] yet not everyone experienced these 'tastes', but instead they felt 'boredom, sadness and bitterness':[30] the 'sweetness' and the taste of manna and honey which the body of Christ released, was inexplicably transformed into a bitter mouthful. These contrasting effects were induced by an obscure bivalent force. In the same way, certain long and miraculous fasts may have been the work of the subtle arts of the Tempter. Martino del Rio told the story of a young girl whose throat was blocked by the Evil One ('thus blocking the passage of her throat'[31]) so that for nearly seventy days she could neither eat nor drink ('admitting no food and no drink for some seventy days and as many nights, the Devil revealed his fast in a captured and possessed vessel'[32]). Surprisingly, after such a long fast, which was then prolonged for a further fifteen days during her stay in the monastery where she had been taken to find help, the young girl was as healthy as before, and showed no signs of having lost weight, or of being exhausted or pale. The demon was exorcized using the eucharist.

Whoever could succeed in not living an 'animal life'[33] like other common mortals, whoever could survive 'without recourse to the usual instinctive habit'[34] and nourished themselves on the food of angels alone, whoever succeeded in the 'monstrous and immense task' of living without food, moved in a sphere of supernatural 'stupor and excess',[36] in an ambiguous and alarming space which was inhabited not only by angels but also by demons, who also do not eat; they found themselves in a country where saintliness and degradation exchanged roles, and where the sacred could disguise the perverse face of wickedness. A late fifteenth-century chronicler from Cesena recorded in his diary, with some perplexity, the rumour which had reached his home town in Umbria of the prodigious fast of a Dominican nun. It was said

that the nun had repeatedly succeeded in surviving the forty days of total Lenten abstinence by eating the divine flesh alone:

> Sister Colomba of the Order of Saint Dominic was at that time [1493] in Perosa. She never drinks wine, nor does she eat cooked food and during Lent more than once she has never eaten any form of food at all except for the Communion which she took every day, that is the *corpus domini*. It is a great and miraculous matter to consider whether it is a holy or rather diabolical thing.[37]

The hazy confine between saintliness and demonism also included the grey area in which imposture, pretended saintliness, false ecstasy and conversations with the angels, the affectation of ambiguous 'sanctimony', or merely the vainglory of imagining oneself to be saintly, prospered. This was the case of the 'young girl of lowly birth' who, unaware of being tricked by the devil, none the less helped to 'give credit to and maintain her false and vain saintliness by deceitful means and pretence'.[38]

> Disguised as Our Lord the demon for a long time said mass with her in such a melodious voice that she was entranced; he often gave her communion disguised as a white and shining cloud, from whose face a false host emerged and entered her mouth; he made her live without eating anything. When she carried alms to the gate, he multiplied the bread in her breadbasket so that if she had only enough bread for three beggars, there was enough for thirty, and sufficient to give abundantly to all; and the bread was so delicious and out of the ordinary, that on many occasions her confessor (who belonged to a most reformed Order) sent it here and there out of love for several of his friends who were spiritual persons. She had so many revelations, that in the end their frequency made many persons of the spirit suspect her . . .[39]

The case of the 'hermit who never ate', Saint Nicolao of Flue (born in 1417), was also debatable; in fact, at the start of his great twenty-year fast he was suspected of imposture. One day, this peasant–soldier, from rough, fighting Switzerland, 'thought that his body had been pierced by a ray of heavenly light, causing him the most intense pain. From that moment he ceased to be either hungry or thirsty and until his death, some twenty years later, he never touched either food or drink again.'[40]

> 'At first many spoke of imposture. The government of Obwalden set a chain of guards around his hut and all those who approached it were scrupulously searched. After these trials had continued for a month the

authorities were persuaded to build a cell and a small church at the expense of the State. That the extremely cautious administrators of a Canton in the middle of Switzerland decided to spend this sum, is to me,' observed Lorenzo Montano in 1949, 'a wonderful confirmation of the miracle, and barely short of miraculous itself.

'This period was not inclined to be so credulous and other verifications were carried out, especially by the Church. Before consecrating the chapel, the bishop of the diocese, which was Costanza, offered the hermit a loaf and a bottle of wine which he had brought with him on purpose, and ordered him to eat them. Out of obedience, Nicolao swallowed a mouthful of bread and wine with great difficulty; tradition then has it that he was ill for forty days. In short, the miracle was generally accepted.'[41]

Perhaps, if instead of the Bishop of Costanza, the very suspicious doctor, author of *Quaestiones medico-legales* and papal physician, Paolo Zacchia, a specialist in unmasking impostors and an expert on fasts and similar ecstasies, had gone to verify this and other cases, there would have been no more talk of such phenomena.

Instead, with the approval of high-ranking ecclesiastics, even more edifying stories continued to circulate; such as the one, which was publicly endorsed by the Jesuit father Emerio de Bonis (1531–95), about a humble believer, an ex-cattlewoman, who 'was so enflamed by the love of God that she refused all food except the most holy Sacrament, on which she lived'.

A woman called Alpaide, even though she was of mean and base descent since once her job had been to lead the bulls out to pasture, was however full of grace and sanctity in the sight of the Lord; because of her own account she dedicated herself to prayers, fasts and penances, and mortified her body to such an extent that, lying on her bed, she could not receive any other food but the body of Christ and on this alone she fed herself and it alone satisfied her. From this most divine food she acquired such beauty of face that to others it appeared that she lived off an abundance of the most delicate foods.

Since this saintly woman did not taste anything else, she made herself so welcome to the Lord that, with an angel to guide her, her spirit often rose either to glory or descended to the place of punishment, and this happened more often than not on the days of the Lord and the Madonna. She was absent in spirit sometimes for a day, or at other times for several days, and when she returned she said that she had the impression of leaving a great luminous country or of having descended into the greatest darkness. She also demonstrated that the sun is much larger than the earth, and when she was in heaven the earth seemed like an egg surrounded by water which hung from it. She saw many non-

existent things in her mind, she foretold the future, and was most discreet in giving good advice.[42]

It is difficult to explain why the otherwise cautious Company of Jesus should have circulated descriptions of devout pythonesses who journeyed between heaven and hell, and dubious tales of not easily identifiable but well-fed prophetesses who were habituées of Christ's table and were abundantly nourished by the host alone. It can only be supposed that a programmed and tacit cultural strategy could have aimed to spread such unlikely tales among the masses, for external use; tales which, being considered *intra moenia* to be evidently false and unfounded, were none the less capable of increasing the common consent of simple and ingenious spirits who longed for supernatural experiences. These stories of extraordinary abstinences and clamorous fasts were, after all, most apt to catch the imagination of people who had a difficult wordly relationship, and a dramatic and personal economic struggle with their day-to-day food (often against the background of conjunctural starvation) and with their daily bread. The principle of the 'double truth' found an easy and pragmatic vulgarization in these simple anecdotes. The edifying publicity in which the Jesuits excelled (of all the examples in circulation one need only think of *Maraviglie di Dio nel divinissimo sacramento e nel santissimo sacrificio** by Carlo Gregorio Rosignoli, or *Gli stimoli al santo timor di Dio cavati da scelte historie dello sdegno divino usato contra diversi peccatori nel punto di morte*† by Carlo Casalicchio, or by the same father, *Avvenimenti prodigiosi contro quelli che malamente si confessano*)‡ used these improbable examples to bring imaginations which were extremely sensitive to the problems of the survival of the flesh into the sphere of religious perturbance. Stories of the kind 'the hermit (or the saint) who does not eat' pointed the way to the first and most fundamental wonder, the most human and traumatic miracle.

'Of all the miracles which one can imagine,' wrote Lorenzo Montano, reflecting on the legend of the loss of appetite of Saint Nicolao of Flue or Flueli, 'perhaps this is the most likely to spark the profane imagination, and perhaps it is the greatest indication that they can dream of faith and sanctity. What humiliating law of nature is it that makes a digestive tube both the axis and motor of our organism! The necessity of keeping

* Holy marvels in the most divine sacrament and most holy sacrifice.
† Stimuli to godly fear taken from selected stories of God's scorn to various sinners at the time of death.
‡ Prodigious happenings to those who confess wrongly.

it filled nowadays governs the major part of human activities only to a slightly lesser degree than during the era of the caveman. It is true that humanity has endeavoured to render this squalid necessity sublime and virtuous by using every possible variation, from the *Georgics* to the *Re dei cuochi*, but the truth is that from this point of view we have remained very close to the amoeba.'[43]

The space of the 'divine banquet', the altar, contrary to what might be supposed, even at the height of the Counter-Reformation was a place where pompous ceremonies were alternated with widespread neglect and extremely off-hand behaviour on the part of the clergy. In the first half of the seventeenth century it was necessary to circulate detailed instructions (including those by Pope Benedict XIV, '*Del culto e mondezza delle chiese*') so that celebrants, ministers and accolytes should behave according to the norms of ecclesiastical etiquette. In preparing to celebrate mass the minister not only had to 'wash his hands, brush his hair, clean his nails and cut them if they were long',[44] but also 'be careful not to hold his gloves, sleeve, fan or streamers in his hand'.[45]

The slovenliness of the celebrants was astonishing.

> It is also bad custom while serving at Holy Mass to keep one's hands in one's pockets, to count money, to scratch one's head, to clean one's ears or nails or to bite them with one's teeth; to chase flies, to spit on the altar-step where the priest makes his genuflexion, so that he will dirty his cassock; and if the priest himself spits there, one must place one's foot there without making a noise; and likewise around the altar, one must not spit on the steps, or cough noisily or yawn loudly, and always blow one's nose with one's handkerchief and never use one's fingers; one must never blow the trumpet which is the signal for trouble, or shout loudly at beggars or chase away dogs with shouts, or argue with anyone, since all these are unseemly actions which are not very civil . . .[46]

It seems that the presence of dogs in church was a scourge which was even more widespread and troublesome than the beggars who none the less disturbed the orderly performance of services with their shouts and supplications.

> 'But how will that cleric or minister chase those dogs out of the church,' wondered the priest, Don Bartolomeo Pignattari, 'when he himself takes his own dog to Mass? Do you believe that this will set an example to the others? Certainly not. Does he, like the others, take care not to disturb, nor to take with him anything that might disturb whoever was celebrating, since this would impede the major fruit that can be got from the

153

Holy Mass? Nicola Laghi (in tract 6, chapter 6 of *Libro de'Miracoli del Santissimo Sagramento*) tells how during Mass a priest only freed ninety-nine souls from Purgatory, rather than one hundred, because of an argument at the church door. Therefore, those who take their dogs to Church, whose fighting and barking cause such disturbance to the celebrant and his assistants are very worthy of punishment!'[47]

Behind the indignation of the good Bolognese priest can be seen the grotesque and surrealistic effect of the precise calculation of the souls freed from the purgatorial flames, and the comic although real and authentic regret for the 'full house' which had just been missed.

Such a degree of levity at the altar, for example the cross-fire of spit between communicant and minister, was in violent contrast to the minute casuistry which related to all the most convoluted procedures for celebrating the sacrifice at the altar. This detailed, bureaucratic and intransigent ceremonial was prepared for the mass and was intended to establish its length, the gestures and the pronunciation, and to stress the obligation to omit nothing, the absolute prohibition to add anything. There was a vast subtle network of distinctions between venial and mortal sins should a passage or even a letter be omitted, or should the sign of the cross be made at a point not marked in the rubric. In *Quaestio fundamentalis de rubricis Missalis*, the Theatine father Paolo Maria Quarti, who was also the author of a monumental treatise, *Rubricae Missalis Romani commentariis illustratae* (Rome, 1674), under the heading of the 'second difficulty' ('what a sin it is to omit a single letter in the words of the consecration'), discussed the agitation of those priests who were unable to pronounce clearly certain letters in the ritual formulae.

> Some priests are very worried that they pronounce the final letter S or M in the words *meum* and *corpus*, or the letter T in the verb *est*, too distinctly. In reply, I say first of all: as far as the validity of the consecration is concerned, even if the M in *meum* was left out, the consecration would be valid, because the sense is not altered, as is self-evident. There is more room for doubt in the word *est*. If the final letter were left out, the third person of the indicative mood would be changed to the second of the same. Still, it must be said, that if it is not omitted with the intent of changing the sense but out of ignorance of the laws of grammar, or from negligence, the consecration will still be valid. This is because the sense remains the same because of the context of the phrase.[48]

An omission in the 'active rituals' (*'de omissione rituum qui in actione consistunt'*), especially in the words which 'contain the great mystery', was judged as committing a mortal sin.

It is difficult to evaluate the importance and quality of the sin committed if new or extraneous parts were added to the mass, either as gesture or as words: 'If anything is added with the intent of introducing a new rite, even in a modest and trivial matter, a doubt arises whether a mortal or a venial sin is committed'.[49] Not only was sacrilege always impending, but the 'danger of superstition'[50] was also constantly to be feared if extraneous gestures or words were added.

The infringement (even when unintentional) of the rigid ritual of the consecration of the bread and the wine was particularly serious: the extremely delicate moment of the transubstantiation of these ordinary substances into the divine body and blood had to be a faithful copy and an accurate repetition of the liturgical formulae and ceremonial precepts. The moment of the eucharist, the sacrifice at the altar, a time of great magic and liturgical tension, the 'great mystery', the culminating act of the entire mass, the dramatic apex of divine participation and supernatural presence could become a stage for 'transformations, apparitions and wonders'. Everything was possible in the arcane atmosphere of the transubstantiation, in these miraculous acts of balance performed by the divine alchemy of transformations: both the heavenly forces and those of the devil could be unleashed in a struggle between opposing powers.

'Apparitions' were divine and 'illusions', satanic. It was not always easy to distinguish between the two: it was difficult to tell 'whether the aforesaid apparitions proceed from God or whether they are sometimes illusions'. Even the apparitions themselves fluctuated in an ambiguous fashion, 'apparitions of this kind can be caused either by divine handiwork or miraculously by God, or by the craft and illusion of the Devil'.[51]

> It is moreover to be set forth as a certain thing, that it cannot be denied that the said apparitions and miracles have happened: that a small boy, or flesh or blood, have been seen on the Altar, to confirm Christ's presence under the species of the sacrament either to comfort the faithful and confound the unfaithful or to frighten sinners who approach unworthily. The Eucharist is from time to time turned into a stone in the mouth of one who takes it unworthily, and from time to time into ashes, and the like . . .[52]

Even if apparitions were not seen, the altar none the less remained the disquietening space in which the awesome responsibility rested on the 'visible priest' of representing the 'invisible priest',[53] computing a 'sacrifice of infinite Excellence',[54] and of rendering alive and present the ancient '*mactatio*' which had been performed by 'a priest of infinite

perfection such as Christ',[55] and which through the celebrant (*'causa ministerialis'*) effected its own unheard of transformation and sacrifice.

'Many priests became extremely anxious' and the 'miracle of miracles' brought with it tension, worry and anxiety. The wonder of the transubstantiation which occurred on the 'holy and mysterious table'[56] made the officiator feel like the enacter of a supernatural act of occult violence. While, on the one hand, he proceeded to make a sacrifice, albeit bloodless ('sacrifices are made every day by the priests on the altars . . . in which such an adorable victim places himself in a virtual state of death'[57]), on the other he was changed into a necromantic mediator who transformed 'two inanimate substances', bread and wine, into supernatural food, by making 'the body and blood of Jesus Christ' reappear and relive 'in the guise of the body and blood of a lamb bled dry; thus, for this reason in each Mass the Redeemer returns to die mystically, without dying in truth, at the same time both living and dead'.[58] But, of all the 'unheard of wonders' and the 'greatest and extraordinary miracles which shine through this Mystery',[59] 'the final wonder is that all these miracles and prodigies, which nature cannot but admire with trepidation, are computed by means of three or four simple words from the mouth of a man'.[60]

If through the words of His priest, God 'destroys the substances of the bread and the wine in the Mass, He does so in order to reproduce, through an infinitely greater miracle, the body of Jesus Christ in their place'.[61] But, in an inexplicable portent, and by changing 'the established order of reason' and overturning His own law, through the words of the consecration He divides the

> natural connection between the substance of the bread and wine and their accidents; wherefore, the substance completely perishes and the accidents continue to endure without support. And in this you do not know what to admire most, since such a destruction of the substance, and such a manner of being and working of the accidents without their usual support, have never been seen nor will ever be found elsewhere in nature. An angel can easily sustain the weight of a great machine in the air, but he cannot sustain the taste of wine, nor the colour, nor the smell without the subject; and although he can destroy the bread's substance, he cannot reduce it to nothingness. These unheard of miracles are everyday occurrences in the Holy Mass, and forcibly remind us of the supreme Dominion which God holds over all, and that He is the Lord of life and death, and that it is fitting that all creatures are consumed in honour of His infinite perfection, and that in the same way that He annihilates those substances, so He could also destroy us.[62]

The terribleness of the sacrifice resulted in the unhinging of the laws of nature, which were violated by a series of impossible reactions of the highest form of alchemy, thus throwing the relations between the substances and their accidents into disorder. Colour, smell and taste survived the destruction of the substances of which they were part. When transformed into flesh and blood, the primordial substances, the wine and the bread, were radically altered in essence, but their chemical properties (the 'accidents') survived the metamorphosis. The sacrifice changed the inanimate into animate. The living heavenly enzyme, the Incorruptible, fermented in an unleavened bread; a vital, life-giving and blessed food was formed from a lifeless substance; God had been miniaturized into a sweet-smelling and 'mysterious food'[63] in order to change and reform, without Himself being altered, whoever ate and digested it. This extraordinary food overturned the laws of nutrition and the principles of digestion according to which food is always transformed and modified by the person who eats it.

And since He habitually obeys a man's voice, humbling Himself and becoming smaller in order to come to us; He lives a hidden life, with eyes that do not see, with ears that do not hear; mortifying all the senses, He overturns the laws of nature by separating the most united things and strengthening the weakest, in order to produce effects which far surpass their own power . . .[64]

These were wonders of the hypostatic union: 'He is in us and we in Him', '*Unum quid efficimur*'. As heavenly bread and divine flesh, as the incorruptible body, as the 'dish from His table'[65] which the devout follower received daily straight from heaven, and under the guise of bread and wine, the Omnipotent gave himself

to us in the form of food. Because there is nothing which is more intimately connected to us than food, since through natural heat it becomes our own substance, it becomes one with us . . . 'Whosoever eats my flesh and drinks my blood will remain in me, and I in him.' However, there is a difference between this and other foods, namely that other foods are transformed within us and become our substance. But this food changes us into it.[66]

The 'sacramental' food which contains 'in a single mouthful, the quintessence of all good and the antidote of all evil',[67] which is 'incorruptible and immortal',[68] does not change itself but changes us.

157

It is very probable that when the host was placed in the mouth of a believer it caused a trauma whose dimensions are difficult to measure. When it was swallowed, all the terrifying images associated with the act which had just been performed – the Lamb's purest body immersed in the filth of the digestive system, the divine flesh contaminated by the mucus and juices of the corruptible flesh, all the filth of the bowels – came to mind and must have produced a dizzying sense of bewilderment.

The 'marvellous effect' of the 'stupendous excess' was even recorded in sacred verse in the reflections on the 'vile worm' which housed the divine 'Majesty':

> God offers himself as food and drink
> To sinful man tainted by wicked guilt.[69]

Trouble was in store for those who were 'bound to Satan, yet none the less dared to draw close to the table of Jesus'.[70] By causing the 'Redeemer's most sacred blood' to be shed in vain, these individuals 'performed a massacre instead of a sacrifice'.[71] This heavenly medicine, *'medicina sacramentalis'* (Saint Bonaventura), which had been shed to 'sanctify body and soul', cannot be contaminated by the 'filth'[72] and 'monstrous impurity' of persons like the lecherous and 'lewd' parish priest who every day also 'handled the Body of the Lord' and 'was always present at these tremendous mysteries'.[74] The divine bread endowed the human body, which is wholly abominable, with 'such great privileges', 'dirtying our flesh and soiling it, after we have united it with His flesh on the altar', after 'our miserable flesh' has shared in the 'virtues of the blessed flesh of the Redeemer'.[75]

The eucharist succeeded in effectuating an intimate communion between the immortal and the human flesh: an absolutely perfect body penetrated a corruptible bowel in this 'miraculous marriage' in order that the whole man should be 'deified' by this holy union:

> This is not only the case in those functions which are truly of the body ... such as feeding oneself, digesting and nourishing oneself with the sacramental species, but all the more in that most sublime spiritual union, by virtue of which the powers of the blessed Flesh of the Redeemer become participants of our miserable flesh in that act. These powers are wondrously visible in two ways: one in the present and the other in the future. The first effect is to moderate immediately the

dissoluteness of our sensual appetite and to mortify the evilness of our wicked habits, as balsam mitigates the snake's poison in those places where this plant is the snake's habitual food. The second effect, which lies in the future, gives us a special right to our glorious resurrection.[76]

The balsamic moderator and sedative of the flesh, the manna of the soul, was inextricably linked to the resurrecting flesh and embalmed for eternity; it was entrusted to the power of incorruptibility and to the aromatic eternity of the paradise of the blessed. It was the deposit and mortgage on a fund of unimaginable ecstasy and incomprehensible delight, a secure viaticum towards the 'incomprehensible and immortal light'[77] and towards the 'invisible light',[78] which regenerated body and soul to the fullness of the senses and the spirit.

Like balsam and honey, the divine body innoculated whoever received the host with the sweet germ of immortality, the seed of eternal life.

> Thus, like honey transmits its own incorruptibility to the fruit which is immersed in it, so it is right that the body of our Saviour, by uniting itself with us, plants in us the seed of His own immortality and the special right to live for ever.[79]

Like an elixir and the 'sweetest medicine',[80] the Omnipotent 'humbles Himself by becoming our food' and in it He dies a 'mystic, moral and real death',[81] following the ineluctable passage of the decay of the substances which enter and descend into the fleshy labyrinth of the human stomach. The divine body is absorbed by our 'foul body'[82] and the pure is united to the infected so that 'our souls and bodies will be fed by immortal life'.[83]

After the body has become a 'living ... tomb and temple (G. Marino), the 'new sacramental life', which was acquired by the host through the words of the consecration, slowly decomposes in the folds of the ventricular *antrum* as the magic words and their arcane powers are extinguished by the inarrestable physiological functions which alter, transform and remould all that they find.

> Now, this new sacramental life, which Jesus Christ acquires through the above words of the Consecration, is lost when the sacred species, in which He is hidden, are digested and destroyed by the natural heat of our stomachs. And through this act one might say that He dies a death which is at once mystical and real, and that in this way He loses that

sacramental being which, if He did not already have another life, would perish altogether.[84]

Exinanitio Dei, the annihilation and disappearance of God, who was eaten, dissolved and absorbed by the omnivorous stomach, the 'tomb', or – according to the theological dualism of Giambattista Marino, an erudite reader of sacred manuscripts in Cardinal Aldobrandini's library in the 'desert of Ravenna'[85] – 'cradle, despite its filth'.[86] This stupefying metamorphosis, which was filled with incomprehensible cosmic symbols, physical 'impossibilia', and naturalistic paradoxes ('When Ceres heard that Nature could transform itself in Christ . . .'[87]), excited the most fantastic Baroque apotheoses:

> You are the circumference which is the mainland to Immensity,
> The Sphere which comprehends Eternity within itself,
> The Shield of mercy which defends the Great King's beloved
> Bride
> From the Serpent.
>
> You are the Breast of Charity whose milk
> Makes the mind eager,
> The Cup of Love whose eagerness
> Makes the most ardent soul more passionate.
>
> The veiled Gem, the Sun behind the cloud
> Where every lynx-like pupil is darkened by what it sees
> And is dazzled by unseen art and nature.
>
> The vast sky in a tiny Orb, which contains both God and man,
> In which everything is in everything and caring for everything,
> You the Seal of the Mysteries, the Host of the Faith.[88]

This fragile particle, this 'holy artifice',[89] this white disc which released extraordinary powers and occult virtues became a magic and poetical object in the terms of an insoluble theological theorem, an incomprehensible physical enigma, and a mysterious portent laden with unresolved contradictions; it sparked off the pyrotechnics of seventeenth-century sacred verse which was hypnotized by the enormity of the divine oxymoron:

> Secret mysteries! The immortal Host,
> Man's life, is born among the dead
> And the narrow sphere, the fatal orb, closes
> When the poles meet and the wheel of Fate turns.

Portentous mysteries! A veiled God
Is the vital food for the bloodless Spirit;
It has the power to withstand lethal blows,
It conceives the accent and exhales breath.

Therefore the Divine Word comes from the Empyrean,
It descends from above: it acquires
The voice and breath of an elect Soul.

Oh, what impressions does a great Faith dictate here!
The accidents have no subject, and gaze at
Immensity restricted by boundaries.[90]

The invisible and the immense were confined within a 'narrow sphere'; miraculous virtues and immense powers were contained within the smallest disc; irrepressible forces and supernatural powers were encapsulated in a few grams of flour.

Thus I eat and nourish myself
On human food, and when,
According to nature's custom,
This descends into my stomach
It is transformed into my flesh, my body;
But when I eat and pasture
On heavenly bread
By supernatural law
When these substances pass into my body
I am myself changed into food and transformed into Christ.[91]

Nor was it believed that the eucharist was 'fruitful only in relation to the soul; on the contrary, it also helped to cure and preserve us from bodily diseases, when we resort to it in need'.[92] It was a mystical medicine, a traumatic sacrament, which was linked directly to Christ.

The other sacraments are used and received by us with external actions, with unctions and water, with said and heard words, and through the use of other external materials. But the eucharist, which was instituted as a food and drink, is received internally and brings Jesus Christ in person into our heart ... It unites us to Christ through his Grace, and makes us one with the Person of Christ. In this way we become living parts of His body and truly attached to our Head which is Jesus, and to a certain extent this makes us one with Him. We become part of His body, of His flesh and of His bones. When we eat His divine flesh with His bones, through this union we become even more part of His divine body ... with the sole difference that food for the body becomes the

substance as the person who eats it, since it transforms itself into
erson. Quite the opposite occurs with the eucharist: it is not the
.ood which changes into the person who receives it, but the man who
receives the host is spiritually transformed into the food he has eaten.[93]

The process of transformation of the worldly substances which,
consecrated by the mass, converted the bread into divine flesh and the
wine into regenerating and life-giving blood, led to the introduction of
a powerful dose of supernatural forces into the mortal body, and to a
penetration laden with 'marvellous fruits'.[94] The communion became
communication with the ineffable.

Whoever received this heavenly manna emerged transformed by the
miraculous contact, strengthened in body and in spirit, and cleansed
in soul and flesh by this antibody which was often used in cases of
witchcraft, temptations and possessions as a potent and exorcizing
antidote. The diffusion of this sacrament and its utilization against evil
became increasingly widespread in those centuries during which the
witchcraft epidemic spread like an ink stain. 'This consecrated blood
keeps demons away from us since when they see the blood of the Lord
in us they flee.'[95] The progressive curve of the consumption of the host,
which rose ever steeper and higher from the second half of the
sixteenth century onwards, and the increasingly widespread custom of
taking daily communion (in pre-Tridentine society the severe, res-
trained practice of taking the eucharist twice or three times a year was
considered to be sufficient, otherwise one risked being accused of
pharisaism or pietistic exhibitionism) reflected the gradual decline of
the 'humanist' image of man. It also marked the irresistible insinua-
tion into the collective conscience (which was increasingly under the
sway of the spiritual security measures devised by the ecclesiastical
hierarchy according to which everyone was obliged to take out a
compulsory insurance on their soul) of a sense of the body's complete
insecurity and utter fragility; in fact, the body was increasingly con-
sumed by temptations and remorse, by falls and rebirths, by excesses,
by imbalances, by spiritual anguish and by mental scruples. These
'imbalances' of the spirit were a reflection both of the break with the
old Ptolemaic cosmos and the adventures of the new science, and of
the internal tensions which were made increasingly acute by the
growing speed with which the earth was separated from heaven,
demoted to a subordinate rank as a tributary to the sun and displaced
from the centre of the universe to its periphery. To these men who had
discovered that they lived on the margins of the universe, time and the
day itself seemed to have been shortened, their lives appeared abbrevi-

ated and condensed compared to the long, mythical existences of remote and privileged eras. Even the stars themselves seemed to emanate more evil influences, increasing the general malaise and deepening the sense of uneasiness: 'the duplicate and dangerous dominion which Saturn had over the months of our generation'[96] were observed with anxiety.

The orbit of the sun, 'that merciless heavenly body', was also directed against man, who was likened to a soap bubble (*homo bulla*), and it increased the 'malignity of fate', while sinister 'Saturn circled around him each hour'.[97]

The most powerful Church, with its infinite voices, was content to let this gloomy image of man as dust, of man as nothingness, destined to swift decomposition, circulate at all levels. 'What is man?'

> Snow in the sun, dust in the wind, and fire on the wave,
> They flash like a light arrow, a short-lived spark,
> A common reed, frail glass, the smallest drop,
> A delicate flower, humble stubble, a deciduous leaf.

> Mist on the ground, smoke in the air and foam on the wave,
> The clap of thunder, the dawn chorus and the chime of cowbells,
> Hung up high, a stone on the shore, and a boat in Scylla's thrall
> Which is heavily struck, slides and sinks.[98]

Tempus breve est. 'Time is brief and passes, eternity comes and never ends.'[99] Over this sense of abbreviated time loomed the 'deserts of vast eternity' (Andrew Marvell).

> One jumps from the coffin into the grave . . . because the years of our life gallop towards death in the chariot-races of heaven. Our days speed past in a few hours from dawn to sunset; the moment of leaving our mother's womb and our entry into the womb of the earth are the beginning and the end of a single leap. The whimperings of our birth recall the songs of our funeral; with a single step we touch the cradle with one foot and the coffin with the other: only a single letter separates *orimur* from *morimur*, and only a sigh separates life from death.[100]

The story was told from the pulpits of how in a densely populated city in France a bishop had confronted the register of baptisms with that of deaths:

> in the book of baptisms he found one hundred persons born in the same year; he looked for these same persons in the book of deaths to see what had become of them, and he found that of this hundred, forty-two had

163

already died in the space of seven years. Between the ages of seven and twenty-six, another twenty-five died. Between twenty-six and thirty-six, nineteen of them died. By the fifty-sixth year, ninety-four out of the original hundred had died. Neither had there been any plague or famine in that city, nor any infectious disease; but in the space of fifty-six years almost all had died commonplace and ordinary deaths, and only six were left alive.

In his writings, Cardinal Federico Borromeo said that he had made the same comparison and that in places with clean air he had found that only ten out of one hundred persons born in the same year reached the age of sixty. Where are now the sixty or seventy years of life which everyone so readily promised themselves? If we had lived in the first era of the world, when people lived for eight or nine hundred years, and when they were married at sixty, and the blossom of youth remained for two or three hundred years, I would almost discount the fact that time passes. But what of the present? When nowadays constitutions are so weak, either because of the vices of their fathers or because of the disorders of youth, people die rather than marry before the age of sixty.[101]

It was with 'this most evident experience of short lives and early deaths', caused by 'weak constitutions' exhausted by the 'vices' of their fathers and following a brief life spanning but a few decades, that 'man went to the tomb before he reached sixty'.[102] The human fetus did not represent a life about to be born or an incubated existence but rather a 'breathing corpse' (Tommaso Gaudiosi). At fifty, there was no other choice but to prepare for death which was drawing near: 'I carry the weight of ten lustres of life or thereabouts on my back.' These were burdensome years which were a troublesome weight on the shoulders:

> 'If the life which is left to me is so hard,
> Is it worth living, when I expect to die every day?
> It is less trouble to die than to wait for death!'[103]

As the acoustic symbol of the invisible mill of time, the striking of the clock agitates us. The church bells weave a pattern of sonorous messages around the day, scanning the daily pattern of existence in an interminable liturgy of sacred time and lay time, as the resonant inspectors of a time which is sworn to the supernatural and to death. Funereal olfactory messages emanated from the churches, cemeteries and ditches, and from the world of decay. From pulpits, confessionals, prayer books, pious practices, homilies and sermons the *memento mori* penetrated the marrow and brain, and became a collective obsession

164

and a personalized nightmare. In a world where all was vanity and everything was a sign of death, the manipulation of statistical data and the lugubrious mathematical calculation of the number of lives to be cut short and the expected number of demises served as a wonderful exercise for a good death; this was encouraged by an ecclesiastical policy which was well aware of the advantages of a widespread diffusion of. the ideology of death, of the punishments and torments of the underworld, and of the terror of eternal damnation.

Even Baroque erotic poetry was pervaded by the metaphysical concept of the brief life, set against the background of remote times when – as Carlo Ambrogio Cattaneo (1645–1705) said – 'at sixty you became a husband',[104] and courtships lasted for centuries:

> Had we but world enough and time,
> This coyness, Lady, were no crime.
> We would sit down and think which way
> To walk, and pass our long love's day;
> Thou by the Indies Ganges side
> Shouldst rubies find; I by the tide
> of Humber would complain. I would
> Love you ten years before the flood;
> And you should, if you please, refuse
> Till the conversion of the Jews.
> My vegetable love should grow
> Vaster than empires and more slow;
> An hundred years should go to praise
> Thine eyes, and thy forehead gaze.
> Two hundred to adore each breast . . .
>
> But at my back I always hear
> Time's wingèd chariot hurrying near,
> And yonder all before us lie
> Deserts of vast eternity.
> Thy beauty shall no more be found
> Nor, in thy marble vault, shall sound
> My echoing song; then worms shall try
> That long-preserved virginity,
> And your quaint honour turn to dust,
> And into ashes all my lust . . .

In the poem by Andrew Marvell (son of a Puritan minister) Eros and Thanatos were united. The bed of love is evoked by the image of the tomb in which the couple cannot touch one another: 'the grave's a fine and private place, but none I think do there embrace'.

12

In the Pit of the Stomach

The stomach occupies an important place in theological meditations on the eucharist. This organ, and all the physiological processes connected to it, becomes the focus of vigilant attention and minute and thoughtful research. This fleshy sac is the organic terminal in which the final and definitive prodigy of this supernatural metamorphosis takes place. The descent of the body of Christ into the *antrum*, into the wet and foul-smelling guts, is followed by theologians with a worried gaze and with thoughtful anxiety.

The journey of the host from the mouth along the 'road to the stomach' must be preceded by a detailed ceremony of purification. The fasting, rigorously observed from at least midnight, is described in detail in all its particulars: any neglect or non-compliance can invalidate the assumption of the holy particle, even to the extent of committing sacrilege. At a time when oral hygiene was very precarious and the toothbrush was unknown, even the involuntary retention of small fragments of food between the teeth could constitute a serious theological problem. Even the great Saint Thomas, who was 'ravenous for sacraments',[1] dealt with the question in the *Summa* (III, q. 80, art. 8), and decided that 'the remnants left between the teeth' and 'remnants of food'[2] (*reliquiae cibi*), if involuntarily swallowed would not impede the reception of the sacrament: 'However, if the bits of food which remain in the mouth become unstuck by chance, they do not prevent the taking of the sacrament.'

Strengthened by such authority, the theologians decreed that 'neither saliva, nor blood, nor any other humour which comes down from the head and is swallowed, nor remnants of food left between the teeth, if swallowed after midnight mixed with saliva, would break the natural fast since they were not taken as food'.[3]

After the fashion of taking snuff had invaded the continent, those who could not do without the 'rapé', or abstain from the 'stinking delights of Indian tabaccoes'[4] could continue to sniff it without restraint since this aromatic powder was similar to innocent saliva as far as sin was concerned, and had nothing to do with Satan (indeed, in 1779 the Pope opened a tobacco factory which abolished once and for all the widespread suspicion concerning the diabolical character of the 'Indian' herb[5]).

> And the same can be said of tobacco which is taken through the nose in a powdered form, and which is clearly not taken in the form of food, through the mouth rather than through the nostrils; wherefore, if it is swallowed it is ingested with the saliva.[6]

When these regulations regarding the purity of the route had been satisfied, the host, which was made from the purest flour, could start its descent into the obscure meanders of the bowels, into man's internal flesh, into the *fundo ventriculi* where the Man–God, having been 'swallowed into his chest',[7] came to rest. Of all the sacraments the eucharist alone penetrated as far as the guts, since the others only affected the body's surface. Through its intimate, direct contact

> we become living parts of His body and truly attached to our Head which is Jesus, and to a certain extent this makes us one with Him. We become parts of His body, of His flesh and of His bones. When we eat His divine flesh with His bones, through this union we become even more part of His divine body ... The other sacraments are used and received by us with external actions, with unctions and water, with said and heard words, and through the use of other external materials. But the eucharist, which was instituted as a food and drink, is received internally and brings Jesus Christ in person into our hearts...[8]

The *manducatio*, the act of swallowing, the ingestion and the digestion of the sacred unleavened bread had to take place according to the rhythms and processes of a perfect physiological assimilation, in exactly the same way as the best and fullest assimilation of a natural food. To obtain a perfect abundance of grace, it was necessary that, in full accordance with the digestive mechanisms, the natural heat of the stomach performed its function to the best of its abilities so that grace would be kindled from within, stimulating the gastric walls, and the mechanism of a perfect transformation by means of an impeccable assimilation of the natural substance. The stomach became the delicate place in which the mystery of the transubstantiation took place:

167

the miraculous metamorphosis which led to the assimilation, first, of God in man, and then to the passage and fusion of man in God; it became the crucible in which the food eaten was transformed into the same substance as those who had eaten it. But there was a fundamental difference: 'food for the body becomes the same substance as the person who eats it, since it transforms itself into that person. Quite the opposite occurs with the eucharist: it is not the food which changes into the person who receives it, but the man who receives the host is spiritually transformed into the food he has eaten.'[9]

However, this supernatural transformation of the communicant occurred according to the patterns and rhythms of human physiology. The natural species were subjected to the rhythms of the normal digestive processes. And the divine grace could only become effectively manifest after the eucharistic food, having been deposited in the heat of the stomach, had been dissolved into pulp by the warmth of that natural oven. The simple introduction of the host into the oral cavity was irrelevant in terms of the perfect reception of the sacred bread, since only in the stomach could it perform the miracles of the presence of the *corpus mysticum*, the miracles of total *communio*, the absolute fusion between divine flesh and that of man, the release of the 'action of grace'.

> So this sacrament begins to create grace at the point when it is first true to say that the host has been received in the stomach or at the last and final point when it is true to say that the species of the sacrament have been passed on into the stomach.[10]

For this reason it was also forbidden for the sick to receive the host since 'they cannot dislodge it from their palates, none the less great care is usually taken that they do swallow the host. The eucharist does not therefore confer grace as soon as it touches the tongue or palate, or while it is retained in the mouth, but instead it is required and expected to pass through the throat.'[11]

The analogy between the spiritual and the material, between the beneficial effects of an easy digestion and the fruition of the supernatural goodness induced by the host, was perfect. As the natural warmth of the stomach, and it alone, is instrumental in the correct consumption of food and drink, so the spiritual warmth of the swallowed sacrament produces the plenitude of the charismatic effusion. This reached the extent that some theologians considered the action of the host to be nullified if the sufferer died with the host in his mouth before

it had reached his innermost bowels (*'nec gratia sacramenti conferretur . . .
ut neque si moriaris dum hostia adhuc est in ore'*[12]).

Christ's presence in the stomach was not without effect for long
(*'Christum otiose non manere eo tempore in stomacho'*).

> This sacrament confers grace by means of nourishment, but food
> nourishes above all when it is assisted by natural heat in the stomach.
> Likewise, this sacrament, as though assisted by the warmth of a better
> disposition, will still nourish the soul spiritually; this spiritual nourish-
> ment consists of an increased level of grace.[13]

Spiritual nourishment could not be diffused in all its fullness if not
by means of bodily nourishment, even if, 'once the taking of the
sacrament has been completed and once the eucharist is in the
stomach, the consumption of the sacrament does not continue in a
physical sense, but instead goes on morally on account of the com-
municant's disposition'.[14] From this premise arose the problem of the
time of grace, the complex questions of the duration of the supernatu-
ral effects and the length of time Christ remained in the host, and the
corollary debate about the time required for the species to be con-
sumed. It was widely accepted that within the space of an hour the
species were transformed (*'certum est apud omnes, saltem inter spatium horae
species in omnibus immutari'*[15]), but it was recognized that the time could
vary depending on the nature of the stomach, since some were warmer
than others (*'juxta qualitatem stomachi magis vel minus calidi, aut validi,
species consummantur'*[16]). According to the Roman doctors consulted by
Cardinal De Lugo, the process of consumption was concluded in
under ten minutes in priests, while in lay persons the process was more
rapid and lasted barely a minute: *'plures medicos a se Romae consultos
putasse in laicis species intra minutum corrumpi, et in sacerdote intra medium
quadrantem'*.[17] Others believed that the digestive process was completed
in lay persons within the space of five Paternosters and Ave Marias,
but only began in priests after they had taken off their vestments.
Cardinal De Lugo, who was a theologian, was of the opinion that in
priests the process of the corruption of the host could only be con-
sidered complete a quarter of an hour after the communion.

In this way theology answered the question, 'How long does Christ
remain in the eucharist?' Replies to the other question, 'When is grace
received?', were not entirely consistent since some maintained that
grace began the moment all the fragments had been deposited in the
stomach, whereas others thought that it commenced when only a

single portion of the host, and not all the fragments, had completed its journey. 'Grace is transmitted in the first chewing of the very first part, since this is the entire sacrament. Chewing, moreover, is interpreted as the passage from the mouth to the stomach, though others say that grace is first given when a particle is received in the stomach.'[18]

For good Christians the most important thing was to obtain a plentitude of grace, and many requested to receive communion like priests, *sub utraque specie* (both bread and wine), thinking that 'more grace is given under both species than under one'.[19] It was not the practice for wine to be withheld from the faithful who were desirous of assuring themselves of a double portion of grace: 'It does not appear that a layman who wishes to be a priest is to be prevented from making communion under both species because he thinks that more grace is given under both than under one, because it is not probable that this is the case.'[20]

It should be noted that in this context there was a peculiar but perfectly understandable tendency, bearing in mind the perfect analogy between the digestion of the sacred host and that of normal food; namely, the widespread conviction that the larger and more substantial the divine nourishment which was masticated and swallowed, the greater and longer lasting would be the grace and beneficial influence emanated from it. Hosts of unheard of size, or even several particles at once were administered to the faithful who requested them. The official theological line of thought was not contrary to this practice: 'Nor should we censure the devotion of a man who takes a substantial quantity to be consecrated, with the intent that the species be not so swiftly consumed in his stomach, and that in this manner Christ may remain and more often increase his grace.'[21] And, once again, what was later considered to be an 'abuse' was justified by an argument which based its reasoning on physiological processes: 'This sacrament was instituted through the means of food, so just as food nourishes the body all the time it is in the stomach, so likewise all the while that the Eucharist remains in the body, it nourishes the soul by increasing its grace.'[22] None the less, in spite of popular support and the consent of many theologians, Pope Innocent XI 'condemned the abuse of giving several pieces at once, or pieces which were larger than usual to those who took communion'.[23]

The host was so full of the power of grace that, if by chance the consecrated species were vomited, and provided they retained the form of bread and wine, they should still be revered. And if, subsequently, they were eaten again, they would still provoke that blessed fermentation: as '*species per vomitum rejectae, si tales sint, ut sub illis panis et*

vinum possit existere, vere sunt adorandae; et si iterum sumantur, iterum conferre gratiam, docet Card. de Lugo'.[24]

The 'greatest and most extraordinary miracles'[25] which occurred at the 'saintly and mysterious table',[26] the 'great wonder' of the small consecrated host which turned the act of the eucharist into a terrible Mystery, were the cause of profound 'admiration and wonder'.[27] The stomach became the invisible altar at which occult and incomprehensible rites were performed, the place in which a liturgy which mediated between the high and the low was recited and in which an unimaginable rite of transformation was accomplished.

> Oh sovereign and incomprehensible Majesty is it possible that you are in Heaven and yet I can see you in my wretched stomach, and that you have performed so many miracles and overturned the whole of nature in order to get there? I feel myself shaking all over and entranced in wonder when I think about this infinite favour . . .[28] I believe, without a shadow of doubt, that you are in my stomach in body and soul . . .[29]

The moment of separation, the end of this extraordinary contact, the withdrawal of the terrible but joyful presence was the most delicate and painful moment.

> Having retained Our Lord in this manner, we must beseech him not to leave us when the species have probably been digested and as a result he ceases to have a bodily presence in us . . . But since You have resolved to depart bodily and since I must support this mortification, I give in to Your holy and divine will and accept this separation, however bitter it is.[30]

The final destiny of these material 'accidents', the bread and the wine, the mysterious happenings which accompanied the decay of the species, represented the last act of a whole series of 'miracles and prodigies which nature can only gaze at with terror'. Since,

> when these accidents become corrupted, and when worms are generated in their decaying substance, many theologians maintain that God, for this purpose, recreates a primary material, probably that of the bread which has been destroyed, and generates in it and with this the actual bodies of these insects. In other words, to cite Angelico's opinion, who sustains an even stranger thing, God makes the quantity of consecrated host serve as primary material, and He makes the forms of these animals out of it. Lastly, all these miracles and prodigies which nature can only gaze at with terror, are accompanied using three or four short words uttered by the mouth of man. This is a most wonderful thing and

171

incomparably more miraculous than when the sun was halted in its orbit by Joshua's voice which none the less was and still is an object of wonder for all the following centuries.[31]

This 'tremendous sacrifice' could appear so great that not all Christians could accept its inhuman atrocity, and preferred to interpret it either symbolically or figuratively: like the 'old hermit', who 'although he was very famous and long-lived, was mistaken because he was an idiot and simple-minded'.[32] This devout old man believed that 'the consecrated host was not truly the body of Christ, and instead he spread the word that it was merely a symbol'.[33] A revealing vision appeared to this old man and two other 'ancient' hermits, who had prayed to God for a whole week that He would convince their friend of his error, as they were taking mass together one Sunday at the moment the 'bread and wine were placed on the altar'.

> All three of them saw a very young boy; and when the priest began to break the host, they thought they saw an angel coming down out of the sky who cut the boy up with a knife and collected his blood in the chalice. And when the priest broke the host into many parts to give to the people, they saw the angel dividing the boy into many tiny particles. And when the mass was over and the hermit went up with the others to receive communion, he thought that he alone was given a particle of the boy's bloody flesh. And seeing this, he was very afraid and shouted and said, 'Lord God, now I truly believe that the bread which is consecrated on the altar is your holy body, and the cup, that is the wine, is your blood'. And immediately the flesh appeared to change back into bread and he took it. Then the two hermits said to him: 'Knowing that human nature is horrified by the idea of eating raw flesh, God ordered this sacrament to take the form of bread and wine...'[34]

The faithful, especially those who lived long before the present century, considered, to a greater or lesser extent, the sacrifice of God a prodigy of horrifying grandeur, and they were aware that bloody strips of divine flesh were swallowed down into their stomachs disguised as the host. To the disgust provoked by this act of cannibalism, which was already foul in itself, was added the sacred consternation of introducing forbidden particles of an immeasurable food, global fragments of the divine flesh, into their unworthy bowels.

In the vision handed down by Domenico Cavalca, the youth who was torn to pieces by the angel, whose bleeding flesh was cut into tiny fragments, reflects the profound feelings of attraction and repulsion which the sacrificial mystery (the *mactatio*, the 'mystic butchery')

aroused; this is underlined by the uncontrollable disgust which the mention of human flesh causes in the depths of the Ego. With the passing of time, the sensitivity of the faithful and ecclesiastical doctrine ('*incruente immolatur*', according to the Tridentine canon) have almost removed the image of the bloody offering, anaesthetizing and slowly reducing it to little more than a symbolic act which has been civilly dulcified and dehumanized, and reinterpreting it 'in a figurative sense'. They have unconsciously rejected the terrible act of transubstantiation, and have refused to bear its intolerable weight. But the image and the sensation of a cruel totemic rite, during which the wretched sons eat their father's raw flesh (a father who sacrificed himself to his Creator as the most perfect and purest victim, the sole victim worthy of his Creator's glory), weighed on the consciences of those who approached the communion table until the eighteenth century, if not later.

In the mid-eighteenth century the Bishop of Sant'Agata dei Goti (and many other ecclesiastics like him) did not hesitate to propound yet again the archaic description of the sacrificial meal and the King's sacrifice.

'What a refinement of love,' said Saint Francesco of Sales, 'would it be thought if a prince, seated at table, were to send a portion of his meal to a beggar? What indeed, if he then were to send him his entire meal? And what, finally, if he were to send him a piece of his arm so that the beggar could eat it? In the Holy Communion Jesus feeds us not only with a part of his meal, or a part of his body, but with his whole body . . .'[35]

In this tremendous sacrifice the celebrant was required to follow the complex ceremonial of the sacred mystery with rigorous attention: he should not omit anything, and he should control the timing, his appearance, voice, movements and gestures, and the rhythm of the words like an exemplary and highly professional actor in a sacred drama. Negligence, non-observance, not to mention irreverence and fraudulence, would be duly punished. Haste and carelessness bordered on sacrilege:

It is an omission, which verges on sacrilege, to celebrate Holy Communion in shabby and indecent vestments, and with dirty purificators or altar cloths, or in such a filthy condition that it would be much better not to celebrate than to take communion and commit a execrable blasphemy against the most saintly and pure Body of Our Lord . . .
 It is a fault to celebrate Mass with a short soutane, and a much worse one to celebrate in secular clothing . . . It is not admissible to place a

173

handkerchief or glasses on the cup ... It is a failing not to know the secret and other prayers well, and also the prayers which must be said at particular moments, when the hands are washed or when the sacred vestments are put on ... Since there are three genuflexes, deep, medium and simple, to perform one instead of another is likewise a failing. So is saying the mass too quickly, sometimes syncopating the words and moving the ceremonies, performing them before or after the given time. Saying mass with too loud or too soft a voice ... Bowing before the image of the Sacristy with an uncovered head ... Making the sign of the cross above the Host or the cup with a half-clenched hand or with the first three fingers raised and the other two bent, or doing so either with a hand crooked to the side, or with it fully open so that the crosses do not extend over a palm's width.[36]

This is only a short extract from a lengthy list of 'faults', 'omissions', 'failings' and 'indecencies' – 'It is indecent to stand with the right toe pointed behind the left foot during the consecration of the Host or the cup . . .'[37] – which without doubt had the effect of making the mass a long 'via Crucis' for the celebrant, especially if he was a novice; the priest was a solitary actor in front of an attentive and demanding audience which was quick to whisper and be scandalized. The sacred altar became a controversial stage and the liturgical function a difficult play during which not a single word or movement could be misinterpreted.

The task was enormous and was inevitably accompanied by anguish. During the tiring recital, the sacred actor had to represent and even incarnate Christ, using sacred formulas he had to make the Omnipotent descend from the heavens, he had to reincarnate Him in the host and in the wine. With his mouth and his voice he had to recite the terrible words which miraculously brought Christ back to earth, in flesh and blood.

The bewilderment and uncertainty of many priests were more than justified. Even if a few words of the sacred formula were changed (as in *Hoc est enim corpus meum*) the consecration might be made 'invalid', or 'valid but illicit', or even 'doubtful'. It was enough to say '*hic* [adverb] *est corpus meum*'[38] to invalidate the consecration. But if the same '*hic*' was changed from 'masculine to neuter, the consecration is valid, even if ungrammatical'.[39] The novice had only to mispronounce a word to commit a mortal, or at best a venial sin. Pronounced in the name of Christ, the words had to be as weighty as lead and make veins and pulses throb: 'the forms should be uttered as by the person of Christ, formally and meaningfully, or with assertion (that is, both with

utterance and with meaning), and not only with utterance or in an historical sense'.[40]

Thousands of scruples beset the priest who battled with a mystery which even the Seraphic Francesco felt unworthy of celebrating. A faint trace of these fears and anxieties remains; and there is still an echo of those uncertain, hesitant, unsure, bewildered or ingeniously emphatic voices, of those unnecessarily expressive or resonant words in the instructions of the theologians.

> Those priests do not behave well, who, because of their trivial anxiety not to perform the consecration properly, utter the words with such force, that they are even tempted to associate some word or other with a movement of the head. Certainly this cannot encourage reverence in those present, but rather provokes wonder and sometimes even laughter. Other priests utter the words with such expression that for 'hoc' they clearly say 'hocche', for 'meum' 'meumme', for 'calix' [cup] 'calixe', and so on. Others, having begun a word, start again from the beginning, saying for example 'me meum'. They may be excused because of the scruples which agitate them, but they should not say the words of the consecration as they please, but at the very least with a decisive voice. Let them reflect whether we should believe that Christ the Lord, uttering the words of consecration at the Last Supper waggled his head in this way, or pronounced the words in any other way than in a natual manner of speech.[41]

In these 'ceremonies', 'precision' was a compulsory requirement and it was essential to respect the formalities since it was almost always possible to 'identify' an 'evil' soul in the 'darkness of indecency, immodesty and impiety'.[42] 'Those who hurry through the mass, hurry on to hell', Doctor Angelico had warned, and in any case 'due to the poor manners of those who celebrate, the most saintly and sacred functions of the sacred Altar become objects of laughter and scorn in the squares and clubs, and in conversations'.[43] This most sacred drama could be basely degraded to an ignoble comedy performed by clumsy and negligent third-rate actors. The sacred theatre ran the risk of being transformed into a sacrilegious buffoonery.

> Those priests who confused the holy rites, who muddled, entangled or omitted the ceremonies, or who made badly performed genuflections to the Most Holy Sacrament, who gobbled their words, made thousands of syncopes, made fun of the most mysterious signs of the cross or blessings which are made over the Cup and the Host, by making them in such a clumsy manner that they might have been fencing; and those priests

175

who walked about the church wearing sacred vestments so immodestly and indecently, make themselves despicable both to the heavenly angels and to men on earth.[44]

Haste, that cursed haste which Saint Augustine had deplored (the 'blindness of some priests, who are so quick to celebrate mass that they are often suspected of having omitted something in their haste, or of having confused the ceremonies or of having performed them in the wrong order and without the due pauses and gravity'), transformed priests into 'coachmen' and 'postilions', into impudent mountebanks and third-rate comedians.

In Bologna they ironically called this form of mass 'the hunter's mass'. In *Ricordo alli Superiori, a' Soprastanti delle Sagrestie, e a' Sacerdoti*** (a leaflet without a date, but which was probably written at the end of the seventeenth or early eighteenth century), the author warned that 'it is greatly to be feared that the majority of priests who hurry through Mass end up in hell ... and that there are so many Priests who go to Hell every day that it is difficult to imagine that there are that many in the world. Think on this, priests of God, reflect on it and assiduously meditate.' Therefore, 'the Bishops and the other Prelates and Rectors of the Church, both Regular and Lay, who allow Priests to read or perform the Ceremonies with too much haste, and permit them to celebrate Hunter's Mass (as it is popularly known), commit a mortal sin due to the prejudice and damage which they cause both to the Holy Church and to the worship of God.'

It is none the less surprising to learn that in the Diocese of Bologna a normal mass did not last for more than half an hour.

> 'The Priest,' as is stated in the above-mentioned *Ricordo*, 'must celebrate Mass according to the five letters: A, B, C, D, E. Namely, loud [*alta*], brief, clear, devout and exact. It must be loud so that it is understood; brief, in that it should last for no more than half an hour; clear, in that he pronounces all the words; devout, in that he is careful about what he says; and exact, in that he performs all the ceremonies that are indicated by the rubric with the diligence, gravity and decorum required by so great a Sacrifice ... The Priest who celebrates Holy Mass in less than a third of an hour is often guilty of venial sin. He who finished Mass in less than a quarter of an hour is usually guilty of the gravest sin.'

These surprisingly short times raise doubts about the advent of a new and disciplined Christian society. In fact, one suspects that the

* *A Reminder to Father Superiors, Sacrestans and Priests.*

decrees, regulations, instructions, warnings, advice and pastorals remained for the most part on paper, and that licences, abuses, arbitrary acts, evasions and varying degrees of negligence and personal interpretation formed the day-to-day reality and the authentic dimension of daily liturgical practice and ecclesiastical custom. The virulent denunciation of Alessandro Spinelli, Bishop of Gubbio and a passionate planner of religious order, discipline and behaviour, was a sign of the profound disorder which had not even been formulated, let alone eliminated, by the mid-seventeenth century. For the majority of the clergy, the sacrifice at the altar – as is demonstrated in the book *La troppa brevità della Messa condannata nel Sacerdote**** – was often clumsily enacted by professionals who were bored or inept, or who suffered from exhibitionist tendencies. These liberties continued to thrive well beyond the mid-eighteenth century in spite of continuous criticism.

These buffoon-like priests persisted lightheartedly to omit rubrics from the missal, and, using words, gestures and jokes, to play havoc with the holy script. The 'hunter's mass', which was virtually a parody of the serious, slow, solemn rite, or at best, used impertinent abridgements, those symptoms of shameless and unjustifiable haste, was widely practised. Obviously, it is impossible to know exactly how many parish priests were condemned to hell for their damnable haste, but one can safely assume that it was no small number, judging by the continuous complaints and reproofs. Many holy theatres were in the hands of actors who wore wigs and rigs, who were shabbily dressed, foul-tongued and who showed little respect for their 'profession'; they were often armed with knives and were *habitués* of taverns; they were dancers and playboys, with no tonsure, who were inclined to singing profane songs and were irresistibly attracted by parties and carneval masquerades; they were often apt to drink in inns and markets, and attended '*mechanicis, sordidisque operibus*';[45] they doubled up as vineyard workers, peasants, kitchen gardeners, or middlemen ('*negotiorum gestores*'), all of which were trades and activities which sullied the sanctity of the holy vocation and the decorum of the office, and detracted from the cure of souls. The diocesan constitutions which were promulgated by the Synod of Faenza in 1748 condemned the indecency of those priests who disguised their tonsures ('*capillorum tonsuram et coronam*') with false hair and wigs: '*maxime dedecet Ecclesiasticos homines ad adscititios capillos, vulgo parucca, ad elegantiam et ornatim studiosius colere*'.[46] Likewise, they prohibited the sumptuous banquets whose 'splendour exceeded all moderation . . . and led to excesses and intemperance', especially if

* *The clergy criticized for reciting the mass too quickly.*

there were women present; it was prohibited to entertain oneself with song recitals (*'prophana canendo'*) or musical refrains (*'impudenter perstrependo'*); night-time sorties and illicit walks were not allowed (*'nocturnae deambulationes'*); it was forbidden to enter taverns (*'ad cauponas et tabernas'*); it was absolutely prohibited to wear fancy dress (*'larvas seu personas agere, comoediis turpia repraesentantibus, et choreis publicis aut venalibus aut inhonestis interesse'*)[47] during carneval (*'baccanalium tempore'*). Nuns were also warned not to wear men's clothing (*'ne virorum habitum induant'*). It was forbidden to carry 'any form of weapon, either offensive or defensive', and to wear rings except during the mass (*'annulos, etiam extra Missam'*).

While the preachers ranted against the profanation of the sanctuaries and the 'confusion in the basilicas', and condemned the presence of female 'scented idols' propped up against the 'consecrated ciboriums', and of noblemen who habitually 'walked up and down the churches as if they were in their private galleries'; while they inveighed against the widespread abuses which had degraded the churches into 'schools of public immorality' and had reduced the holy places to 'temples of Venus, citadels of incontinence, and consistories of impropriety', so much so that impurity now brooded on the 'nest of innocence'; and while they hurled insults at the impiety which had contaminated that 'great and awesome place', fearful of the 'terrible majesty of the God who resided there' and of the 'terrifying sanctity of the mysteries',[48] in those same churches and above all in the sacristies (*'in sacrario'*) the men of God ran amok in brawls, obscene language and jests (*'rixari, obscena loqui, cachinnari, aut immodeste vagari'*[49]): *Itali Dei contemptores.*

'The Superiors and Deputies or Supervisors of the Sacristies commit a grave sin if they allow people to talk in a loud voice and do nothing to stop the bad custom of telling jokes and stories or of making impudent remarks there.'[50] But the battle against the abuses which took place inside the 'holy enclosure' was hard-fought; in the very place where the Divinity resided 'in fullness and in the flesh', the irresistible impulses of base and carnal humanity seemed to find thrills and seductions which were unknown elsewhere, in spite of the 'awesomeness of the place' (on the contrary, this unreal atmosphere, which was pervaded by a high degree of supernatural power, may have provoked very worldly reactions and feelings which were far from being arcane). The preachers of the seventeenth and eighteenth centuries repeatedly berated the 'carefree ladies' and immodest men who came to church to worship the terrible 'Lord who resided here, who was invisible but none the less present because of that', as if they had come to 'make fun

of a ghost of the divinity, a make-believe God of the theatre', albeit knowing that from the very beginnings of Christianity immodesty and 'abominable nudity' had been found in these holy places. 'If anyone wants to attempt to seduce a married woman,' Saint John Chrysostom had deplored many centuries earlier, 'this place may be considered the most suitable.' The churches appeared to Saint John to be places of ambiguous promiscuity and of indecent meetings, comparable to public baths and the squares of the city: 'there was a great tumult, a great confusion, and as much noise and laughter as in the public baths or the forum.'

In a homily, Saint Basil lamented that the churches were a veritable workshop for all possible forms of licentiousness: *'omnis incontinentiae officina'*. The dreaded Tertullian, that rigorous holy procurator, considered them virtually equivalent to shameful brothels: *'sacrarium veneris, arcem omnium turpitudinum, privatum concistorium impudicitiae'*. Saint Augustine thought that they were worse and even more dangerous than the already infamous theatres: *'si verum attendamus, deteriora sunt templa, ubi haec aguntur, quam theatra ubi finguntur'*. In fact, the obscene deeds were merely enacted at the theatre, while they were actually committed within the holy walls. An imaginary dialogue between the Saint from Hippo and his far-off follower, the Discalced Augustinian hermit Angelo Maria da S. Filippo, who lived from 1670 to 1703, ran as follows:

> 'Where is that virgin going,' said my Augustine. 'To church, my Saint.' 'To church? Call her back. Her purity will be in too much danger.' 'Where is that maiden going?' 'To the theatre.' 'Let her go. There they enact the rape of Proserpine, the nets of Mars, and the golden rain of the Danae. In church? Well, there they really commit those acts'.[51]

'Vanity', 'lewd glances', 'abominable nudity', 'burning lust', the 'blind lechery' of 'haughty' women and bedevilled men contaminated churches and sanctuaries, and sacrilegious sparrow-hawks lay in ambush on their thresholds, or in front of their altars:

> what impudence, what sacrilege is it that makes you take up such bold positions either at the entrance to the sanctuary or beside the tabernacle, intent on searching out with your exorbitant gaze all the objects which are used in the sacred mysteries or which are present on the holy table, or with impudent and daring glances I would almost say that you violate the most bashful and innocent faces, hunting among them for the choicest prey for which you set snares and lay traps; like gyrfalcons, you eye your prey and hover around it with looks, hints and even evil words;

179

at the very foot of God's throne you spread the sparks of the brutal fire, you weave your plot, you commence the series of those excesses to which the blind lust which infatuates and governs you, furiously leads you.'[52]

The holy places were insidious areas, enclosures filled with excitement, temptations and visions, where divine dreams and demoniacal memories, transportations to heaven and worldly seductions, angelic ecstasies and sinful flattery could all be found: they were bivalent places, where the senses, surprised in ambush, struggled against the impulses and flights of the spirit. While he celebrated mass one day, even the dreams and visions of Saint John Chrysostom were contaminated by the 'impurity' of a cleric who formed part of the Saint's retinue':[53] the 'divine spirits' in which he had delighted, dissolved and vanished from his sight. The lips, the mouths, the foreheads, the eyes, the hair, the precious clothes, the pearls, and the dazzling suns of the cherubs disappeared into nothingness. Then the 'feet of the bodies inhabited by those divine spirits' vanished into thin air, 'those feet whose remarkable proportions exceeded human beauty and showed how advanced these celestial beings were since even their feet surpassed those of humans'.[54]

While he was celebrating the divine Mystery of the Mass, John himself was sacrificed; he was taken by He who takes; the patriarch's face was pallid and the heat left it to return to his heart, desiring to make itself useful in its burning affection towards its God. Everyone recognized the love of the Saint in such paleness; everyone saw how clear and luminous was his Saintliness which received greater light from the pallor.[55]

'This blessed blood does not always protect us from devils:'[56] the presence of an impure accolyte was sufficient to interrupt the divine conversation, to cloud the ecstatic contemplation and to make it fall in hollow, opaque dust away from the bright suns which illuminated the heavenly spaces and ineffable beatitudes.

Strange things could happen on those 'awesome tables'. Priests had the 'power to recall God from Heaven to earth',[57] and 'every day this portentous, tremendous and ineffable sacrifice was renewed with such masterly ceremony, such trembling of the angels and such gravity of ministers . . . ; on these tables this great victim was immolated', and the 'greatest of the miracles worked by God in this world' was renewed, *miraculorum ab ipso factorum maximum*.

Those priests were all the more wretched who, being obliged to interpret 'wonderous mysteries'[58] and to celebrate 'such mysterious rites',[59] instead reduced them to an obscene farce.

Now, what opinion can one have of such priests if they perform this sacrosanct ministry more awkwardly than comedians perform their acts? And truly, what mountebank, having to play the role of a prince in a comedy, does not study to observe decorum, to show himself serious and composed, to speak gravely and with authority, and to use the gestures and manner of speech which suit that rank, so as not to be laughed at and greeted with cat-calls? Certainly, the priests at the altar, when dressed in their sacred vestments and performing the unbloody sacrifice, represent neither Cyrus, nor Assur, nor Augustus, but Christ himself. In this way they consecrate in the name of Christ: they do not say "This is the body of Christ" or "This is the Cup of the Blood of Christ", but "This is my Body" and "This is the Cup of my Blood". They perform in a noble theatre, on an august stage, in which not only men but also heavenly spirits are the spectators. Therefore, when in their actions, in their voices, in their irreverent haste, in their immodesty and in their absence of passion and faith, they are so far from observing the necessary decorum and from clothing themselves in the manners and Person of Christ, is it not clear that they are equally far from being recognized as true and good priests? In fact, I would go as far as to say that they are esteemed less than the worst comedians and fakers.[60]

13

The Horror of the Guts

The God who abases himself to take 'the form of bread, a substance which is far baser than man himself'[1] (the history of the incarnation and of salvation is marked throughout by degrading and humiliating acts, and by 'miserable accidents'[2]); the Omnipotent, having come from a far-off, blessed immortality to a life measured by the passing of time, performs a series of incomprehensible acts of humiliation and belittlement for his own unfathomable and redeeming purposes, which lead along an enigmatic path backwards to destruction and annihilation. Until, in fact, the point of union between human flesh and the Saviour's body is reached, 'so that your limbs become the limbs of that divine body'.[3]

> If, at that time, He shrank his immensity into the smallness of a human body, now [in the eucharist] it is restricted by the narrow diameter of the host, or rather by each individual particle. At that time, as Saint Ambrose and Saint Augustine recounted in their hymn, He did not find it horrendous to enter the guts of a Virgin, even though she was the purest and holiest in the world: '*Tu ad liberandum suscepturus hominem, non horruisti virginis uterum*'. And now He does not find it horrendous to enter the mouth, chest and stomach of any person, irrespective of how wretched or beggarly he is. Then, He was hypostatically joined to the purest, most saintly and most impeccable humanity. But now through the sacrament He is made one with sinners, who have been conceived and born in sin. Then He suffered hunger and thirst and had to beg food from others in order to survive. But now He is himself food for his creatures, and the creatures feed off their creator. Then, even if God disguised himself under mortal form, He revealed himself in miracles and showed his Divinity. But now He performs miracles so as to hide himself better. Because when the substance of the bread is destroyed by

182

the Consecration, the accidents should also be destroyed on account of their necessary connection to the former. But He miraculously preserves them without any form of support, and He hides himself under them so that his true body and blood, together with his soul and godliness, are within the host; but to the senses it seems only to be bread, with the taste and smell of bread. Therefore here, more than elsewhere the name that the prophet gave him, the hidden God, is fitting.[4]

Disgust for the slippery human guts, a labyrinth of worms and a sinkhole of filthy liquids, and horror of the slimy womb, the dark cavern which Christ did not abhor, were added to the repugnance for the mouth and the stomach; they became part of the new *via crucis*, part of the path leading down into the unpleasantly wet crevices of the 'infamous body' (Segneri) into which, having been swallowed by the foul mouths of wretched persons infected by every vice, the Most Holy Body, 'the undefiled sun', fell. The sacrifice at the altar was interpreted in the light of this particular phenomenon as the descent of the pure into the impure, the absorption of the holy by the unclean, and of the incorruptible by the rotten.

> Oh sovereign and incomprehensible Majesty, is it then possible that You are in Heaven and yet I see You in my wretched stomach, and that You have performed so many miracles and have overturned the laws of nature to get there? I feel my whole body tremble and I am overcome by wonder ... I believe, without a shade of doubt, that You are in my stomach in body and in soul ...[5]

The transubstantiation was perceived, over and above its mere symbolic status, as a real alimentary phenomenon; it was considered a mysterious and ambivalent act which did not in the least exclude the physical nature of compenetration and assimilation, the dual chemical journey, the 'holy artifice'[6] of the permeation of both body and soul. At the 'holy and mysterious table ... instead of base and corruptible foods, one truly ate the Holy Body and drank the precious blood'.[7] 'Food to nourish us', 'the food of his Holy Flesh', are phrases which are repeated with the insistence of hammer blows in order to make believe that the metaphorical veil hides a concrete reality, a bodily reminder of the organic and physical nature of the union:

> what is most remarkable about this union between Our Lord and ourselves is that it is attained through food, which is the most closest and most intimate union that exists in nature ... but the union between food and the person fed exceeds all others since in the latter the

substances remain united only while they continue to exist; and what is more they preserve their distinct properties. In this union, on the other hand, food is converted into the substance of the creature it is nourishing. Thus, the dead and lifeless bread which a man eats, becomes his flesh and blood owing to the different properties engendered by the natural heat. Thus, it becomes a living creature, reasonable and human, as he is, and in this way passes from union to unity. In the same way by uniting himself to us in the form of food, Our Lord does not leave us as we are . . . but changes us into himself, and likens us to his own godly image and makes us to a certain extent part of God.[8]

The 'wonder' of this small consecrated host also lay in its capacity to overturn the physical and mental make-up of whoever received it, like a sublime drug which, once taken, is impossible to refuse. Its absence produced a total sense of emptiness, comparable – naturally on a different plane – to withdrawal symptoms. Through the divine toxins one could glimpse the gratification of all needs, all aspirations and all desires (in fact, the early Christians called this sacrament *desiderata*), and flashes of a countryside of ineffable consolation which excited a fervent 'desire for the eternal hills'[9] (*desiderium collium aeternorum*).

Saint Catherine of Siena burnt with such a great ardour to take communion, to be united with Our Lord, that she died a living death. Blessed Catherine of Genoa suffered from extreme hunger and an incredible desire, so much so that seeing the host in the priest's hand she felt a wonderful urge to run and take it, saying to herself in her heart, 'Hurry, hurry, for this is my bread and I will languish and die until I receive it.' Sometimes Saint Teresa suffered from such a violent desire to take Holy Communion that she could not endure it; in fact, there was nothing, neither danger nor labour, which could prevent her from receiving the host. And much earlier the invincible martyr, Saint Ignatius, who much loved Our Lord, wrote to the Romans, saying: 'I do not taste any flavour in the corruptible food that I eat to sustain my body, nor in the pleasures of this life. I only desire the bread of God, the heavenly bread, the flesh of Jesus Christ. To drink I ask for the blood of Him who is incorruptible Charity and eternal life.'[10]

But the effects of this 'mysterious food'[11] which 'makes all creatures lose their appetites' vanished fairly rapidly: the logic of the flesh was inevitably subordinated to physiological patterns and rhythms. Thus, 'having received Our Lord, and when the species have probably been digested and, in consequence, He is no longer bodily present in us, we must beseech him not to leave us'.[12] Once the 'heavenly food' has been digested, the drama of its absence begins.

184

The results of the metabolism of the host were surprising and bewildering not only for the soul but also for the body, since by its mere presence the 'living bread'[13] succeeded in strengthening, re-invigorating and transforming the body, 'enriching it with its treasures and sanctifying body and soul . . . and embedding in it a living seed of the blessedness which one day it will possess'.[14] It provided a foretaste of that paradisiacal happiness, a taste of that boundless joy which would belong to the flesh for eternity in the New Jerusalem. This inebriating fragment of Eden worked on the body, strengthening and transfusing it, for a disappointingly short time, with the mysteries and the extraordinary treasures which lie in eternity's womb.

> In this way He enters a man with his immortal and glorious body, like the body which He offered on the Cross to his Father, not mortal and susceptible, so as to impart the gifts of impassivity, clarity, subtlety and agility to the body, and to the soul a certain impassibility to sin by touch and through the union with his Sacred Body . . .[15]

The eucharistic food represents a rite of passage and of detachment from the 'delights down here'[16] to a supernatural journey, laden with 'penetrating joys', towards 'rest and marvellous tranquillity'.[17] The sacrament was established by Christ 'in the evening and at supper, because the morning leads to lunch and lunch to supper; but supper does not lead to anything but rest and sleep'.[18] It was a narcotizing nepenthe, a heavenly tranquillizer, a transcendental opium which was even represented by the Egyptian priesthood with images of nocturnal calm, and symbolized by the ciphers for drowsiness and oblivion.

> The Egyptians cleverly depicted this with the image of a youth who carried ears of corn in one hand and a cup full of wine in the other, with a poppy hanging from his neck, to indicate that he who ate corn bread and drank wine in the evening could retire to sleep. In the same fashion, after the faithful have eaten the living bread of the Body of Our Lord and drunk the precious wine of his blood they should think of nothing but sleeping in the affection of all creation and, together with his beloved Disciple, nestle in the breast of the same Lord and rest saying '*In pace in idipsum dormiam et requiescam*'.[19]

The bread and wine were a miraculous medicine for body and soul, a blessed nocturnal viaticum for journeys into worlds unimaginable in daylight, an electuary pschyopomp, and the companion of the faithful in new dimensions, in indescribable countries.

185

But who can tell of the admirable tastes and penetrating delights which pure souls experience in receiving this heavenly food? They are matters which excel our powers of speech. Saint Macario says that they are filled with heavenly goods, ineffable joys and the immense riches of the Divinity, which no eye has ever seen, no ear has ever heard, and no heart has ever conceived; Our Lord leads them into a state of rest and marvellous tranquillity, into an enlargement and rejoicing of the heart, into inexpressible contentment ... And before him Saint Cyprian had said 'Mira sunt, quae sentit; magna, quae videt; inaudita quae loquitur, quem Agnus iste Paschalis inhabitat; cuius animam meri huius fortitudo hilaritate inexplicabili laetificat et delectat. Panis iste angelorum omnia carnalium saporum irritamenta et omnium exuperat dulcedinum voluptates'.[20]*

Since the first days of Christianity and over many centuries the mysterious force of the sacred host and the holy wine-cum-blood was perceived as a sweet and awesome drug, a fragment of sacred flesh which estranged from reality, led elsewhere, opened dimensions which were unknown to the senses and broadened and transformed the conscience (albeit temporarily). 'The flesh of God' which was hidden in the sacred fungi or in the flesh of the holy Lamb, the communion with the invisible at 'the holy and mysterious table',[21] the union—unity with the incomprehensible, all lead to one end: man's irrepressible need to reach, during his lifetime, places that were inaccessible to the daily experience of the senses, and to penetrate remote spheres that enhance body and soul, infusing them with massive supplements of unexplored pleasures.

'He in whom the Paschal Lamb dwells,' wrote Saint Cyprian, 'experiences admirable things, sees great things, and says unheard of things; the power of the mysterious wine which he has drunk fills his soul with inexplicable joy. This bread of the Angels surpasses the flavour of the most tasty things, and exceeds all sweetmeats which are capable of flattering our senses.'[22]

Several centuries after Cyprian, the great French Jesuit Jean-Baptiste Saint-Jure (1588–1657), using the biblical text of Isaiah as his starting point, depicted the holy table as a colossal banquet set out by God on the mountain:

'On the mountain of his Church, the God of the Armies will give a more sumptuous and magnificent banquet than all those which have ever

* Translator's footnote: translation on this page.

been for all the people who will gather there. He will set out a table laden with infinitely nourishing and delicious food, and with the most delicate and exquisite wine. And as the Seventy and the Fathers are transported, with emphasis, they will reflect: 'Bibent laetitiam, ungentur unguento': they shall drink joy and they shall be anointed with unguent. They will call this holy table the banquet of joy and ointment . . . Since the just and well prepared souls will not drink wine there, but joy and delight; and they will feed their minds, their wills and all their powers embalmed in an inner unction, so that they can easily, joyfully and perfectly perform virtuous acts. For this same reason, the heavenly nutriment is represented as a manna which the Holy Scriptures praise so highly and described as a food *'omne delectamentum in se habentem et omnem saporis suavitatem*: it contains in itself all delight and every form of sweetness'.[23]

The 'infinite power' of this 'mysterious food', 'the antidote to death and the potion of immortality', which wonderfully fortifies both the living and the dying ('it is given as a Viaticum to those on the verge of death, in order to arm them and give them vigour and strength in their last battle'), of this heroic and 'oversubstantial' food, 'since it nourishes man's principal substance' (the soul), the 'bread of eternal life' was kept ready to hand by the Christians in the first centuries, both at home and while travelling, 'so that they could use it when necessary and take advantage of its powers in danger'. This heroic food, which acted as a painkiller for bodily aches and pains, estranged the taker from his body at moments when his torments became insupportable, such as during torture, massacres and crucifixions.

For this purpose it was still customary to distribute the host to martyrs before they appeared before the judges in order to fortify them in their pains. Without this sacrament, said Saint Cyprian, no one was allowed to enter the martyr's arena: *'Nec terreant Crucifixi haeredes mortis supplicia; sed pascant et reficiant maturatae resurrectionis laetabunda solemnia.'* And thus the heirs of the Cross were not terrified by the pains of death, but were fed and strengthened by the pleasant and joyful mystery of their anticipated resurrection.

And so it happened that, thus provided for, they became so strong that often youths, young boys and tender and delicate young girls, laughed and were joyful in the midst of the most fatal torments, scorning the pain, as if they had bodies of steel and saying after the Psalmist, according to the version of the Seventy, *'Parasti in conspectu meo mensam adversus eos, qui tribulant me: impinguasti in oleo caput meum, et calix meus inebrians quam praeclarus est!'* (Psalm 23: 5).

You have laid before me a table set with admirable food which gives me an insuperable power to beat my enemies. You have anointed my

body with a mysterious ointment ... And the wine you gave me to drink, until I became inebriated, how exquisite and strong it is!

'The martyrs were drunk with this cup,' said Saint Augustine. In fact, when going to martyrdom, they did not recognize their most intimate relations, and were not impressed by the sight of their tousled and crying wives, or their children shouting and groaning, or their relations and acquaintances who, using every sort of trick tried to save them from punishment and death . . .[24]

Inebriated by bread and holy blood, and drugged by the supernatural food, they confronted their tortures laughing. This delirium and collective possession gave a remarkable impression of total alienation, of an inhuman detachment from life, of the tribal vertigo of the 'mad men of God', of an irrepressible desire for sacrifice, sufferance and destruction so that, by the shortest possible path, they would reach the place of definitive joy, the moment of metamorphosis into blessed eternity. It is difficult to interpret these steps as a mere representation of the most profound spirituality: the sacrifice of the body was sparked off by the divine drug which made one forget the love of oneself and destroyed one's love for others. The bread and blood acted as powerful heroic potions. These fragments of God, eaten and drunk, the liquid relics and solid scraps of the victim who was sacrificed for the good of the community, transmitted to the pious devourers the force and excitement of a rite of re-integration, of sacrificial identification: the blind, demential and subliming energy of a portion of the divine which was sucked, drunk, chewed and absorbed. Landscapes unrolled before the eyes of the blind which those who were excluded could not even imagine.

And when the persecution of the faithful began again, as occurred during the French Revolution, when the 'sacred vases, the priestly vestments and the ornaments of the Sanctuary' were 'put up for sale in the vilest fashion, or used in indecent and obscene ways';[25] when 'ciboria were forced open, pyxes were stolen, and the sacred particles were spilt on the ground and trodden on'; when some of the 'most zealous pastors of souls were unjustly exiled, some violently imprisoned, and others barbarously killed',[26] the triumphant image of the 'heavenly river' re-emerged. This symbol of the eucharist, whose 'perennial and rapid waters watered and fed the tree of life . . . , brought with it the gifts of the Holy Spirit, extraordinary graces and the powerful and winning aids of the most subtle and seductive flattery, the most severe and terrifying threats, the most serious discomforts, and the most atrocious and endless torments. 'Living waters flowed from the stomach of the Lamb.'[27]

If you see what appear on the outside to be tender youths, defenceless maidens, delicate matrons, and stumbling old men combatting like magnanimous lions declaring the glorious crime of their faith before tyrants, and challenging all the worldly and infernal powers to battle; if you hear them singing hymns of praise to God that He will give them strength and comfort while they are whipped, stoned and beaten with leads, while they are on the rack, the wheel or cross, or in the midst of flames, as if they had a body made of bronze not flesh, do not wonder, warned Saint John Chrysostom, since they have drawn such courage and joy from the springs of the Lord, who has strengthened and cheered them with the bread of angels. *Hauserunt aquas in gaudio de fontibus Salvatoris.* And when you hear persons say how Catherine of Siena, Giuliana Falconieri, Margarita of Cortona, Maddalena de'Pazzi, Pasquale Bajlon, Stanislau Kosta, the Ivoni and the Bonaventuri and all the other souls enamoured of Consecrated Jesus, spent days without tasting any sort of food, and transformed by the sweet strength of holy love, they conversed with Heaven in their delight until they seemed more like angels than men; attribute these singular phenomena and these sweet metamorphoses to the waters from the Throne and Stomach of the Holy Lamb, on whose life-giving flesh we are fed and satiated, and whose most precious blood purges, refreshes and inebriates us, and raising us above ourselves, to use Saint John's emphatic words, spiritualizes and deifies us.[28]

The vivifying flesh and the precious liquid which spurts from the Lamb's stomach vanquish pain and death since the 'Word's flesh was made life-giving as if united to the very nature of life'.[29] The eucharistic rapture stems from an indestructible faith in the physical nature of the union, in total communion, in the transmission of the power and energy of the incarnate and sacrificed Word. Life spouts vigorously from those bloody shreds because 'the Lord has made another material and another yeast enter this flesh, namely his own divine flesh which is the same as that of man in nature, only that it is empty of sin and full of life'.[30]

The fullness of the union did not occur in a languid and luke-warm fashion, in an almost symbolical way, as in our modern religiosity which has lost the concept of the penetration of flesh by flesh, and is diffident towards the messages and signals of the body and senses, sceptical towards the direct transmission from high to low, from the immense to the infinitely small, and incredulous of the fact that the sacred nature can be transmitted to man's inner tissues by ingestion and assimilation; but rather it took place in a vital and bodily dimension which, while denying the flesh and the world, transfigured and transformed them, exalting and transporting them to heaven. One

189

of the effects of this food was to 'sedate hunger, and this was achieved through taste and pleasure'.[31] Hunger in this context certainly meant the hunger of this world and the appetite for worldly pleasures; but, leaving aside these figures of speech, there remained a powerful charge of sanguine corporality which was only satisfied by the great sacrifice and the consumption of the immolated substance.

The manner in which the saints of the past approached the holy table has all the fascination of a disturbing, emotional and visceral liturgy.

> When receiving the Body of Our Lord and even sometimes when merely looking at it, Saint Catherine of Siena felt such extraordinary consolation that her soul was immersed and absorbed in an ocean of delight; her heart shone in her chest and at times beat so loudly that her companions could hear it. And she said to her confessor: 'My soul is rejoicing in such great happiness and in such a delicious taste . . .'.[32]

'Such an excellent thing' filtered into her heart, filling it to the brim, to the point that 'all worldly things, and not only the riches and pleasures of the body but even the consolations of the soul, seemed to her to be diseases and filth'.[33]

The 'union was so perfect' that 'for several days' she continued to taste 'in a miraculous way, the flavour and smell of the blood of the body of the crucified Christ in her mouth'.[34]

However, if the sublime mystic was to attain that 'abyss of humility' which is God, it was not enough to abandon 'the great sins internally and externally, but he should not search for pleasure even in spiritual and internal things, such as fasting, vigil, prayer, reading, meditation, consolation, sweetness, taste, knowledge, hunger and desire for recompense and for the holy sacrament'.[35] Perhaps even Saint Catherine, who enjoyed in such rapture the taste and the sweetness of communion, did not reach the last step on the ladder of perfection, this liquefaction into *anéantissement*, into annihilation. In order to achieve this, it was necessary to eradicate every vibration and every discontinuity, and to immerse oneself in the obsessive contemplation of the image of Christ: 'Walk and speak as if you were in front of his image; when you eat, bathe each mouthful in the loving blood of his heart; when you drink, imagine that he is refreshing you from his holy wounds; when you sleep, rest on his bleeding heart'.[36]

Notes

Chapter 1 The House with Three Floors

1 Migne, *Patrologia latina*, vol. XL, col. 991.
2 *De triplici habitaculo*, in Migne, *Patrologia latina*, vol. XL, col. 993.
3 In P. Villari, *Antiche leggende e tradizioni che illustrano la Divina Commedia*, Pisa 1865, anastatic reprint, Bologna, Forni, 1979, p. 77.
4 Sancti Petri Damiani, *De poenis inferni*, in *Opera omnia*, Bassano, Remondini, 1783, t. III, col. 62.
5 Dionysii Carthusiani, *Liber utilissimus, de quatuor hominis novissimis*, Venetiis, apud Bartholomaeum Rubinum, 1568, c. 102 r.
6 Bernardo Maria Amico, monaco olivetano, Olivetan monk, *Vita di Santa Francesca Romana*, Venice, Alvise Pavino, 1710, pp. 47–8.
7 Ibid., p. 47.
8 Paolo Segneri, *Il cristiano istruito nella sua legge. Ragionamenti morali*, Venice, Baglioni, 1773, part II, p. 165.
9 Carlo Gregorio Rosignoli, S.J., *Verità eterne esposte in lettioni ordinate principalmente per li giorni degli Esercizi Spirituali*, Milan, C. A. Malatesta, 1688, p. 160.
10 Ibid., p. 180.
11 Ibid., p. 181.
12 Bedae Venerabilis, *Historia ecclesiastica*, in Migne, *Patrologia latina*, vol. XCV, col. 218.
13 *Il Purgatorio di San Patrizio*, in Villari, *Antiche leggende e tradizioni*, p. 58.
14 Dionysii Carthusiani, *Liber utilissimus*, c. 113 v.
15 Sancti Gregorii Magni, *Moralium libri, sive Expositio in librum B. Job*, in Migne, *Patrologia latina*, vol. LXXV, col. 911.
16 Ibid., col. 911.
17 G. Bertoni, *I «Tre morti» e i «Tre vivi» e la «Danza macabra»*, in *Poesie leggende costumanze del medio evo*, Modena, Orlandini, 1927, p. 109.
18 *Buccolicum carmen*, eloga X.

191

19 Cesare Bottalini, S.J., *Quaresimale*, Venice, G. Corona, 1738, p. 331.

20 *Dialogo della Serafica Vergine, et Sposa di Christo S. Catherina da Siena diviso in quattro trattati. Nel quale profondissimamente si tratta della Providenza di Dio*, Venice, G. Sarzina, 1611, p. 154.

21 Bonvesin de la Riva, *Il libro de la scriptura negra*, in *Le opere volgari di Bonvesin da la Riva*, ed. G. Contini, Rome, 1941, vol. I, p. 112.

22 Dionysii Carthusiani, *Liber utilissimus*, c. 113 v.

23 Ibid., c. 135 r.

24 A. Tannoia, *Vita del venerabile servo di Dio Fr. Gerardo Maiella*, Naples, 1853, p. 26 (1st edition, Naples 1811).

25 *Vangelo di Nicodemo*, in *I vangeli apocrifi*, ed. M. Craveri. With an essay by G. Pampaloni, Turin, Einaudi, 1962, p. 353.

26 Cf. A. M. Di Nola, *Inchiesta sul diavolo*, Bari, Laterza, 1979, p. 164.

27 Giacomino da Verona, *De Babilonia civitate infernali et eius turpitudine et quantis penis peccatores puniantur incessanter*, in *Poeti del Duecento*, ed. G. Contini, Milan–Naples, Ricciardi, 1961, vol. I, p. 641.

28 *Dialogo della Serafica Vergine . . . S. Catherina da Siena*, p. 150.

29 Ibid., p. 149.

30 Bonvesin da la Riva, *Il libro de la scriptura negra*, p. 112.

31 *Dialogo della Serafica Vergine . . . S. Catherina da Siena*, p. 149.

32 Dionysii Carthusiani, *Liber utilissimus*, c. 113 r.

33 Ibid., c. 113 v.

34 Ibid.

35 Ibid., c. 135 r.

36 Ibid., c. 119 r–v.

37 *Sermo XXXVI*, in *Biblioteca Patristica*, t. VI.

38 *Revelationes S. Brigittae, olim a card. Turrecremata recognitae, nunc a Consalvo Duranto . . . notis illustratae*, Romae, apud Stephanum Paulinum, 1606, p. 242.

39 Cited from Dionysius the Carthusian, in *Liber utilissimus . . .* , c. 134 v.

40 Giacomino da Verona, *De Babilonia civitate infernali*, in Contini, *Poeti del Duecento*, vol. I, p. 641.

41 *Vangelo di Nicodemo*, in *I vangeli apocrifi*, p. 353.

42 Ibid., p. 357.

43 Ibid., p. 374.

44 *Les structures antropologiques de l'imaginaire*, Paris, P.U.F., 1963; Italian trans. *Le strutture antropologiche dell'immaginario*, Bari, Dedalo Libri, 1972, p. 90.

45 Giacomino da Verona, *De Babilonia civitate infernali*, p. 644.

46 Dionysii Carthusiani, *Liber utilissimus*, c. 113 r.

47 Ibid., c. 115 v.

48 *Gargantua e Pantagruele*, ed. Mario Bonfantini, Milan, Mondadori, 1961, part I, p. 551 (III, 12).

49 J. Hillman, *The Dream and the Underworld, Il sogno e il mondo infero*, Milan, Edizioni di Comunità, 1984, p. 43. The passage cited by Hillman is taken from J. Zandee, *Death as an Enemy according to Ancient Egyptian Conceptions*. Leida, Brill, 1960, p. 73.

50 G. Dumézil, *Le livre des Héros*, Paris, Unesco, 1965, Italian trans., *Il libro degli eroi*, Milan, Adelphi-Bompiani, 1976, p. 113.
51 Ibid., p. 118.
52 Ibid., p. 113.
53 Ibid., p. 121.
54 Ibid., p. 113.
55 Ibid.
56 Ibid., p. 114.

Chapter 2 The Doubtful Eternity

1 Daniello Bartoli, S.J., *Delle due eternità dell'huomo l'una in Dio l'altra con Dio*, Bologna, Monti, 1675, p. 18.
2 Ibid., p. 15.
3 Carlo Gregorio Rosignoli, S.J., *Verità eterne esposte in lettioni ordinate principalmente per li giorni degli Esercizi spirituali*, Milan, C. A. Malatesta, 1688, p. 169.
4 Bartoli, *Delle due eternità dell'huomo*, pp. 14–15.
5 Emilio Manfredi, S.J., *Quaresimale*, Venice, F. Pitteri, 1748, p. 116.
6 Rosignoli, *Verità eterne*, p. 169.
7 Sebastiano Pauli, *Prediche quaresimali*, Venice, T. Bettinelli, 1752, p. 120.
8 L. A. Muratori, *La filosofia morale esposta e proposta a i giovani*, Naples, F. C. Mosca, 1737, p. 47.
9 Ibid., p. 49.
10 Ibid., p. 47.
11 Ibid., p. 52.
12 Claudio Achillini, *Rime e prose*, Venice, N. Pezzana, 1673, p. 296.
13 Anonimo, *Breve ristretto della vita del Padre Gio. Pietro Pinamonti della Compagnia di Gesù*, introduction to the *Opere* of Padre Pinamonti, Venice, N. Pezzana, 1719, c. 2r.
14 Ibid., c. 3 r.
15 Ibid., c. 1 v.
16 Ibid., c. 4 r. & v.
17 Ibid., c. 5 r.
18 Ibid., c. 4 r.
19 Ibid., c. 5 r.
20 «Lettera al Padre Rettore del Collegio di Firenze sopra le virtù del Padre Paolo Segneri, scritta dal Padre Giovanni Pietro Pinamonti per commissione di Cosimo III», in *Lettere inedite di Paolo Segneri della Compagnia di Gesù al Granduca Cosimo terzo tratte dagli autografi* [by Silvio Giannini], Florence, Le Monnier, 1857, p. XLII.
21 Ibid., pp. XLII–XLIV.
22 Ibid., p. XLVI.
23 Ibid., p. XL.
24 Ibid., p. XLV.

25 Ibid.
26 Ibid., pp. XLV–XLVI.
27 Ibid., p. XLVIII.
28 Gio. Stefano Menochio, S.J., *Le stuore, overo trattenimenti eruditi tessute di varia eruditione, sacra, morale, profana. Divise in sei parti*, Venice, Paolo Baglioni, 1675, I, pp. 7–8.
29 Antonio Masini, *Ristretto della Passione di N. S. Giesù Christo. Divisa ne' sette viaggi e stationi tormentose, che fece prima di morire. Col giorno, hora, misure, e distanze di luoghi ove patì* . . . , Venice, Andrea Baroni, 1706, p. 16. It was reprinted at least ten times. The first edition appears to have been printed in Bologna in 1672: *Sette viaggi tormentosi di Christo, nella sua Passione*.
30 Ibid., pp. 18–19.
31 Ibid., p. 53.
32 Ibid., p. 50.
33 Ibid., p. 55.
34 Ibid., p. 126.
35 *The Visione di Tugdalo* was vulgarized in the fourteenth century, but was only printed for the first time by F. Corradini, Bologna, G. Romagnoli, 1872, p. 62. (Scelta di curiosità letterarie inedite o rare dal secolo XIII al XIX, dispensa CXXVIII, vol. XXXII. Commissione per i testi di lingua, anastatic reprint, Bologna, Forni, 1968).
36 Masini, *Ristretto della Passione di N. S. Giesù Christo*, p. 117.
37 Ibid., p. 122.
38 Ibid., p. 169.
39 Ibid., p. 170.
40 G. Casoni, *La Passione di Christo*, in *L'Opere del Sig. Cavalier G. C.*, 12th reprint, Venice, Tomaso Baglioni, 1626, p. 232. On G. Casoni and the «poesia artificiosa» cf. G. Pozzi, *Poesia per gioco Prontuario di figure artificiose*, Bologna, il Mulino, 1984; and by the same author, *La parola dipinta*, Milan, Adelphi, 1981.
41 Ibid., p. 230.
42 G. Marino, *La strage de gl'innocenti*, in *Dicerie sacre e la Strage de gli innocenti*, ed. G. Pozzi, Turin, Einaudi, 1960, p. 480.
43 Ibid., p. 469.
44 Ibid., p. 480.
45 *Il Christo flagellato et le sue essequie celebrate co'l Pianto di Maria Vergine*, Venice, B. Giunti & G. B. Ciotti, 1667, first sonnet.
46 Ibid.
47 J. Rousset, *La littérature de l'âge baroque en France. Circé et la paon*, Paris, Librairie José Corti, 1954, p. 193.
48 Ibid.
49 *De cultu corporis*, in Hieremia Drexelli, *Opera omnia*, Lugduni 1658, t. II, p. 412.
50 P. Segneri, *Il cristiano istruito nella sua legge. Ragionamenti morali*, Venice, Baglioni, 1773, part II, p. 167.
51 Carl'Ambrogio Cattaneo, *L'esercizio della buona morte*, in *Opere del Padre*

C.A.C., Venice, N. Pezzana, 1768, t. II, p. 167. The work was reprinted several times, even by N. Pezzana himself.

52 Ibid., p. 225.
53 Ibid., p. 223.
54 Ibid.
55 Pauli, *Prediche quaresimali*, Venice, T. Bettinelli, 1752, p. 120.
56 J. P. Camus, *Homélies dominicales*, cited by J. Delumeau, *Le péché et la peur. La culpabilisation en Occident XVII^e–XVIII^e siècles*, Paris, Fayard, 1983, p. 447.
57 Pauli, *Prediche quaresimali*, p. 120.
58 Ibid.
59 L. Magalotti, «Confessioni al Granduca Cosimo III», in *Scritti di corte e di mondo*, ed. E. Falqui, Rome, Colombo, 1945, pp. 172–3.
60 *Lettere inedite di Paolo Segneri*, p. 155.
61 Ibid., p. 163.
62 Etienne Durand (1585?–1618), *Stances à l'Inconstance*, in *Méditations*.
63 *Lettere inedite di Paolo Segneri*, p. 161.
64 Ibid., p. 163.
65 Ibid., p. 167.
66 Ibid., p. 155.
67 Ibid., p. 162.
68 Ibid., p. 163.
69 Ibid., p. 167.
70 Ibid., p. 162.
71 Ibid.
72 Ibid.
73 Ibid.
74 Ibid.
75 Ibid., p. 173.
76 Ibid., p. 167.

Chapter 3 Scruples and 'Counterfeit Chimeras'

1 Romolo Marchelli, *Prediche quaresimali*, Venice, Gaspare Storti, 1682, p. 147.
2 F. Pona, *La lucerna*, ed. G. Fulco, Rome, Salerno, 1973, p. 291 et passim.
3 Daniello Bartoli, *La ricreatione del savio in discorso con la natura e con Dio*, Venice, N. Pezzana, 1669, p. 354.
4 Muratori, *La filosofia morale*, p. 264.
5 Bartoli, *La ricreatione del savio*, pp. 340–1.
6 Tertulliano, *De resurrectione corporum*, ch. XII.
7 Bartoli, *La ricreatione del savio*, p. 340.
8 Muratori, *La filosofia morale*, p. 264.
9 Bartoli, *La ricreatione del savio*, p. 366.
10 Paolo Zacchia, *De' mali hipochondriaci*, Rome, Vitale Mascardi, 1644, p. 51.
11 Ibid., pp. 43–4.

12 Ibid., p. 45.
13 Ibid.
14 *La tentazione di Sant'Antonio o il sogno del malinconico,* in *La malinconia nel Medio Evo e nel Rinascimento,* ed. A. Brilli, Urbino, Quattro venti, 1982, p. 16.
15 Ibid., p. 17.
16 Zacchia, *De' mali hipochondriaci,* p. 44.
17 Pauli, *Prediche quaresimali,* p. 119.
18 Manfredi, *Quaresimale,* p. 116.
19 Segneri, *Il cristiano istruito,* part II, pp. 166–7.
20 Manfredi, *Quaresimale,* p. 116.
21 Segneri, *Il cristiano istruito,* part II, p. 166.
22 L. A. Muratori, *Della regolata divozione de' cristiani.* Trattato di Lamindo Pritanio, Siena, Pazzini Carli, 1789, p. 81.
23 Jean-Joseph Surin, *Guide spirituel pour la perfection.* Texte établi et présenté par M. de Certeau, S.J., Paris, Desclée & Brouwen, 1963, p. 305.
24 Ibid.
25 Ibid., p. 304.
26 Ibid., p. 305.
27 Ibid., pp. 305–6.
28 Ibid., p. 306.
29 Muratori, *Della regolata divozione de' cristiani,* p. 81.
30 Ibid.
31 Ibid., p. 82.
32 M. de Certeau, introduction to *Guide spirituel* by Jean-Joseph Surin, p. 19.
33 Giambattista Bonomo, *Il buon governo dell'anime. Opera divisa in trenta discorsi: proposta ad utile di tutti; ma specialmente di parrochi e confessori,* Venice, A. Zatta, 1766, p. 237.
34 Ibid.
35 Ibid., p. 239.
36 Muratori, *Della regolata divozione de' cristiani,* p. 83.
37 Manfredi, *Quaresimale,* p. 113.
38 L. A. Muratori, *Della forza della fantasia umana,* Venice, G. Pasquali, 1745, p. 142.
39 Ibid.
40 Ibid., p. 143.
41 Muratori, *La filosofia morale,* p. 69.
42 Muratori, *Della forza della fantasia umana,* p. 143.
43 Ibid.
44 Ibid., p. 145.
45 Muratori, *La filosofia morale,* p. 69.
46 Muratori, *Della forza della fantasia umana,* p. 143.
47 Ibid.
48 Ibid., p. 145.
49 Ibid.
50 Muratori, *Della regolata divozione,* p. 78.
51 Muratori, *Della forza della fantasia umana,* p. 144.

52 Ibid.
53 Ibid., p. 145.
54 Ibid., p. 144.
55 Ibid., p. 145.
56 Ibid., pp. 144–5.
57 Alessandro Terzi, conventual minor, *Prediche quaresimali*, Bergamo, Fratelli Rossi, 1765, p. 220.
58 Ibid., p. 221.
59 Ibid.
60 Marchelli, *Quaresimale*, p. 91.
61 Muratori, *La filosofia morale*, p. 51.
62 Muratori, *Della forza della fantasia umana*, p. 112.
63 L. A. Muratori, *Riflessioni sopra il buon gusto nelle scienze, e nelle arti*, Colonia, 1721, part I, p. 130.
64 Bernardino Trevisano, *Introduzione all'opera del Pritanio, cioè la Teorica del Buon gusto*, in Muratori, *Riflessioni sopra il buon gusto*, part I, p. 4.
65 Bartoli, *La ricreatione del savio*, p. 353.
66 Ibid.
67 Ibid.
68 Ibid., p. 365.
69 Ibid., p. 350.
70 Ibid.
71 Ibid., pp. 347–8.
72 Ibid., p. 348.
73 Ibid., p. 366.
74 Ibid., p. 349.
75 Ibid.
76 Ibid.
77 Ibid.
78 Ibid.
79 Trevisano, *Introduzione all'opera del Pritanio, cioè la Teorica del Buon gusto*, pp. 4–5.
80 Ibid., p. 9.
81 Muratori, *Riflessioni sopra il buon gusto*, part I, p. 127.
82 Ibid.
83 Ibid., p. 130.
84 Ibid., p. 127.
85 Ibid., p. 131.
86 Ibid.
87 *De spectaculis*, in Migne, *Patrologia latina*, vol. I, coll. 660–1.
88 Ibid., col. 660.
89 Ibid., col. 661.
90 Sancti Bernardi, *Sermones*, in Migne, *Patrologia latina*, vol. CLXXXIII, col. 214.
91 Ibid., col. 215.

Chapter 4 The 'Unhappy Country'

1 Cattaneo, *L'esercizio della buona morte*, p. 82.
2 Ibid.
3 Ibid., p. 84.
4 Ibid., p. 82.
5 *Visione di Tugdalo*. Vulgarized in the fourteenth century, p. 51.
6 Ibid., p. 50.
7 Giacomo Lubrani, *Prediche quaresimali postume*, Padua, Stamperia del Seminario, 1703, p. 250.
8 Paolo Segneri, *La manna dell'anima*, Venice, S. Occhi, 1777, vol. IV, p. 65.
9 Ibid., pp. 65–6.
10 Carlo Gregorio Rosignoli, S.J., *Verità eterne esposte in lettioni. Ordinate principalmente per li giorni degli esercizi spirituali*, Milan, C. A. Malatesta, 1688, p. 157.
11 Lubrani, *Prediche quaresimali postume*, p. 249.
12 Ibid., p. 255.
13 Ibid., p. 248.
14 G. K. Chesterton, *S. Tommaso d'Aquino*, Milan, Agnelli, 1938, p. 32.
15 Segneri, *Il cristiano istruito nella sua fede*, part II, p. 168.
16 Lubrani, *Prediche quaresimali postume*, p. 251.
17 Luigi Giuglaris, S.J., *Quaresimale*, Milan, Lodovico Monza, 1665, p. 141.
18 *Prediche . . . Predicate in Roma la Quaresima l'anno 1542 nella Chiesa di S. Lorenzo in Damaso*, Venice, Giunti, 1590, pp. 164–5.
19 Giovanni Giudici, *Gli «Esercizi spirituali» come testo poetico*. Introduction to Ignacio de Loyola, *Esercizi spirituali*, Milan, Mondadori, 1984, p. 12.
20 Ibid., p. 13.
21 Zuccarone, *Quaresimale*, p. 124.
22 Emmanuele Orchi, *Prediche quaresimali*, Venice, Giunti & Baba, 1650, p. 52.
23 Ibid.
24 Ibid.
25 Ibid.
26 T. Tasso, *Il mondo creato*, c. VII, vv. 364–5.
27 *Lezioni sacre su la fine del mondo*, vol. II, in *Opere* dell'abate Giambattista Roberti, vol. XIV, Bassano, Remondini, 1797, pp. 230–2.
28 Ibid., p. 232.
29 Ibid., p. 240.
30 Zuccarone, *Quaresimale*, p. 123.
31 Rosignoli, *Verità eterne esposte in lettioni*, p. 154.
32 Marino, *La musica*, in *Dicerie sacre*, p. 253.
33 Ibid., p. 260.
34 Ibid., p. 258.
35 Marino, *La strage de gl'innocenti*, I, 42, 1.

36 Marino, *La musica*, in *Dicerie sacre*, pp. 254–5.
37 Ibid., p. 255.
38 Ibid., p. 254.
39 Marino, *Il Cielo*, in *Dicerie sacre*, p. 395.
40 Rosignoli, *Verità eterne esposte in lettioni*, p. 179.
41 Ibid.
42 Ibid., p. 157.
43 Ibid., p. 155.
44 Ibid., p. 156.
45 Ibid., p. 157.
46 Mattioli, *La pietà illustrata*, part I, p. 327.
47 Lorenzo Montano, *Lorenzo Magalotti*, in *Carte nel vento. Scritti dispersi*, Florence, Sansoni, 1956, p. 442.
48 G. L. de Fromentière, *Quaresimale*. Translated from French, Venice, G. B. Recurti, 1732, pp. 192–3.
49 Geremia Dresselio, *L'inferno prigione, e rogo de' dannati. Parte seconda dell'Eternità dichiarata*. Translated from Latin into Italian by P. Lodovico Flori, Rome, Mascardi, 1641, p. 125.
50 Ibid., pp. 289–91.
51 Bernardino Ramazzini, *Le malattie dei lavoratori (De morbis artificum diatriba)*, ed. F. Carnevale, Rome, La Nuova Italia Scientifica, 1982, p. 91.
52 Ibid., p. 84.
53 Ibid.
54 Ibid., p. 91.
55 Ibid.
56 Ibid., p. 84.
57 Dresselio, *L'inferno prigione*, pp. 162–3.
58 Matteo Piazzi, *Prattica per espurgare le case, et robbe infette, e sospette di contagio*, Bologna, per l'Herede del Benacci, 1630, p. 7.
59 Ramazzini, *Le malattie dei lavoratori*, p. 144.
60 Ibid., p. 145.
61 *Novelle dell'altro mondo. Poemetto buffonesco del 1513*, ed. V. Rossi, Bologna, Zanichelli, 1929, p. 37.
62 Ibid.
63 Ibid.
64 Ibid.
65 Ibid., p. 33.
66 Americo Mini, *Quaresimale*, Rome, A. Fulgoni, 1785, p. 192.
67 Ibid.
68 *Visione di Tugdalo*, p. 42.
69 *Novelle dell'altro mondo*, p. 39.
70 Ibid., p. 35.
71 Ibid., p. 39.
72 *Libro di Carnevale dei secoli XV e XVI, raccolto da Luigi Manzoni*, Bologna, Romagnoli, 1881 (anastatic reprint, Bologna, Forni, 1968), p. 51.

73 *Aucassin et Nicolette*, Paris, Flammarion, 1984, p. 59.
74 Keith Thomas, *Religion and the Decline of Magic*, London, Weidenfeld & Nicolson, 1973. p. 203.
75 Ibid., p. 205.
76 Ibid., p. 193.

Chapter 5 *The 'Foul-Smelling Drains'*

1 Ercole Mattioli, S.J. (1622–1710), *La pietà illustrata. Accademie sacre, dove s'erudisce in ordine ad essa, un giovane nobile*, Parma, A. Pazzoni & P. Monti, 1694, part I, p. 228. The first and second parts are contained in the first volume. The third part was printed in 1696, and the fourth in 1700.
2 Venerable Bede, *Historia ecclesiastica*, in *Patrologia latina*, vol. XCV, col. 248.
3 Mattioli, *La pietà illustrata*, part I, p. 229.
4 Ibid., p. 230.
5 Ibid., p. 223.
6 Bede, *Historia ecclesiastica*, vol. XCV, col. 249.
7 Sancti Petri Damiani, *Sermo LIX*, in *Opera omnia*, Bassano, Remondini, 1783, vol. II, col. 316.
8 *Sermo LXXXIX*, in Horoy, *Biblioteca Patristica*, t. VI.
9 Giacomino da Verona, *De Babilonia civitate infernali et eius turpitudine et quantis penis peccatores puniantur incessanter*, in *Poeti del Duecento*, p. 642 et passim.
10 Sancti Petri Damiani, *Laus eremiticae vitae*, in *Opera omnia*, vol. III, col. 236.
11 *L'inferno aperto al cristiano perché non v'entri*, in *Opere del Padre Gio. Pietro Pinamonti della Compagnia di Gesù*, Venice, N. Pezzana, 1719, pp. 402–3.
12 Ibid., p. 403.
13 Ibid., p. 404.
14 P. Segneri, *Quaresimale*, Florence, L. Ciardetti, 1829, t. I, p. 452.
15 Pinamonti, *L'inferno aperto al cristiano*, p. 403.
16 Tommaso Fasano, *Della febbre epidemica sofferta in Napoli l'anno 1764. Libri tre*, Naples, Michele Morelli, 1783, p. 31.
17 Ibid., p. 29.
18 Ibid., p. 28.
19 Ibid., p. 29.
20 Ibid., p. 13.
21 Ibid.
22 Ibid., p. 12.
23 Ibid.
24 Ibid., p. 27.
25 Ibid.
26 Ibid., p. 28.
27 Ibid., p. 30.
28 Ibid., p. 21.
29 Ibid., p. 34.
30 Ibid.

31 Ibid., pp. 34–5.
32 Ibid., pp. 35–6.
33 Pinamonti, *L'inferno aperto al cristiano*, p. 405.
34 G. Bachelard, *La psychanalyse du feu*, Paris 1967; Italian trans., *L'intuizione dell'istante. La psicoanalisi del fuoco*, Bari, Dedalo libri, 1973, p. 227.
35 Padre Sebastiano Ammiano, *Discorsi predicabili per documenti del viver christiano*, Venice, Al Segno della Concordia, 1589, part III, c. 80 r.
36 Pinamonti, *L'inferno aperto al cristiano*, p. 406.
37 Ibid., pp. 405–6.
38 Ibid., p. 405.
39 Romolo Marchelli, *Prediche quaresimali*, Venice, G. Storti, 1682, p. 144.
40 Ibid.
41 *Moralia in Job*, IX, 39.
42 Marchelli, *Prediche quaresimali*, p. 145.
43 Ibid., pp. 147–8.
44 Mattioli, *La pietà illustrata*, part I, p. 239.
45 Ibid., pp. 232–3.
46 Marchelli, *Prediche quaresimali*, p. 149.
47 Pinamonti, *L'inferno aperto al cristiano*, p. 407.
48 Ibid.
49 Lubrani, *Prediche quaresimali postume*, p. 250.
50 Marchelli, *Prediche quaresimali*, p. 147.
51 Quirico Rossi, S.J., *Lezioni sacre*, Parma, F. Carmignani, 1781, part I, p. 129. Q. Rossi takes as his starting point a sermon which the Jesuit, Cornelio Della Pietra (Cornelius a Lapide), who was Belgian by origin but died in odour of sanctity in Rome in 1627, wrote that he had heard one day in Flanders given by a famous holy orator.
52 Pinamonti, *L'inferno aperto al cristiano*, p. 407.

Chapter 6 The Laughing God

1 Padre Angelo Maria da San Filippo, *Quaresimale*, Venice, G. B. Recurti, 1715, p. 88.
2 Ibid., p. 88.
3 Ibid., p. 89.
4 G. Marino, *La strage de gli innocenti*, In *Dicerie sacre e la Strage de gli innocenti*, ed. G. Pozzi, Turin, Einaudi, 1960, II, 6.
5 «Il libro a chi legge», premise to his *Quaresimale*.
6 Ibid.
7 Ibid.
8 Lubrani, *Prediche quaresimali postume*, p. 255.
9 Angelo Maria da San Filippo, *Quaresimale*, p. 88.
10 Ibid., p. 196.
11 Ibid., p. 89.
12 Segneri, *Quaresimale*, I, 447.

13 Ibid., pp. 446–7.
14 Lubrani, *Prediche quaresimali postume*, p. 255.
15 John Bossy, *Essai de sociographie de la Messe*, «Annales», 36 [1981], p. 59.
16 *Eccellenza e pregi della Divozione del Cuor adorabile di Gesù Cristo . . .* , Venice, Giovanni Gatti, 1787, p. 69.
17 Padre Emanuele Orchi, cappuccino, *Prediche quaresimali*, Venice, Giunti & Baba, 1650, p. 52.
18 Agostino, *I soliloqui*, p. 209.
19 Giovan Luigi di Fromentière, Bishop of Ayre, *Quaresimale*, translated from French, Venice, G. B. Recurti, 1732, p. 192.
20 Padre Carlo Solfi, de' Chierici Regolari ministri degl'infermi, *Il ministro degl'infermi. Per aiuto alla buona morte*, Venice, Baglioni, 1765, p. 33. The first edition appeared in 1680.
21 Ibid.
22 Agostino, *I soliloqui*, op. cit. p. 209.
23 Orchi, *Prediche quaresimali*, pp. 52–3.

Chapter 7 *From the Heart of the Earth to the Sun*

1 Pier-Maria da Pederoba, alias il Pietrarossa, *Prediche quaresimali*, Vicenza, per Giacomo Leoni Conduttor della Ditta Gio. Batista Vendramini Mosca, 1786, vol. I, p. 148.
2 *Apologeticum*, Turin, Paravia, 1926, p. 66.
3 Pederoba, *Prediche quaresimali*, vol. I, p. 149.
4 *Paraenesis sive adhortatio ad Theodorum lapsum*, I, 10, in Joannis Chrisostomi Archiepiscopi Costantinopolitani. *Opera Omnia*, Venetiis, ex Typographia Balleoniana, 1780, vol. I, p. 7.
5 G. Leopardi, *Zibaldone*, in *Tutte le opere*, ed. F. Flora, Milan, Mondadori, 1961, II, p. 488.
6 Pederoba, *Prediche quaresimali*, vol. I, p. 143.
7 Ibid.
8 Ibid.
9 Ibid.
10 Ibid.
11 Boulainvilliers, *Réfutations des erreurs de Spinoza*, cited from P. Hazard, *La crisi della coscienza europea*, ed. P. Serini, Turin, Einaudi, 1946, p. 24.
12 Muratori, *Riflessioni sopra il buon gusto*, I, p. 129.
13 Muratori, *Della forza della fantasia umana*, p. 131.
14 Ibid.
15 Ibid., pp. 130–1.
16 Ibid., p. 131.
17 Ibid. On the 'boiling imagination' of witches and melancholics, the mother of 'bizarre and extravagant spices' and 'monstrous chimeras', cf. Girolamo Tartarotti, *Del congresso notturno delle lammie*, Rovereto, Pasquali, 1749, p. 183.

18 This is the tenth verse of the sonnet dedicated to Pierre Bayle by Father Appiano Buonafede, alias Appio Anneo de Faba Cromaziano, alias Agatopista Cromaziano, in *Ritratti poetici, storici e critici di varii moderni uomini di lettere*, Venice, P. Pasquali, 1788, part I, p. 69. The first edition of *Ritratti* appeared in Naples in 1745.

19 P. Hazard, *La crisi della coscienza europea*, p. xi.

20 G. Marino, *La Pittura. Diceria prima sopra la Santa Sindone*, in *Dicerie sacre e La strage de gl'innocenti*, ed. G. Pozzi, Turin, Einaudi, 1960, p. 101.

21 The citation is taken from the French translation: *Recherches sur la nature du Feu de l'Enfer, et du lieu où il est situé* par M. Swinden . . . traduit de l'anglais par M. Bion, Ministre de l'Eglise Anglicane, avec figures, Amsterdam, 1757, p. 107. The work was translated into French by J. Bion, Anglican minister, first in Amsterdam in 1728; this translation was reprinted in 1728, 1733 and 1757. It was also translated into German in 1728, 1731, 1738, 1755. Cf. D. P. Walker, *The Decline of Hell. Seventeenth-Century Discussion of Eternal Torment*, London, Routledge and Kegan Paul, 1964, pp. 39–40, 61–2. After the first London edition of 1714, *An inquiry into the nature and place of hell*, a second edition was printed, again in London, in 1727 *With a supplement, wherein the notions of Abp. Tillotson, Dr. Lupton, and others, as to the eternity of hell torments, are impartially represented. And . . . Mr. Wale's sentiments of this work.* See also the entry 'Enfer' in *Encyclopédie*, Paris, 1755, t. V, pp. 667–8. Swinden's theory was confuted in Italy by the Dominican Giovanni Vincenzio Patuzzi in *De sede inferni in terris quaerenda dissertatio ad complementum operis de futuro impiorum statu, tributa in partes tres. In quarum prima nova refellitur opinio Swindenii Doctoris Angli Sedem Inferni in Sole collocantis. In altera communis sententia de Sede Inferni subterranea defenditur et illustratur. In tertia sensus ac doctrina Ecclesiae Catholicae de Articulo Symboli Apostolici «Descendit ad Inferos» propugnatur, tum contra Swindenium, tum contra Vossium, Bochartum, aliosque Heterodoxos*, Venetiis, ex Typographia Remondiniana, 1763. As the author himself declared this work completed the treatise *De futuro impiorum statu libri tres. Ubi adversus deistas, nuperos origenistas, aliosque novatores Ecclesiae Catholicae Doctrina de poenarum Inferni veritate, qualitate, et aeterninate asseritur et illustratur*, second edition, Venice, 1764.

22 *Recherches sur la nature du Feu . . .* , p. 18 of the preface by J. Bion.

23 L. Magalotti, *Lettere familiari*, Venice, S. Coleti, 1732, p. 282.

24 Ibid., p. 294.

Chapter 8 *The 'Soft Life' and 'Weak Sinners'*

1 A. Valsecchi, *Quaresimale*, Livorno, Vicenzo Mansi, 1847, p. 179. A preacher, a teacher of theology at the *Studio* in Padua, a polemic and controversialist, Antonio (or Antonino) Valsecchi was also the author of *La religion vincitrice relativa ai libri de'fondamenti della religione, e dei fonti dell'empietà*, Padua, 1771 (another edition Padua, Manfré, 1778); and of *La*

verità della Chiesa Cattolica Romana dimostrata, illustrata e difesa, Padua, Bettinelli, 1794.

2 Ibid., p. 181.

3 Ibid.

4 G. B. Roberti, *Lettera ad un vecchio e ricco signore feudatario sopra il lusso del secolo XVIII*, in *Scelta di lettere erudite del Padre G.B.R.*, Venice, Tipografia di Alvisopoli, 1825, p. 138 et passim.

5 E. and J. de Goncourt, *La femme au dix-huitième siècle*, Paris, Flammarion, 1982, p. 146.

6 Pier-Maria da Pederoba, alias il Pietrarossa, *Prediche quaresimali*, dedicate alla S. R. M. di Vittorio Amedeo III, Re di Sardegna, Vicenza, per Giacomo Leoni conduttor della Dita Gio. Battista Vendramini Mosca, 1786, part I, p. 288 et passim.

7 Ibid., part I, p. 250.

8 Ibid., part II, p. 74.

9 Ibid., part II, p. 70.

10 Ibid., part II, p. 72.

11 Ibid., part II, p. 73.

12 Ibid., part II, p. 71.

13 Ibid., part II, p. 70.

14 *Dei peccati del secolo XVIII*, in *Quaresimale di celebri moderni autori italiani*, Venice, Curti, 1823, I, p. 95 et passim.

15 Ibid., p. 102.

16 Ibid., part II, p. 71.

17 E. and J. de Goncourt, *La femme au dix-huitième siècle*, p. 146.

18 Francesco Zuccarone, S.J., *Quaresimale*, Venice, P. Baglioni, 1671, p. 123.

19 Ibid., p. 82.

20 Ibid., p. 81.

21 Pederoba, *Prediche quaresimali*, part I, p. 228.

22 Zuccarone, *Quaresimale*, p. 82.

23 Ibid.

24 Pederoba, *Prediche quaresimali*, part II, p. 70.

25 Americo Mini, *Quaresimale*, Rome, Antonio Fulgoni, 1785, p. 196.

26 Pederoba, *Prediche quaresimali*, part II, p. 73.

27 Pauli, *Prediche quaresimali*, p. 113.

28 Bartolomeo Vio, «ex gesuita veneto» (1708–89), *Prediche*, Venice, Antonio Curti, 1789, t. I, p. 269.

29 Ibid., p. 270.

30 Ibid.

31 Ibid., p. 268.

32 Ibid.

33 Voltaire, *Dizionario filosofico*, ed. M. Bonfantini, Turin, Einaudi, 1955, pp. 182–3.

34 P. L. Grossi, *Dei peccati del secolo XVIII*, p. 94.

35 Ibid., p. 95.

36 Ibid., p. 113.

37 Vio, *Prediche*, p. 271.
38 Ibid., pp. 269–70.
39 T. Buffa, *Prediche quaresimali e lezioni sacre*, Naples, Libreria e tipografia Simoniana, 1843, p. 73.

Chapter 9 *The Stolen Ciborium*

1 Anonimo, *Succinta relazione del processo, e sentenza contro Niccolò del Medico alias Cavanella della città di Carrara, reo di furto sacrilego, ed ereticale della sagra pisside con 215 particole consagrate. Come pure della pubblicazione di detta sentenza seguita nella chiesa di S. Francesco de' RR.PP. Minori Osservanti della città di Massa del giorno 12 dicembre 1723*, in Modena, per Bartolomeo Soliani Stampator Ducale, 1724, p. 3. All the extracts relating to the story of Cavanella are taken from this publication.
2 Anonimo, *La sclerata vita, e vituperosa morte di Angelo Secchiarolo detto Bigaratto, nuovamente occorsa nella città d'Ancona . . . per diversi omicidi da lui commessi, e per non volersi mai confessare, et invocare li santissimi nomi di Gesù, e di Maria è stata portata l'anima sua a casa del Diavolo*, Bologna, per Costantino Pisarri, n.d. (but 1729), c. 2v.
3 Giacinto Manara, S.J., *Notti malinconiche. Nelle quali con occasione di assister' à condannati a morte, si propongono varie difficoltà spettanti à simile materia. Serviranno per instruttione à confessori, confortatori, e altri assistenti nelle confortarie. E fuori di tale contingenza saranno di utile à chi confessa. Con un'appendice, nella quale si pone il modo di preparare i rei a morire christianamente. Et un esame generale di conscienza, che servirà per far meglio la loro confessione*, Bologna, Gio. Battista Ferroni, 1668, p. 295.
4 Ibid., p. 296.
5 Ibid., p. 297.
6 Ibid., pp. 296, 298.
7 Ibid., p. 298.
8 Ibid., pp. 299–300.
9 Frate Carlo Verri da Cremona, *Ricordi per esercitar il caritativo officio d'aiutar a christianamente morire quei meschini che sono dalla giustizia condannati a morte. Con l'aggiunta d'alcuni dubbij spettanti allo stato, e salvezza di detti giustitiati dopo la loro morte*, Milan, Federico Agnelli, 1672.
10 Ibid., p. 63.
11 Ibid., p. 202.
12 Ibid., pp. 59–60.
13 This, and all the other extracts relating to the story of the false priest, Domenico Spallaccini, are taken from the anonymous publication, *Distinta relazione della condanna fatta nel Salone del S. Officio dal Supremo Tribunale della S. Inquisizione, di Domenico Spallacini da Orvieto. Per aver per lo spazio di cinque anni celebrato il Santo Sacrifizio della Messa senza esser stato ordinato Prete. Con l'esatta notizia del suo Processo, e d'altri errori da lui commessi, e di tutte le Ceremonie*

seguite in tale occasione. Con la descrizione della sua morte, e dell'ordigno con cui fu incendiato il suo cadavere, Rome and Bologna, Costantino Pisarri all'Insegna di S. Michele, 1711.

Chapter 10 *The 'Stupendous Excess'*

1 Nicola Laghi da Lugano, *De miracoli del Santissimo Sacramento. Con historie, sentenze, instruttioni, e avvertenze intorno alla Santissima Communione, e Messa*. Part I. Aggiuntovi in questa nova impressione la seconda parte di altri simili Miracoli, con l'*Historia de' Sacri Corporali di Daroca*, dal R. D. Girolamo Canini d'Anghiari. Et *Il Propugnacolo della vera, e real presenza di Christo nell'Eucharistia Santissima* del R. D. Giorgio Polacco, Venice, Gio. Battista Bertoni, 1615, c. 2r. From the dedication to the 'pious reader'.

2 Gio. Battista Turrini, *Tributi di lode alla Santissima Trinità, alla mirabile Incarnatione dell'Verbo, alla Sacrosanta Eucarestia, e all'Immacolata Concettione di Maria sempre Vergine, e Madre di Giesù Christo N.S. appassionato, morto, e resuscitato. Seconda parte de' Componimenti poetici* del Sig. Can. Gio. Battista Turrini, Cesena, Giuseppe Gherardi, 1711, p. 70.

3 Ibid., p. 72.

4 Ibid., p. 69.

5 Ibid., p. 68.

6 G. Lubrano, *Scintille poetiche*, ed. M. Pieri, Ravenna, Longo, 1982, p. 81.

7 P. Segneri, *Il parroco istruito. Opera in cui si dimostra a qualsiasi curato novello il debito che lo strigne, e la via da tenersi nell'adempirlo*, Bologna, Stamperia del Longhi, n.d. [1691?], p. 283.

8 Ibid., p. 284.

9 Ibid., p. 283.

10 Ibid.

11 Ibid., p. 284.

12 Ibid.

13 Ibid.

14 Giordano da Pisa, *Quaresimale fiorentino 1305–1306*. Critical edition, edited by C. Delcorno, Florence, Sansoni, 1974, p. 336.

15 Ibid., pp. 162–3.

16 Ibid., p. 336.

17 Caesarius Heisterbacensis, O. Cist., *Dialogus miraculorum*. Testum … accurate recognovit J. Strange, Colonia, Bonn and Brussels, 1851 (rist. Ridgewood, Gregg, 1966), vol. II, p. 166.

18 *Trattato della Messa*, in N. Laghi, *De miracoli del Santissimo Sacramento*, cit., pp. 24–5.

19 Martinus del Rio, *Disquisitionum magicarum libri sex*, in tres tomos partitos, Venetiis, apud. Ioan. Antonium et Iacobum de Franciscis, 1606, t. II, p. 204.

20 Agostino Coltellini, *La Grazia che condanna overa Discorso contr'all'abuso del Santissimo Sacramento dell'Altare*, Florence, per il Massi da Forlì, 1652, pp.

18–29. This forms part of a series of small works, with independent dates and numeration, collected in the volume *Discorsi sacri* di Agostino Coltellini, Florence, per il Landi, 1654.

21 Ibid., pp. 19–21.

22 Cf. Ioannis Stephani Duranti, *De ritibus Ecclesiae Catholicae libri tres*, Romae, Ex Typographia Vaticana, 1591, Libro II, cap. XXXIX.

23 Emmanuele de Azevedo, coimbricense, *Vita del taumaturgo portoghese Sant'Antonio di Padova*, Bologna, Lelio Dalla Volpe, 1790, p. 44.

24 Ibid.

25 N. Laghi, *De miracoli del Santissimo Sacramento*, in the dedication to 'the pious reader', c. 1r.–v.

26 Ibid., c. 1v.

27 Ibid.

28 Ibid.

29 Giovanni Imperiale, vicentino, *Le notti beriche. Overo de' quesiti, e discorsi fisici, medici, politici, historici, e sacri libri cinque*, Venice, Paolo Baglioni, 1663, p. 31.

30 Martino del Rio, *Disquisitionum magicarum libri sex*, cit., t. II, pp. 9–10.

31 Ibid., t. III, p. 70.

32 Caesarius Heisterbacensis, *Dialogus miraculorum*, p. 171.

33 Martino del Rio, *Disquisitionum magicarum libri sex*, t. II, p. 8.

34 Jean-Baptiste Thiers, *Traité des superstitions qui regardent les sacraments, selon l'ecriture saincte, les decrets des conciles, et les sentiments des Saints Pères, et des theologiens*, Paris, 1697, t. II, p. 319.

35 Ibid., p. 336.

36 Emerio de Bonis, S.J., *Trattato del Santissimo Sacramento dell'Altare, et del modo di riceverlo fruttuosamente, con un altro trattato della Santissima Messa, & del modo d'udirla con frutto. Con uno specchio di Confessione*, Brescia, Pietro Maria Marchetti, 1598, p. 94.

37 Caesarius Heisterbacensis, *Dialogus miraculorum*, p. 195.

38 Virgilio Cepari, S.J., *Vita del Beato Giovanni Berchmans della Compagnia di Gesù*, Rome, 1865, p. 129.

39 E. de Bonis, *Trattato del Santissimo Sacramento dell'Altare*, pp. 90–1.

40 F. Sacchetti, *Il trecentonovelle*, ed. E. Faccioli, Turin, Einaudi, 1970, nov. 89.

41 Ibid., nov. 103.

42 Imperiali, *Le notti beriche*, p. 32.

Chapter 11 The Mysterious Food

1 C. G. Rosignoli, *Maraviglie di Dio nel Divinissimo Sacramento, e nel Santissimo Sacrificio*, Turin, G. B. Zappata, 1704, p. 220.

2 S. Francesco di Sales, *Lettere spirituali*, translated from French into Italian by one of his followers, part I, Padua, Stamperia del Seminario, 1728, p. 283.

3 Ibid.

4 Ibid.

5 Cited from F. Picinelli, *Mondo simbolico formato d'imprese scelte, spiegate, ed illustrate*, Venice, P. Baglioni, 1670, p. 341.

6 C. Berruti, *Vita del Venerabile servo di Dio Gerardo Maiella*, Naples, Miranda, 1847, p. 35.

7 Cesario d'Heisterbach, *Dialogus miraculorum*, p. 202.

8 Ibid.

9 Ibid.

10 Gio. Battista Sangiure, S.J., *Erario della vita cristiana, e religiosa. Overo l'arte di conoscere Cristo Gesù, e di amarlo. Dove si tratta delle Virtù, e de' Punti più importanti della Vita spirituale*, Venice, N. Pezzana, 1711, part III, p. 228.

11 Ibid.

12 Ibid., p. 330.

13 Ibid., p. 238.

14 Ibid. p. 239.

15 Ibid.

16 Ibid., p. 241.

17 Ibid., p. 332.

18 Ibid., p. 239.

19 Ibid.

20 Ibid.

21 Ibid., p. 244.

22 Ibid., p. 243.

23 Ibid.

24 Ibid.

25 Ibid., p. 240.

26 Ibid.

27 Emerio de Bonis, S.J., *Trattato del Santissimo Sacramento dell'Altare et del modo di riceverlo fruttuosamente. Con un altro Trattato della Santissima Messa & del modo di udirla con frutto*, Brescia, P. M. Marchetti, 1598, p. 85.

28 C. G. Rosignoli, S.J., *Verità eterne, esposte in lettioni ordinate principalmente per li giorni degli Esercizi Spirituali*, p. 364.

29 De Bonis, *Trattato del Santissimo Sacramento*, p. 60.

30 Ibid.

31 Martino del Rio, *Disquisitionum magicarum libri sex*, Venetiis, apud Ioan. Antonium et Iacobum de Franciscis, 1606, t. III, p. 179.

32 Ibid.

33 Imperiali, *Le notti beriche*, p. 67.

34 Ibid., p. 67.

35 Ibid., p. 62.

36 Ibid., p. 67.

37 *«Caos». Cronache cesenati del sec. XV*, by Giuliano Fantaguzzi. Publicate ora per la prima volta di su i manoscritti con notizie e note dal dott. Dino Bazzocchi, Cesena, Tip. Bettini, 1915, p. 47.

38 S. Francesco di Sales, *Lettere spirituali,* op. cit. p. 177.

39 Ibid., pp. 176–7.

40 Montano, *La famiglia del santo,* op. cit. p. 359.

41 Ibid.

42 *Trattato del Santissimo Sacramento dell'altare*, op. cit. pp. 89–90.

43 Montano, *La famiglia del santo*, op. cit. p. 360.

44 B. Pignattari, *Manuale de' sagri riti diviso in due parti. Nella prima si contiene il modo di ben servire alla Santa Messa bassa o solenne da' chierici ne gli ordini minori, con le parole, che il ministro deve rispondere alla Messa Romana, Certosina, Domenicana, e Carmelitana. Nella seconda le Funzioni da praticarsi nella Settimana Santa da tutti li Sagri Ministri* . . . , Bologna, Gio. Pietro Barbiroli, alla Rosa, 1714, p. 15.

45 Ibid., p. 16.

46 Ibid., p. 28.

47 Ibid., pp. 17–18.

48 *Rubricae Missalis Romani commentariis illustratae*, Romae, sumptibus Felicis Caesaretti, sub Signo Reginae, 1674, p. 22. The form *ly* or *li*, which is characteristic of late medieval theological texts, is derived from the misunderstanding of the letter *h* with a dot above it which in fact means *hoc* (scil. *nomen* o *verbum*): Bruno Nardi, *Saggi sulla cultura veneta del Quattro e Cinquecento*, Padua, 1971, pp. 124–9; cf. *lyhomo* in *Baldus* by Folengo, XXV, 492. (I thank Augusto Campana and Italo Mariotti who enabled me to add this note.)

49 Ibid., p. 27.

50 Ibid.

51 Ibid., p. 362.

52 Ibid.

53 Gio. Pietro Pinamonti, *L'albero della vita. Pregi, e frutti della S. Messa. Con la maniera di parteciparne copiosamente*, in *Opere* del Padre G.P.P., Venice, N. Pezzana, 1719, p. 425.

54 Ibid.

55 Ibid.

56 Gio. Battista Sangiure, S.J., *Erario della vita cristiana, e religiosa. Overo l'arte di conoscere Gesù, e di amarlo*, part III, p. 295.

57 Pinamonti, *L'albero della vita. Pregi, e frutti della S. Messa*, p. 426.

58 Ibid.

59 Sangiure, *Erario della vita cristiana, e religiosa*, p. 290.

60 Ibid., p. 292.

61 Pinamonti, *L'albero della vita*, p. 427.

62 Ibid., p. 426.

63 Sangiure, *Erario della vita cristiana*, p. 228.

64 Ibid., p. 308.

65 Alessandro Diotallevi, S.J., *La beneficenza di Dio verso gl'uomini e l'ingratitudine degl'uomini verso Dio. Considerazioni*, Venice, A. Poletti, 1716, p. 253.

66 Ibid., p. 258.

67 Ibid., p. 274.

68 Ibid., p. 259.

69 Ciro di Pers, sonnet, «Meditazione in andando alla santissima comunione», in *Poesie*, ed. M. Rak, Turin, Einaudi, 1978, p. 312.

70 Agostino Coltellini, *La Grazia che condanna overo discorso contro all'abuso del Santissimo Sacramento dell'altare*, Florence, per il Massi da Forlì, 1652, p. 19. In the volume *Discorsi sacri* d'A.C., Accademico Apatista, Florence, per il Landi, 1654, p. 17.

71 Ibid.

72 Paolo Segneri, S.J., *Il parroco istruito. In cui si dimostra a qualsiasi Curato novello il debito che lo strigne, e la via da tenersi nell'adempirlo*, Bologna, Longhi, s.a., p. 285.

73 Ibid., p. 284.

74 Ibid.

75 Ibid., p. 283.

76 Ibid., pp. 283–4.

77 Sant'Aurelio Agostino, *I soliloquj*, in *Le divote meditazioni*, Venice, Erede di Niccolò Pezzana, 1775, p. 209.

78 Ibid.

79 P. Segneri, *Il cristiano istruito nella sua legge. Ragionamenti morali*, Venice, Baglioni, 1773, part III, p. 74.

80 Ibid., part III, p. 71.

81 Ibid.

82 Ibid., part III, p. 74.

83 Ibid., part III, p. 71.

84 Ibid.

85 G. Marino, *Lettere*, ed. M. Guglielminetti, Turin, Einaudi, 1966, p. 49.

86 *La Lira*, Rime del Cavalier Marino, Venezia, F. Baba, 1653, part I, p. 187, sonnet «Nel Santissimo Sacramento dell'Eucharistia»: «A questa sacra tua mirabil mensa», v. 13.

87 Ibid., p. 186.

88 «Per lo Santissimo Sacramento dell'Ostia», sonnet by Count Vincenzo Maria Marescalchi, in *Miscellanea poetica de gli Accademici Concordi di Ravenna*, Bologna, per l'Erede del Benacci, 1687, p. 495.

89 Marino, *La Lira*, part III, p. 175.

90 «L'Eucaristico Sacramento», sonnet by Giuseppe Torri, in *Miscellanea poetica de gli Accademici Concordi*, p. 360.

91 Marino, *La Lira*, part III, p. 175.

92 Fulgenzio Cuniliati, O. P., *Il catechista in pulpito* . . . , Venice, T. Bettinelli, 1768, p. 237.

93 Ibid., p. 232.

94 Ibid., p. 231.

95 Ibid., p. 235.

96 Carlantonio Bedori, «Infelicità dell'uomo», sonnet. The short prose observation precedes the sonnet in *Miscellanea poetica de gli Accademici Concordi*, p. 65.

97 Ibid., v. 9.

98 Sonnet by Giovanni Turchi, in *Miscellanea poetica de gli Accademici Concordi di Ravenna*, p. 315.

99 C. A. Cattaneo, S.J., *L'esercizio della buona morte*, in *Opere* del Padre C.A.C., Venice, N. Pezzana, 1768, p. 133.

100 R. Marchelli, *Prediche quaresimali*, Venice, G. Storti, 1682, p. 1.

101 C. A. Cattaneo, *L'esercizio della buono morte*, pp. 132–3.

102 Ibid., p. 133.

103 T. Gaudiosi, sonnet «Dieci lustri di vita o poco meno», in *Marino e Marinisti*, ed. G. G. Ferrero, Milan–Naples, Ricciardi, 1954, p. 1078.

104 C. A. Cattaneo, *L'esercizio della buona morte*, p. 133.

Chapter 12 *In the Pit of the Stomach*

1 Giacomo Lubrani, S.J., *I tre Cieli*. Panegyric VII by Saint Thomas Aquinas, in *Il Cielo domenicano. Col primo Mobile della Predicazione, con più Pianeti di Santità. Panegirici sacri*, t. I, Naples, G. Raillard, 1691, p. 124.

2 Fulgenzio Cuniliati, O. P., *Il catechista in pulpito . . .* , Venice, T. Bettinelli, 1768, p. 218.

3 Ibid.

4 Emanuele Tesauro, *La filosofia morale derivata dall'alto fonte del grande Aristotele Stagirita*, Venice, N. Pezzana, 1712, p. 286.

5 Ibid.

6 Cuniliati, *Il catechista in pulpito*, p. 218. For a rigorous casuistry (*an sumptio tabachi communionem impediat*) cf. Paolo Maria Quarti, *Rubricae Missalis Romani commentariis illustratae*, Rome, sumptibus Felicis Caesaretti, sub Signo Reginae, 1674, p. 458: «communis modus sumendi tabachum non frangit ieiunium naturale, nec impedit communionem sive sumatur in folio, sive in pulvere, sive in fumo . . . Dixi communis modus sumendi tabachum: quia si folium in os admissum traiicitur integrum in stomachum, vel aliqua particula ex industria, certum est violare ieiunium et impedire communionem.»

7 Ibid., p. 225.

8 Ibid., p. 232.

9 Ibid., pp. 232–3.

10 Bartholomaeus Mastrius de Meldula, O.M.C., *Theologia moralis ad mentem DD. Seraphici et Subtilis concinnata*, Venetiis, apud Antonium Moram, 1723, p. 433.

11 Ibid.

12 Alphonsus de Ligorio, *Theologia moralis*, Bassano, Remondini, 1779, t. II, p. 129.

13 Bartholomaeus Mastrius, *Theologia moralis*, p. 433.

14 Ibid.

15 Alphonsus de Ligorio, *Theologia moralis*, t. II, p. 129.

16 Ibid.

17 Ibid.

18 Ibid.

19 Ibid.

20 Ibid.

21 Ibid.

22 Ibid.

23 Ibid., II, p. 69.

24 Ibid.

25 G. B. Sangiure, S.J., [Saint-Jure], *Erario della vita cristiana, e religiosa. Overo l'arte di conoscere Cristo Gesù e di amarlo. Dove si tratta delle virtù, e de' punti più importanti della Vita Spirituale*, Venice, N. Pezzana, 1711, part III, p. 290.

26 Ibid., p. 295.

27 Ibid., p. 324.

28 Ibid., pp. 324–5.

29 Ibid., p. 324.

30 Ibid., pp. 330–1.

31 Ibid., pp. 291–2. On the 'various phases of the dispute of the Eucharist' cf. John Gregory Bourke, *Scatologic Rites of all Nations*, Italian trans., *Escrementi e civiltà. Antropologia del rituale scatologico*, with preface by S. Freud, introduction by P. Meldini, Bologna, Guaraldi, 1971, pp. 81–8.

32 Domenico Cavalca, *Le vite dei SS. Padri*, Milan, Istituto Editoriale Italiano, 1915, vol. II, p. 69.

33 Ibid.

34 Ibid., pp. 69–71.

35 Alfonso de' Liguori, *Apparecchio alla morte, cioè considerazioni sulle massime eterne*, Bassano, Remondini, 1767, p. 390. Cf. C. G. Jung, *Das Wandlungssymbol in der Messe*. Italian translation, *Il simbolismo della Messa*, Turin, Boringhieri, 1978, p. 41 et passim.

36 [Filippo Giriodi], *Sacre cerimonie ecclesiastiche cavate dalle Rubriche del Messale, e da' migliori autori*. Nuovamente accresciute. Compilate da un Sacerdote Secolare Missionario Apostolico, Turin, Zappata & Avondo, 1758, pp. 39–41.

37 Ibid., p. 140.

38 De Ligorio, *Theologia moralis*, t. II, p. 128.

39 Ibid.

40 Ibid.

41 Constantinus Roncaglia, *Universa moralis Theologia qua non solum principia speculativa sed etiam regulae practicae ad usum confessariorum explicantur*, Lucae, Marescandoli, 1773, t. I, p. 43. For the meaning of *ly* see ch. 11, n. 48.

42 *Sacre cerimonie ecclesiastiche*, p. 115.

43 Ibid., p. 114.

44 Ibid., p. 113.

45 *Constitutiones Diœcesanae ... promulgatae in Synodo ... anni 1748 celebrata*, Faventiae, ex Typographia Episcopali Benedicti, p. 69.

46 Ibid., p. 66.

47 Ibid., p. 67 et passim.

48 Angelo Maria da S. Filippo, *Quaresimale*, Venice, G. B. Recurti, 1715, pp. 182–3.

49 *Constitutiones Diœcesanae . . . anni 1748*, p. 67.
50 Carlo Maurizio Ronzoni, *Prediche quaresimali*, Venice, Simone Occhi, 1769, p. 182.
51 Angelo M. da S. Filippo, *Quaresimale*, p. 183.
52 Ronzoni, *Prediche quaresimali*, p. 254.
53 Gaudenzio Altemps, *La Santità Perseguitata trionfante. Vita di S. Giovanni Chrisostomo*, Rome, Andrea Fei, 1645, p. 94.
54 Ibid.
55 Ibid., p. 93.
56 Cuniliati, *Il catechista in pulpito*, p. 235.
57 *Sacre cerimonie ecclesiastiche*, p. 106.
58 Ibid., p. 100.
59 Ibid., p. 102.
60 «La troppa brevità della Messa condannata nel sacerdote da monsignor Alessandro Sperelli vescovo di Gubbio», in *Sacre cerimonie ecclesiastiche*, pp. 94–5. A reformer of ecclesiastical customs, Alessandro Sperelli was the author of a monumental enchyridion for the education of the ecclesiastical hierarchy. *Il vescovo. Opera etica, politica, sacra, in tre parti distinta*, Rome, G. Battista & Giuseppe Corvo, 1656. He also wrote two volumes of *Ragionamenti pastorali fatti al Clero, all Monache, e al popolo. In tre parti distinti*, Venice, Paolo Baglioni, 1675.

Chapter 13 The Horror of the Guts

1 Alessandro Diotallevi, S.J. (1647–1722), *La beneficenza di Dio verso gl'huomini e l'ingratitudine degl'huomini verso Dio. Considerazioni*, Venice, A. Poletti, 1716, p. 260.
2 Ibid.
3 Segneri, *Il cristiano istruito*, part III, p. 74.
4 Diotallevi, *La beneficenza di Dio verso gl'huomini*, pp. 261–2.
5 Sangiure, *Erario della vita cristiana, e religiosa*, pp. 324–5.
6 Marino, *La Lira*, part III, madrigal «Stupì Zeusi deluso», v. 7.
7 Sangiure, *Erario della vita cristiana, e religiosa*, p. 295.
8 Ibid., p. 300.
9 Ibid., p. 307.
10 Ibid., pp. 306–7.
11 Ibid., p. 228.
12 Ibid., pp. 330–1.
13 Ibid., p. 239.
14 Ibid., p. 313.
15 Ibid.
16 Ibid., p. 239.
17 Ibid.
18 Ibid.

19 Ibid.
20 Ibid., pp. 239–40.
21 Ibid., p. 295.
22 Ibid., p. 240.
23 Ibid.
24 Ibid., pp. 235–6.
25 Padre Filippo di Rimella, reformed minor, *Orazione sopra l'Eucaristico sagramento in occasione della solenne esposizione per le quarant'ore. Si allude alle profanazioni, e si combattono gli errori de' nostri dì,* in *Orazioni apologetiche e sermoni morali accomodati alla luttuosa condizione de' torbidi, perversi tempi dedicati al glorioso ed immortale Pontefice Sommo Pio VI,* Fuligno, Giovanni Tomassini, Stam. Vescov., 1795, p. 164.
26 Ibid.
27 Ibid., p. 169.
28 Ibid., pp. 168–9.
29 Sangiure, *Erario della vita cristiana, e religiosa,* p. 245.
30 Ibid.
31 Ibid., p. 240.
32 Ibid., p. 241.
33 Ibid.
34 *Dialogo della serafica vergine, et sposa di Christo S. Catherina da Siena,* op. cit. p. 503.
35 Giovanni Taulero (1300–61), *Prediche,* Milan, Bocca, 1942, p. 168.
36 Ibid., p. 41.

Index

215

217

INDEX

218